PROCEEDINGS OF THE INTERNATIONAL WORKSHOP ON WIND ENERGY AND
LANDSCAPE – WEL/GENOVA/ITALY/26-27 JUNE 1997

Wind Energy and Landscape

Edited by

Corrado F. Ratto
Department of Physics, University of Genova, Italy

Giovanni Solari
Department of Structural and Geotechnical Engineering, University of Genova, Italy

CRC Press
Taylor & Francis Group
Boca Raton London New York

CRC Press is an imprint of the
Taylor & Francis Group, an **informa** business

A BALKEMA BOOK

The International Workshop on Wind Energy and Landscape has been organized as a Satellite to the 2nd European & African Conference on Wind Engineering: 2 EACWE, Genova, Italy, 22-26 June 1997

The figure in the cover, which was also the logo of the WEL Workshop, was conceived and drawn by Simonetta Santus. It represents symbolic wind mills in the Expo area of Genova, near its ancient harbour.

The texts of the various papers in this volume were set individually by typists under the supervision of each of the authors concerned.

Published by
A.A. Balkema, P.O. Box 1675, 3000 BR Rotterdam, Netherlands
Fax: +31.10.413.5947; E-mail: balkema@balkema.nl; Internet site: http://www.balkema.nl

A.A. Balkema Publishers, Old Post Road, Brookfield, VT 05036-9704, USA
Fax: 802.276.3837; E-mail: info@ashgate.com

ISBN 90 5410 913 0
© 1998 A.A. Balkema, Rotterdam
Printed in the Netherlands

Wind Energy and Landscape, Ratto & Solari (eds) © 1998 Balkema, Rotterdam, ISBN 90 5410 913 0

Table of contents

Wind Energy and Landscape, Ratto & Solari (eds) © 1998 Balkema, Rotterdam, ISBN 90 5410 913 0

Foreword

Five thousand years ago the Egyptians were already able to harness the wind to make rudimentary sailing boats to go upstream the Nile river. It has been estimated that the biggest modern sailing ships could extract as much as 4 MW power from the wind.

The first examples of wind harnessing on the land seem to date back to two thousand years ago, with the appearance in Persia of vertical-axis windmills used for water pumping and flour making. The windmill spread, together with the Arabian conquest wars, towards Middle East and Mediterranean lands.

The origins of windmills in Europe are somewhat uncertain, the first definite proofs of their presence dating from the Middle Ages. The leading role in their development was played by Holland in the XVII century, then by Denmark in the XIX century. The central role of windmills, often used for pumping up water, in the history of the United States of America is well known. It has been estimated that about six million windmills were built in that country during the XIX century.

The years between the two World Wars saw the flowering of studies and realizations, especially in Denmark, Great Britain, Germany and France. Due to the relative lack of petroleum, their purpose was mainly that of producing electric energy. In 1931 the biggest wind-powered generator of its time (with a 30 m diameter rotor, a power of 100 kW and a yearly production of 280 MWhe) was built in Yalta, in the Soviet Union. In the same period, the windmills were the only source of electricity for most of the countryside in the USA at least before the boost given by the federal government to the rural electrification in the thirties and in the forties. The largest wind-power installation to be built in this period was at Grandpa's Knob in Vermont, USA, where a 1.25 MW unit was tested during the World War Two, working successfully for more than three years.

The low prices of oil after the World War Two and the development of conventional power plants led to the neglect of wind harnessing, on one hand, and the increase of the size of the wind turbines, on the other.

The 'energy crisis' of the seventies gave new momentum to the research and the development of conversion systems based on the renewable energies, the wind among others. The figures in 1981 of the energy produced world-wide were practically negligible. While nothing particularly striking happened in Europe in these years, the USA saw the realization of wind turbines able to produce more than 1 MWe, up to 2.5

MWe, and the development of the well known wind farms, ensembles of numerous units installed in the same area and connected to the electric grid. As a result, in a few years (1982-1986), the wind turbines installed in the USA had a capacity of more than 1200 MW. In the State of California alone almost 9000 units were providing a total power of about 1000 MW.

The change in the federal policy towards the harnessing of renewable energies halted in North American the interest in the installation of wind turbines just before a renewed European interest towards this technology. Exceeding 1000 MW in 1993, Europe reached almost 3400 MW at the end of 1996, mainly thanks to Germany (1576 MW) and Denmark (785 MW), followed by Great Britain and Holland.

It can be demonstrated that the total energy extractable from the winds blowing around the earth could in no way match the present level of energy demand. But this is certainly not the main limitation to the wind resource.

In books published in the seventies one can find designing and planning of more or less 'autonomous houses' (*The autonomous house, design and planning for self-sufficiency* is the title of a book published in England in 1975), each with its windmill. It was for instance estimated that a minimum unit could be formed by a windmill of 2 m diameter mounted on a telegraph pole, enough to power lights, radio and television of a single home. If this was judged not enough, a wind-powered 2kW generator, with blades approximately 4 m in diameter, would provide enough power for lights, radio, television, stereo, electric iron, electric kettle, spin-drier, vacuum cleaner and similar demands, in an area with fairly low average wind speed.

Even forgetting the intermittency of power provided by wind energy, it is evident that this idea of a windmill in each backyard is absolutely unacceptable, mainly in our European towns with very few separate dwelling houses. Nevertheless, even if this 'one family – one wind turbine' philosophy is rejected, an area of several square meters per family has to be swept by the blades of one or the other wind turbine, if most of the housing electric needs have to be covered. This means many wind driven generators, whose number can be reduced only by increasing the dimensions of single units. Remember that a unit rated 1.5 MW has a hub height of the order of 70 m, a similar rotor diameter and thus a total height of about 100 m or more.

The impact on the environment of so many and/or huge wind turbines cannot be negligible, even though the technological evolution and new materials have greatly reduced this impact with respect to, let us say, twenty years ago. This is certainly true for their interaction with the electromagnetic waves, and thus their interference with telecommunications. This is true also for noise, considering that, at a reasonable distance from these machines, it is absolutely comparable with the natural noise produced by the wind itself. Also the interference between the modern windmills and the birds is a problem at present widely debated.

What certainly cannot be avoided is the visual impact of wind energy. As a matter of fact, with the decrease of the other sources of environmental impact, the awareness that, the harmonization of wind turbines with the landscape is becoming of world-wide importance.

The push toward the organisation of the International Workshop on Wind Energy and Landscape (WEL) in Genova was coming from the decision of the Energy

Assessorship of the Liguria Region to deepen the studies for a thorough investigation of the wind energy resource of Liguria and start a few demonstration projects.

Indeed, in a so narrow region, squeezed between the sea and the mountains, with few flat areas, with short valleys, where housing close to the coast is often continuous, even the identification of the more suitable areas for installing wind turbines is not straight forward. Since the wind energy flux has its highest values above or near the sea and on the main elevations of Alps and Apennines, it is evident that, in these conditions, the visual impact of any installation of wind turbines cannot be neglected.

The idea of having a forum to debate this matter rose from the wish of confronting our local reality with the national and international problems and perspectives.

In the meanwhile it happened that the Department of Structural and Geotechnical Engineering of the University of Genova was organizing the 2nd European and African Conference on Wind Engineering (2 EACWE). This concomitant situation was judged as a unique opportunity for establishing an ideal link between the 2 EACWE technical sessions dealing with general problems in wind energy and an International Satellite Workshop on Wind Energy and Landscape.

WEL took place in Palazzo Ducale, Genova, Italy, on June 26-27, 1997. It was organized by the Department of Physics and by the Department of Structural and Geotechnical Engineering of the University of Genova, under the auspices of Energy Assessorship of the Liguria Region, in co-operation with the European Wind Energy Association (EWEA), the International Association for Wind Engineering (IAWE), the International Solar Energy Society (ISES) and the International Wind Engineering Forum (IWEF).

Twenty lectures from ten nations presented the problem of the introduction of wind turbines into the landscape and, more generally, into the environment. They illustrated the constructions already realized and the future prospects for the exploitation of wind energy in their own countries, the software for visualizing the results of the installations, the effects of the wind turbines on the avifauna, the economic and social effects, the noise impact, the limits set by urban planners and by building standards.

This book collects a selection of the best papers presented at WEL. We hope it will contribute to stimulate the debate on the impact of modern wind turbines on the landscape and diffuse suitable ideas for harmonizing their realization with our environment.

Finally, we cannot conclude this Foreword without thanking those people who gave fundamental and highly appreciated contributions to the organization of the Workshop. They include the Scientific Advisory Board who offered advice and examined abstracts and papers, the Local Organizing Committee, the academical, technical and administrative staff of the Department of Physics and of the Department of Structural and Geotechnical Engineering of the University of Genova, the President, Councillors and Officials of the Liguria Region, the public and private agencies which have sponsored WEL, all bodies and firms who took part in the Scientific and Technical Exhibition, the Organizing Secretariat BC Congressi, the printer of this book, and especially our Secretaries Anna Rizzo, Sonia Aulicino and Anita Visintini.

The last but not least thanks are for Romolo Benvenuto, Councillor Responsible for

the Energy and the Territory of the Liguria Region. Even more than the financial support, however fundamental for realizing the WEL Workshop, we have greatly appreciated his foresighted ideas and enthusiast participation and co-operation.

C. F. Ratto and G. Solari
WEL Co-Chairmen

Wind Energy and Landscape, Ratto & Solari (eds) © 1998 Balkema, Rotterdam, ISBN 90 5410 913 0

WEL Organization

Department of Physics
University of Genova
Via Dodecaneso, 33, 16146 Genova, Italy
Phone/Fax: +39-10-353-6354
http://www.fisica.unige.it

Department of Structural and Geotechnical Engineering
University of Genova
Via Montallegro, 1, 16145 Genova, Italy
Phone: +39-10-353-2525; Fax: +39-10-353-2534
http://www.diseg.unige.it

In co-operation with:
European Wind Energy Association, EWEA
International Association for Wind Engineering, IAWE
International Solar Energy Society, ISES
International Wind Engineering Forum, IWEF

Under the auspices of:
LIGURIA REGION, Energy Assessorship

Workshop co-chairmen
Corrado F. Ratto
Department of Physics
University of Genova, Italy
E-mail: ratto@fisica.unige.it

Giovanni Solari
Department of Structural and Geotechnical Engineering
University of Genova, Italy
E-mail: solari@scostr.unige.it

Wind Energy and Landscape, Ratto & Solari (eds)© 1998 Balkema, Rotterdam, ISBN 90 5410 913 0

Wind engineering and the 2 EACWE: Some background notes

Using the definition given by Cermak in 1975, 'Wind Engineering is the rational treatment of interactions between wind in the atmospheric boundary layer and man and his works on the surface of earth'. It is one of the newest and most pressing lines of research in the modern engineering panorama, because of the importance and variety of the scientific, technological and technical problems of its concern.

Drawing its principles from several disciplines among which are physics of the atmosphere and fluid mechanics, meteorology and micro-meteorology, urban planning, architecture and bioclimatic studies, aerodynamics and aeronautics, civil, environmental, energy and mechanical engineering, physiology and psychology, wind engineering develops autonomous concepts and methods which today are applied in all sorts of contexts.

It deals with forecasting and mitigating damage caused by storms, which alone are responsible for over 80% of the human casualties and economic losses that the world suffers in terms of natural events, with the representation and measuring of the wind and its related meteorological phenomena, the forecasting of weather and climatology, the aerodynamics of constructions and vehicles, wind tunnel experiments, the computer simulation of the flow fields and of actions of wind on bluff bodies, the wind behaviour of all constructions, in particular towers, skyscrapers, bridges, large roofs and all structures whose safety depend on wind, the diffusion of atmospheric pollutants, the quality of air and environmental protection, the use of wind energy and the choice of sites for wind turbines, the territorial planning in terms of wind problems.

The scientific management of this sector is entrusted to the International Association for Wind Engineering (IAWE), funded in 1975 through the action of the Steering Committee for the International Study Group on Wind Effects on Buildings and Structures. IAWE has the primary purposes of the liaison with national and international organizations working in similar fields and the organization of the International Conferences on Wind Engineering (ICWE) (Teddington 1963, Ottawa 1967, Tokyo 1971, London UK 1975, Fort Collins 1979, Goald Coast and Auckland 1983, Aachen 1987, London Ontario 1991, New Delhi 1995, Copenhagen 1999). Together with the Journal of Wind Engineering and Industrial Aerodynamics, formerly Journal of

Industrial Aerodynamics since 1980, ICWE trace the fundamental steps of the subject and reveal its rapid evolution.

The International Association for Wind Engineering is divided into three regions – the European and African Region, the American Region and the Asia-Pacific Region – whose activities are co-ordinated by regional chairmen. These manage relations between the different associations or national groups and plan the scientific initiatives of their area, first of all the regional conferences which take place in the year between two world congresses. Following the conference held in Guernsey, UK in 1993, the 2nd European & African Conference on Wind Engineering (2 EACWE) took place in Palazzo Ducale, Genova, Italy, from June 22-26, 1997.

2 EACWE was organized by the Department of Structural and Geotechnical Engineering (DISEG) of the University of Genova in co-operation with the International Association for Wind Engineering (IAWE), the Italian National Association for Wind Engineering (ANIV), the Liguria Region, the Province of Genova and the Municipality of Genova, under the auspices of UNESCO.

During the days of the conference, delegates from universities, industry, public authorities and private associations joined together in a scientific and technical forum which covered all the facets of wind engineering revealing, on one hand, the great efforts made for co-operation between theoretical and applied research, and, on the other, the most important new aspects of the sector, first of all the widespread diffusion of computational experimentation side by side with and in support of mathematical and physical modelling.

The matter of this discussion is summarized in 240 papers compiled in two volumes of Conference Proceedings of over 2000 pages. A selection of these contributions is published in a Special Issue of the Journal of Wind Engineering and Industrial Aerodynamics published by Elsevier and in a Special Issue of Meccanica published by Kluwer.

2 EACWE gave impetus to numerous satellite activities which created a great cultural back up to the image of Genova, producing a significant link between the city and the wind. The International Workshop on Wind Energy and Landscape (WEL) was the first of these initiatives.

In addition, in the same conference venue of 2 EACWE and WEL, there was a scientific and technical exhibition in which 23 exhibitors from several countries showed their projects, plant, equipment, structures, instruments, books, magazines and almost everything else relevant to wind engineering. Several other collateral activities contributed to bring the wind and the conference into the daily life of the citizens. In particular, in the *Sala Grecale* of the *Magazzini del Cotone* in the old port area, there was a series of films entitled *The wind and the Cinema*. The Italian Navy sent a splendid sailing ship, *Capricia,* moored in the Port of Genova during the week of the congress and open to all. Palazzo Ducale also had an exhibition of kites, while numerous kite competitions took place in the port area.

Summing up the 2 EACWE and its associated activities, some 400 delegates participated at the congress plus 50 exhibitors and several accompanying persons. The scientific and technical exhibition attracted not less than 100 visitors every day. Nobody has calculated how many people boarded *Capricia* or enjoyed the cinema and

the kites. Using a sentence widely repeated by the local and national press and television, during the days of the conference Genova was really the world capital of the wind.

Giovanni Solari
2 EACWE Chairman and WEL Co-Chairman
IAWE European and African Coordinator

Keynote lectures

Environmental and territorial aspects of wind farms in Italy

B. Bellomo
ENEL S.p.a., Rome, Italy

ABSTRACT: Italy is very densely populated country and has a strict legislation concerning nature conservation and environment protection: it is therefore highly probable that the most suitable sites either be subject to land use or environmental constraints or in any case, present competition for land use (for energy production or for other purposes).

This means that even if the installation of wind plants generally does not imply significant interactions, these must be nevertheless carefully considered.

Enel's programs include two demonstration plants totalling 20 MW capacity, based on medium size (200-400 kW) italian generators sited respectively at Monte Arci, a coastal environment and at Collarmele, in an Apennines environment (1000 m a.s.l.)

For the 11 MW wind farm at Monte Arci (Sardinia), the first planned large installation in Italy, extensive environmental studies were conducted. All the main interactions were considered: land planning in the area, land use and human activities, birdlife, flora, fauna, ecosystems, landscape, noise and electromagnetic interference. For each aspect a specific study was carried out, which includes the description of the environmental situation and an analysis of the effects of the project.

The results are both site-dependent and of a more general value.

The knowledges gained from Monte Arci studies have been applied to the 9 MW wind farm of Collarmele (Abruzzo) where the environmental analysis has been focused on the most significant potential impacts: noise and landscape.

The results of the environmental analysis have been used to optimise the wind farm lay-out.

1 INTRODUCTION

Because Italy is situated in the closed basin of the Mediterranean, it does not have the strong and regular winds that blow in other areas of the world. Its geographical position, together with the significant presence of mountain chains and large bodies of wather, bring about a different seasonal distribution of atmospheric pressures and consequently variable winds during the year and within a single region.

Studies carried out by Enel and other institutions in Italy indicated that the areas potentially interesting for wind energy exploitation are essentially located in central and southern Apennines (hilly and mountain regions) and in some coastal regions (Fig. 1) (European Wind Atlas, 1989).

It is also necessary to point out that Italy is very densely populated and has a strict legislation concerning nature conservation and environment protection: it is therefore higly probable that the most suitable sites either be subject to land use or environmental constraints or in any case, present competition for land use (for energy production or for other purposes).

This means that even if the installation of wind plants generally do not implies significant interactions,these must be nevertheless carefully considered.

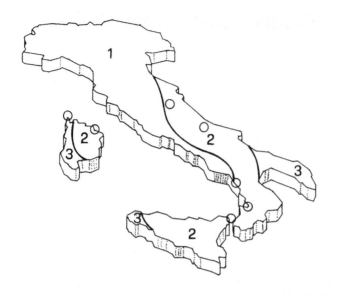

	Sheltered terrain	Open plain	At a sea coast	Open sea	Hills and ridges
1	<3.5	<4.5	<5.0	<5.5	<7.0
2	3.5-4.5	4.5-5.5	5.0-6.0	5.5-7.0	7.0-8.5
3	4.5-5.0	5.5-6.5	6.0-7.0	7.0-8.0	8.5-10-0
O Regions where local concentration effects may occur					

Figure 1. Italian wind resources at 50 metres above ground level for five different topographic conditions (m/s).

Enel's programs include two demonstration plants totalling 20 MW capacity, based on medium size (200-400 kW) italian generators, and a mountain test site for 2.4 MW. The demonstration plants are sited respectively at Monte Arci, a coastal environment and at Collarmele, an apennine environment site (1000 m a.s.l.) whereas the mountain test field, Acqua Spruzza, is an high altitude (1360 m a.s.l.) apennine site caracterized by adverse weather conditions. An older coastal test site is located in Alta Nurra (Sardinia) (Fig. 2).

It must also be considered that in Italy, thanks to a legislation that provides incentives for renewable energies, there are on the table 107 wind installation projects from independent producers, totalling about 730 MW, disseminated in the southern part of the country.

COASTAL ENVIRONMENT	TEST SITE - ALTA NURRA (SARDINIA) - 3 MW
	MONTE ARCI WIND FARM (SARDINIA) - 11 MW
APENNINE ENVIRONMENT MEDIUM ALTITUDE (\approx 1000 m a.s.l.)	COLLARMELE WIND FARM (ABRUZZO) - 9 MW
APENNINE ENVIRONMENT HIGH ALTITUDE (\approx 1300 m a.s.l.)	TEST SITE - FROSOLONE (MOLISE) - 2,4 MW

Figure 2. ENEL programmes.

Environmental analyses have been carried out for the two ENEL wind farm sites: Monte Arci and Collarmele (Fig. 3).

For the 11 MW wind farm at Monte Arci (Sardinia), a comprehensive study was conducted. All the main enviromental interactions were considered.

The results are both site-dependent and of a more general value.

The experience acquired on the Monte Arci site has been applied to the 9 MW wind farm of Collarmele (Abruzzo) where the environmental analysis has been focused on the most significant potentiai impacts: noise and landscape.

2 MONTE ARCI STUDIES

For the Monte Arci wind farm (11 MW, 34 West wind turbines, 320 kW each) a specific study has been performed for each of the following environmental items: planning in the area; land-use and human activities; vegetation, flora, fauna and ecosystems; avifauna; landscape; noise; electromagnetic interference (Bellomo et al. 1991, Bellomo et al. 1992, Bellomo et al. WEC 1995, Bellomo et al. HTE 1995).

In order to evaluate thoroughly the effects induced by the plant, the analysis has been carried out examining, for each item, the modifications caused directly or indirectly, both during the construction and the operation of the plant.

Therefore, the studies involved the description of the site existing environmental situation and the previsions of the project effects.

The site is comprised in the Monte Arci regional park of a 135 km² ca. extension, that is destined to protect the area as an interesting volcanic formation with natural elements of value. Special volcanic structures are in fact found as well as obsidian ore, which was used to manufacture stone devices in the prehistoric age. Evolved formations of holm-oak and Mediterranean bush are observed on the mountain, even though signs of degradation are evident.

In the area of the plant the soil cover consist of a few prevailing typologies, among which the Mediterranean bush stands out; wood surfaces are interrupted by wide grazing areas for raising livestock, chiefly ovines; reforestation in large burned down areas is considerable, as it involves some km² and has started since over ten years, and is joined with felling activities.

The wind-farm is designed for utilizing the existing road system and fire-stop tracks; just short junctions are required to aerogenerator lay-bys which shall be similarly characterized as the existing tracks. The land really withdrawn to actual use due to the lay-bys and the service building of the plant is negligible (< 1 %) with respect to the area covered by the plant which is of about 3.5 km². Even in connecting the existing electrical system underground cables will be used at the borders of the tracks, thus without touching other portions of land. It is a fact that the territory is practically left available for any compatible destination of use as provided in the park regulations; in particular the stock grazing will be allowed, as well as the picking either of pastures or of bush products.

The wind power plant is besides a characterizing element, still unusual in Italy, that could help exploiting the park since in addition to the interest in nature, this innovating typology of plants may somehow be attractive. Within the service building (necessary for the plant) a reception centre for visitors is planned the integration of which has been carefully studied: its location has been optimized and, for its design, reference has been made as much as possible to the rural dwellings in this area (both as regards their typology and coating)

The peculiarity of the installation with no emissions or fuel flows, the careful definition of the lay-out in the design, which as for this type of plant takes advantage of an high flexibility and thus adaptability to the site, as well as the low real withdrawal of land, make this construction compatible with a protected area such as Monte Arci.

The possible coexistence of the plant with the park is provided for even in regulations, as the law, which singles it out, allows renewable energy plants within it after an authorization of the regional council.

So the plant is deemed compatible with a multiple use of the territory, which will permit both sylvan and pastoral activities and the existence of the park, in addition to renewable energy power generation.

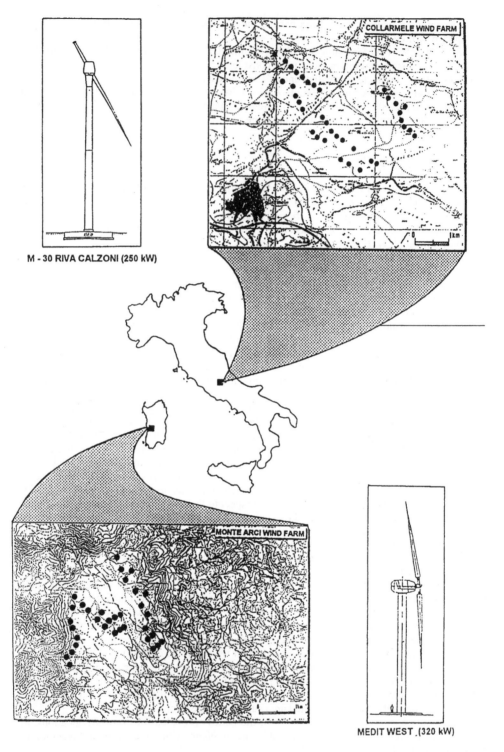

M - 30 RIVA CALZONI (250 kW)

MEDIT WEST (320 kW)

Figure 3. ENEL wind farm sites: Monte Arci and Collarmele.

As for the naturalistic characterization Monte Arci is included in the climax of holm-oak woods (Quercus Ilex). Throughout the mountain woods develop for about 1/3 of an overall surface of 130 km². Also the mediterranean bush is found at its various growth stages also related to degradation events because of fires, tree felling and too much extended grazing. By analysing only the aerogenerators area, it is interested by large extensions of artificial planting and secondary bush, following fire, whereas the most naturalistic elements, such as wood formations, are less extended. As regards fauna, Monte Arci has been such early shelter of species as the Sardinian deer and the moufflon, though currently among large size mammals there is but wild boar.

Fig. 4, expressing the biotic community quality, is a synthesis of the naturalistic caracterization.

The actual surface, withdrawn to the biotic communities, is small by virtue of the very reduced area required by the plant; moreover in the sites chosen for lay-bys there is no arboreal vegetation.

The construction phase implies interactions of small impact: simple operations are in fact required to prepare lay-bys and assemble aerogenerators and supports. Such operations will be moreover of a limited duration.

As impact during the operation period were considered noise increase and the presence of aerogenerators as an obstacle for avifauna.

A proper model estimated the noise levels due to the aerogenerators generation. A comparison between the estimates with and without the plant points out how significant variations of the environmental noisiness cannot be expected. The more so if it is taken into account that when the plant is under operation, the wind causes an increase in ground noisiness because of its interaction with the elements on the territory (vegetation, obstacles, etc.).

The avifauna is diversified according to the different vegetation typologies existing on the mountain; nevertheless, though a few elements of value, Monte Arci cannot be deemed as an emergency of absolute value in this respect, even though, located in the nearby of the sea coast, it is reached by migratory flows.

The species which may more suffer yard works are especially birds of prey, which enjoy wide extensions and are sensitive to disturbances relative to the presence of human beings. Migratory birds could be negatively affected because of the same reason, but such risk appears more negligible because the migration limited span.

During the operation period the estimated effect of the plant will essentially consists in disturbing the migrator's route: when meeting the obstacle, represented by the aerogenerators, they could modify the flight route enough to avoid it.

The number of dead birds for collisions with aerogenerators, as from literature data, will have bare effect, even though which species are concerned is a fact to be considered. In this specific site the impact is deemed to refer mostly to night migrators but, according to figures, it will not be significant for the populations; as for day species, among which there a few which are globally threatened, this impact is considered less probable.

As for the landscape analysis, the elements relative to the mount morphology, its vegetable cover and anthropic signs have been considered. The mount morphology and its vegetable cover attested its peculiarity partially due to the volcanic characteristics; whereas the anthropic signs stressed a situation where the presence of human beings variously revealed since the prehistoric age. The inherent quality and special vulnerability of the plant area were then analyzed and for the most significant point of view a series of computer simulation of the plant, were produced (fig. 5). The landscape analysis led to infer that the aerogenerators location will not cause special interferences. Moreover their presence makes it possible an interesting marriage between them and the landscape. In fact because of its location the wind farm cannot be seen from the main roads or towns, and when it is visible the landscape is not remarkably altered by virtue of the visual dilution of manufactures which do not interrupt the harsh outline of the bush and rocks appearing on the plateau.

Finally as for electromagnetic interference, an in-situ measuring campaign was carried out to detect the type of signal and the level and origin of existing radiocommunications. The site orography is complicated, so much that in adjacent detection points though at various altitudes the magnitude of signals is greatly different. However the survey pointed out that T.V.

broadcasting in this area is generally of good quality; moreover a radar was detected that operates at 2.7 GHz.

The interference of the plant may be excluded for the radar, because it will recognize and map an obstacle almost static like any other existing and the already discriminated ones. In relation to the other transmissions, the considered phenomena are the reflection and scattering of the electromagnetic waves being incident on the structures, since experimental measures exclude detectable electromagnetic emissions from the aerogenerators.

As for T.V. customers, hypothetical interference areas were evaluated and recognized by a model simulation; trouble came out to have a range of one-hundred metres at most for reflection and of one kilometre for scattering; such estimates originate from especially precautionary evaluations.

Inhabited areas closer to the site of the plant are at least 5 km (in a bee-line) far and located at lower altitudes, widely out of the hypothetical interference areas for signals of any origin; moreover reception difficulties would not however arise because of two repeaters, the former on the north side and the latter on the south side of the plant itself.

3 COLLARMELE WIND FARM

The experience gathered with Monte Arci studies has been profitably utilised for the environmental insertion of Collarmele wind farm (9 MW, 36 Riva-Calzoni wind turbines, 250 kW each) (Bellomo et al. 1996).

This experience indicated that, in order to optimise the insertion of a wind farm, it is not necessary to investigate all territorial and environmental aspects, but after a preliminary screening, efforts rather need to be directed to topics selected according to the site characteristics.

The wind farm site is at about 1000 m a.s.l., higher than Collarmele town which is about 1 km distant. The site is NE of the Fucino plain (650 m a.s.l.), a vast area characterised by the presence of agricultural activities, but also of infrastructures and technologically advanced industries.

The preliminary screening showed that the wind farm is compatible with the planning requirements in the area.

Moreover the site, that interests two hills separated by a deep cleft, is tree-free and presents a very limited natural value. It appears like an undulating and dry meadows for grazing that can coexists with the presence of the wind turbines.

The site is not interested by the main migration routes and the avifauna in the area has not specific value or protection requirements.

Taking into account all the aforesaid considerations, environmental studies where directed to the two following main topics: landscape insertion and induced noisiness in inhabited areas.

The current bare, stony landscape characterises the wind farm area. Even in absence of special sensibility elements, the specificity of such landscape is considered in the current instruments of planning and territorial protection (Sirente-Velino Park, Regional Landscape Plan) which, in the subject area, provide for special procedures to modify the "status quo" of the territory.

As for the insertion in the wide area interested by the installation (about 2 km2) the project utilizes the existing tracks, as service roads, to limit the area modifications. Moreover the natural cover damages deriving from the aerogenerators lay-bys will be limited as well. The surface really taken by the structures (service lanes included) shall not be in fact wider than 0,05 km2, whereas the remaining will keep being a grazing land. These solutions enable to maximise the unaltered area in the site, thus improving the integration into landscape.

Due to the absence of natural shields the wind farm is visible from medium and relatively long distances. This means that the installation will be part of the landscape chiefly with medium-good visibility conditions and from medium-long distance; it could so suggest itself as a technological feature of the NE area of Fucino plain.

The landscape study made use of pictorial static and animated insertion simulations of the wind farm, which have been utilised during meetings with the population and local authorities, and which proven useful in the purpose of accepting the project.

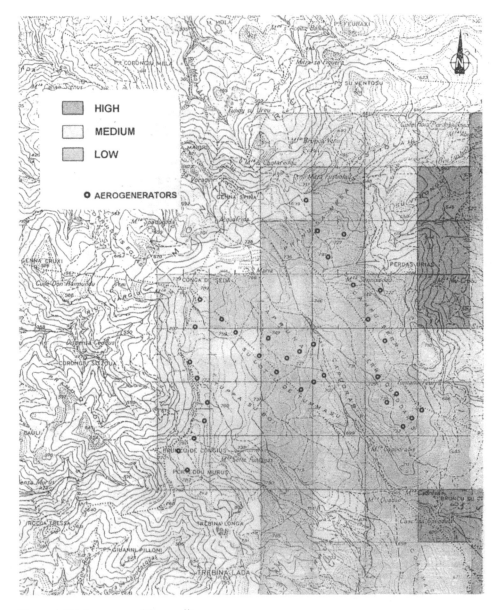

Figure 4. Biotic communities quality.

The noise study was carried out through a measurement campaign for the characterisation of the current environmental noisiness and through an estimate of noise input in the territory by a suitable forecast mathematical model.

The model has been utilised to evaluate noise input deriving from different aerogenerators lay-outs, in order to find out an optimised solution to limit the noise input in Collarmele inhabited areas.

The current environmental noisiness of Collarmele site was characterised by a wide measurement campaign carried out by ENEL over the period February 3rd - March 4th, 1994. This investigation characterised noisiness at four places, of which three in Collarmele built-up area and the fourth near an isolated house toward the wind farm area. The places along the

Figure 5. Monte Arci wind farm visual simulation.

built-up area were selected as the more exposed to a possible disturbance from wind farm operation.

The values of environmental noisiness as from the experimental campaign range from 46 to 60 dB(A) over the day-time period and from 40 to 60 dB(A) over the night period. Noisiness depends on the wind condition. It has been observed that at wind speeds lower than 4 m/s the noisiness does not considerably vary, whereas at higher speeds a large increase occurs of the Leq(A) by 5-6 dB(A)/ms-1; such increase consists of two terms, a real increase in the noisiness owing to the wind and a wind disturbance on the microphone. The analysis of the experimental data did not enable us to distinguish the two effects, therefore values of the Leq(A) concerning winds with a speed higher than 4 m/s overestimate noisiness.

The noise forecasts related to the operation of the wind farm were obtained utilising the Environmental Noise Model (ENM) (Tonin 1995). This model requires as input the environmental data (site orography, sound absorption of the land, weather condition) and the sound power spectra of the sources and their directivity. The level of sound pressure is then evaluated as the sum of the contributions of the various sources, once each sound reduction term has been estimated due to hemispheric divergence, obstacles or barriers, atmospheric and land absorption.

As for the wind, the NE direction has been taken, so that Collarmele town is lee side with respect to the wind farm area, associated with a wind speed of 5 m/s (average value of the NE wind speed from measurements on site).

The source characteristics were obtained from a noise characterisation campaign of a Riva Calzoni M30 aerogenerator, carried out at ENEL test field of Alta Nurra (Sardinia).

Model simulations have been at first referred to a "base" configuration of aerogenerators, and considering a large area, in order to have estimations of noise, especially for Collarmele built-up area. Noise maps, derived from the model, showed, as expected, a greater sound propagation leeward and a squeezing of isophonic lines windward. Values in the built-up area ranged from 48 to 50 dB(A), which can cause only limited increases compared to the "ante operam" situation Fig. 6.

Anyway the population expressed some anxiety, since such values of the noise input could imply a disturbance in the built-up area, this in consideration of the fact that a wind turbine, similar to the ones planned for the wind farm, was currently in operation in the site, and sometimes, especially over the night when background noise is very low, can be heard from the built-up area. An attempt was made of experimentally distinguish the contribution of this wind turbine even in order to check the estimates carried out, but the data analysis did not enable to do such distinction.

In order to limit sound inputs of the wind farm even in the most critical conditions, other lay-outs, preserving the energy capability, were considered.

The analysis carried out through repeated approximations led to defining the "final" configuration, which has been really adopted. With this configuration the wind farm contribution in the built-up area came out to be 46.5-48.5 dBA, thus values lower than about 1.5 dB(A) compared to the base configuration (Fig. 7).

The impact of the wind farm to the environmental noisiness requires the addition of the noisiness current values as out of the measurement campaign to the estimates of the forecast model. As for wind speeds higher than 4 m/s, since Leq(A) out from measurement campaigns overestimate the background noise, a reliable estimate of the impact cannot be made. In any case the higher wind speed conditions are less critical.

For lower wind speed, the comparison between current noisiness and model estimates (final configuration) pointed out that, at wind speeds lower than 4 m/s, the contribution of the wind farm is hardly distinguishable. Besides, wind surveys carried out show that NE winds lower than 4 m/s have an about 4% frequency (two weeks per year), if the only night period is considered. This means that the possible audibility of aerogenerators from the inhabited areas would be however limited to a negligible time fraction over the year.

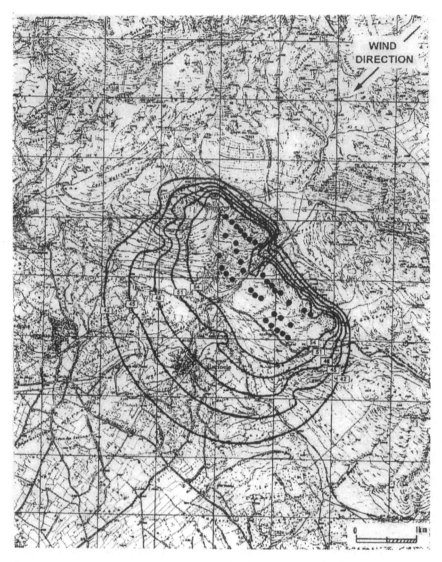

Figure 6. Collarmele Wind Farm: "base" lay-out.

4 THE ACQUA SPRUZZA TEST FIELD

Built in Frosolone, in the Italian region of Molise at 1360 m a.s.l., this center tests the performance of wind energy systems under harsh climatic conditions.

The successful outcome of these tests will have a significant impact on the future usage of wind energy systems in the windy Apennines mountain areas, where a substantial portion of Italy's wind power potential is found.

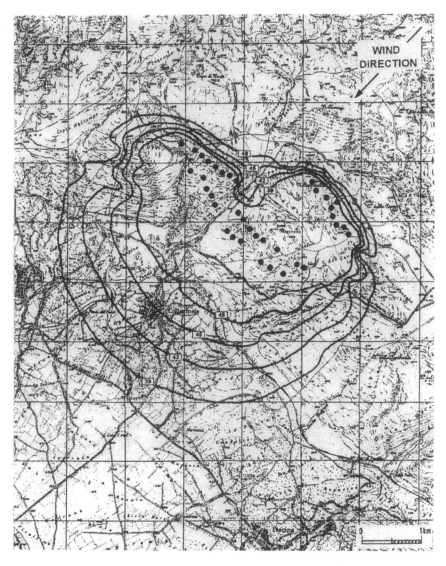

Figure 7. Collarmele Wind Farm: "final" lay-out.

Eight medium-size wind generators have been installed: two for each Italian model (West and Riva Calzoni) and two for each foreign models (Vesta and WEG) with a total installed power of 2440 kW.

The test field requires an open area of about 6 hectares wich will keep its original use as pasture land, except for the spaces where the works actually stand (less than 1% of the area).

Special care was taken to safeguard the natural landscape of the sites: all electrical connections inside the plant area were made with underground cables; even the platforms of the wind generators were covered by grass; the service roads were designed to follow the natural slopes of the terrain and the transformer boxes were covered with stones indigenous to the area. The service building was designed in such a way as to have an optimal visual impact in its natural surroundings (Fig.8).

Figure 8. Acqua Spruzza test field.

5 CONCLUSIONS

The experience so far gathered indicates that also environmental friendly technologies, such as wind, may have environment impact and may encounter acceptance difficulties from population. The dimension and importance of these impacts are definitely lower than those of others conventional energy technologies, but they are even capable of causing oppositions difficult to overcome.

It is obvious how, in such a context as the Italian one (densely populated territory, heavy authorization procedures, diffused sensitiveness to environment values), an underestimation of these problems may threaten to prejudice a large scale spread of these technologies.

The most effective route to reduce competition with other land uses is the one which starts with the energy planning integrated with the territory one.

The next steps, that is to say the siting, the plants design and the development of the authorization procedure, appear to have the best outcomes in the presence of careful assessments of the possible environmental interactions of the plants, with special attention to those that involved people are afraid of.

In fact, in the design phase many measures may be adopted to mitigate possible unexpected effects of plants thus ensuring the best environmental insertion.

As for the italian territorial and environmental context, the articulate and detailed experience so far gathered led to the following general considerations.

5.1 Land constraints do not exclude the settling of a wind farm a priori.

The design of this type of installations is in fact characterized by a great flexibility that makes possible it to a certain "adaptation" to the site conditions. In the case of Monte Arci, though the site is within a natural park, both the design and construction characteristics made the wind farm compatible; moreover, the situation was made easier by a regional law providing the construction of renewable energy plants in the park area.

5.2 A wind farm is compatible with multiple land uses: the current land uses are not changed.

A wind farm, although covering a vast area, takes actually away a very small amount of land to aerogenerators lay-bys and to the connection roads system. A multiple use is thus made possible of the land so that its use for energy purposes supports and substantially overlies the current use. An even better compatibility is achieved if it is possible to utilize existing tracks for the necessary connection road system.

5.3 The natural environment suffers negligible impacts.

Both during construction and operation, the interactions with the environment and above all with the flora-fauna components, are particularly low: both the design flexibility and absence of emissions, are the sign of a technology of low level environment interaction. The results relative to Monte Arci, extendible to other sites, show how an intelligent emplacement of aerogenerators can limit the withdrawal of valuable habitat.

As regards avifauna, the question results to have no special importance. The necessary precautions are the exclusion of sites concerned by the most important migratory routes or where rare endangered species live, where the loss of a few subjects may cause an sensible damage for the species itself.

5.4 Landscape interactions are limited on the whole and can be best absorbed in a morphologically non-homogeneous territory.

Aerogenerators, consisting of simple structures and characterized by a peculiar elegance, can become a part of the landscape context and, beyond the optimizations of their best location, need no additional intervention the only appreciable could be the choice of a colour fitting the background; it is just not to attempt to camouflage, not to create mixtures with the surrounding environment that, paradoxically, can help their insertion. Moreover the perspective impact for this kind of streamlined and projected structures is such as to allow a reduced dimensional perception against their real size.

As for Monte Arci, the dilution of structures in the landscape and their technological contents within a natural park can represent an additional example of attraction, as a meeting point between the protection of the territory and its use for energy purposes.

5.5 Noise and electromagnetic interferences.

The features of aerogenerators have undergone an evolution that, if on one side was being aimed at increasing the efficiency, on the other brought about improvements from the point of view of their interactions with the environment. This is evident for the noise emission which has been decreasing more and more together with the technological improvements. At present, the noise around an aerogenerator is certainly contained and can cause only limited leeward noisiness increase, even in situations of very low background.

As for the possible interferences of the electromagnetic nature, aerogenerators are confirmed not to be a source of electromagnetic waves and their effect as an obstacle to radio

services (television, radio-bridges) is limited to a few hundred metres by aerogenerators themselves.

REFERENCES

European Wind Atlas. Commission of European Communities 1989.

Bellomo, B., Fattore, A., Maffei, C. & G. Montesano 1991. *Studies for the insertion in the environment of wind power plants* EWEC '91 Amsterdam, 897 - 899, Elsevier.

Bellomo, B., Fattore, A., Maffei, C. & G. Montesano 1992. *L'inserimento nel territorio e nell'ambiente degli impianti eolici* HTE, 78, 213 - 214.

Bellomo, B., Caridi, N., Maffei, C., Basevi, F. & U. Rocca 1995. *Wind and solar energy and their environmental interactions* 16th WEC Tokyo '95, 265 - 281.

Bellomo, B., Caridi, N. & C. Maffei 1995. *Inserimento ambientale di impianti eolici e fotovoltaici. L'esperienza ENEL* HTE, 95, 117 - 124.

Bellomo, B., Caridi, N., Giardinieri, L. & C. Maffei 1996. *Environmental Interactions of wind farms* EWEA Conference, Rome, 1996.

Tonin R. 1985. *Estimating Noise Levels from Petrochemicals Plants, Mines and Industrial Complexes* Acoustics Australia, 13 (2) 59 -66.

Wind Energy and Landscape, Ratto & Solari (eds) © *1998 Balkema, Rotterdam, ISBN 90 5410 913 0*

Wind energy development and landscape in Japan

H. Matsumiya
Mechanical Engineering Laboratory, AIST, MITI, Tsukuba, Japan

ABSTRACT: Japanese have brought up refined taste for landscape for long. However, the people seem as if they were not concerned with landscape in the everyday lives. The cities are covered with chaotic advertisements, tall buildings and complex highways. It is often too hard to find any kind of harmony. This comes from the quick development of economy and industry after the second world war. We have experienced deep destruction of nature and environmental pollution. Actually "landscape and wind turbines" is seldom discussed in Japan. But if we look back our own *esthetic sense for beautiful landscape*, it is very special occasion to try to perform "*Renaissance of the nature and human being*" through discussing landscape and wind turbines.

1 INTRODUCTION

Japan is a beautiful island country surrounded by oceans whose landscapes are of full varieties of nature such as mountains, lakes or forests. Fujiyama or Mt. Fuji, the highest mountain in Japan, is a symbol of Japan. Many people have drawn its figures and taken photos. Just the same as foreign nations, the Japanese love and commune with nature.

Figure 1 is shows a monochrome duplication of a woodcut print titled "Deep snow of Fuji" created by *Hokusai*, a famous woodblock artist, born in 1760. It could be understood that "landscape" is not a simple background but a pride of the people's life as shown in this Figure.

Mt. Fuji is a nature itself, but an artificial construction can be a symbol of our life if it has some special values or positive meanings. There are a lot of beautiful buildings, bridges, and so on. However, it is also true that we are surrounded by a number of ugly or oppressive constructions.

In the present paper, the author likes to review firstly the most typical landscapes and cityscapes that are often argued in Japan and then consider what kind of efforts should be necessary when being concerned with the landscape of wind turbines.

2 NATURAL LANDSCAPES IN JAPAN

Before going on to discuss artificial constructions, let me introduce some beautiful natures of Japan.

Figure 2 is a photograph of Mt. Fuji covered with snow over Lake Ashinoko.

Mt. Fuji is 3,776 meters in height and locates in the middle of Japan, Therefore, it has been and still is the symbol of Japan.

Mt. Fuji changes its figure every hour, every day, every month and every season. As is well known, Japan has very distinctive four seasons. It has been sung in songs and "Waka", which are some proofs how the people have cherished the nature.

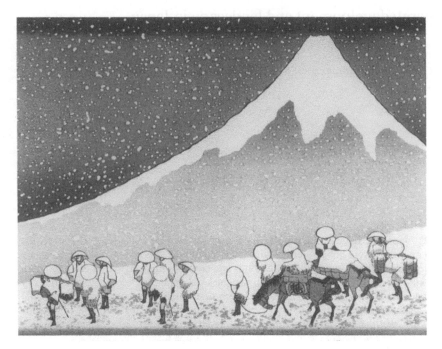

Figure 1. A monochrome duplication of a woodcut print titled "Deep snow of Mt. Fuji" by Hokusai.

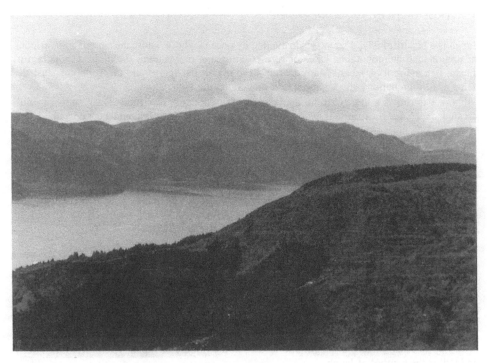

Figure 2. Mt. Fuji covered with snow over Lake Ashinoko.

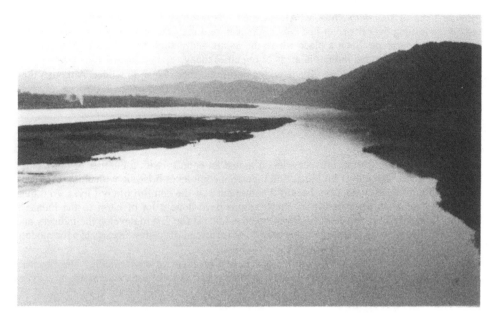

Figure 3. A beautiful landscape of *Shimanto-River*, which is called "the last natural river in Japan".

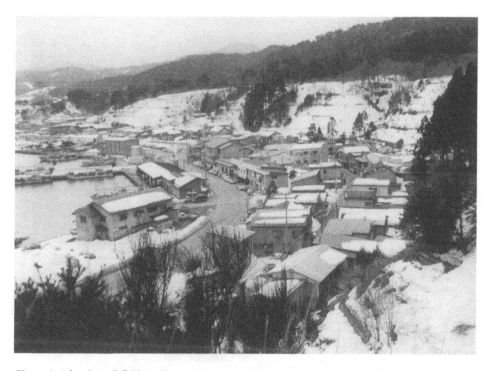

Figure 4. A local small fishing village with a port in winter

Figure 3 shows *Shimanto-River*, which is called "the last natural river in Japan". Although a red bridge is hung over the river just behind the picture, I may say there is no construction that destroys the landscape. Such a place where the nature and natural lives are well preserved is hard to find in and around industrial areas or big cities today.

Figure 4 shows a small fishing village with a port in northern Japan in winter. Although they are not special, there are still many villages surrounded by fine landscapes in the local regions,

3 ARTIFICIAL CONSTRUCTIONS AND LANDSCAPES

On the other hand, Japan is fully developed industrial country with a number of huge cities with highways crossing over buildings and industrial complexes bristling with chimneys. Such modern cultures destroy not only beautiful nature but also the comfort of civil lives. And that, exhausted chemicals from industrial constructions have done a lot of harm to the human's health. During the past one century, Japanese have hurried too fast to develop the industry and modernize the cities, so that we became used to the artificial obstacles. In exchange for modern life style, we lost many natural treasures.

The reclamation of *Isahaya Bay* is today's largest problem of environment. The bay was separated by shelters from the open ocean two months ago. A lot of natural lives are now dying everyday.

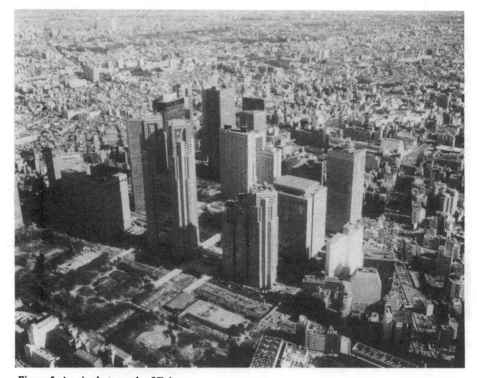

Figure 5. An air photograph of Tokyo.

3.1 *Actual landscapes of our life*

To enjoy more comfortable life, we are surrounded by ugly constructions. This is already a common recognition in our city life, although not a common sense. It is far from difficult to find examples.

We can say that the group of ultra-tall buildings are super modern and beautiful. But millions of people are living or working at the "valleys" between the tall buildings. In the residential zones, *"right to enjoy the sunshine"* is very keen issue, but visual impact is mostly out of discussion.

In the same way, Tokyo is covered with chaotic advertising signs and Tokyo Expressways passing and crossing in the sky above our roofs.

Figure 6 shows a snapshot of a town in Tokyo. Utility poles and telephone poles are built along every street and lines are crossing at every cross. High poles are towering and power cables are running over roofs. In Japan, few people complain such a visual impact.

Japan has many industrial complexes. The landscape looks sometimes awful with their strong visual impacts. When such an industrial zone is separated from the residential, the people tend to accept it as long as they do not suffer from chemicals and noises.

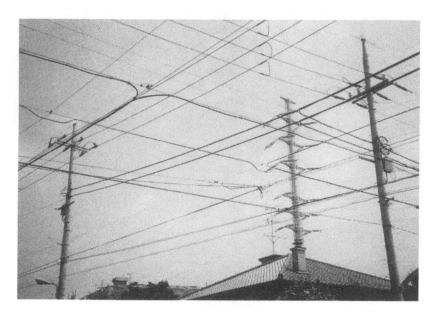

Figure 6. A snapshot of a town in Tokyo

3.2 *Aesthetic sense for landscape*

However, many Japanese are aware of their own traditional aesthetic sense for landscape. Japanese garden is one of the examples. Sometimes, it still has religious meanings such as Zen, but the people have tried to create a real perfect world in the Japanese garden which eases the lives and hearts of mortal beings.

In general, a building or a construction is well admired when it plays an important role among the people. In the times of old or middle age, castles and temples were good examples.

They had special political and religious meanings.

Figure 7 shows "Kinkaku-ji" temple in Kyoto, the most beautiful old capital.

We have once experienced sharp discussion whether tall hotels should be built or not. Now

we often feel disappointed to find a *five-storied pagoda* was hidden by tall buildings. Modern concrete buildings can easily destroy the beautiful views of the traditional houses and temples.

In European countries, the situation seems different from Japan. When I find an old historical zone in the city centre of a city, where traditional houses are kept on the street as they were and no motorcars are allowed to enter into, I think Kyoto should have learnt it. Old historical areas can be separated from the modern developing zones, if the concept of development of city is formed with full of considerations.

I like to remark that the landscapes in Japan are very severely destroyed today, but the aesthetic sense for landscape can come to life again because not only we had once our own but also we belong to the living creature of the nature.

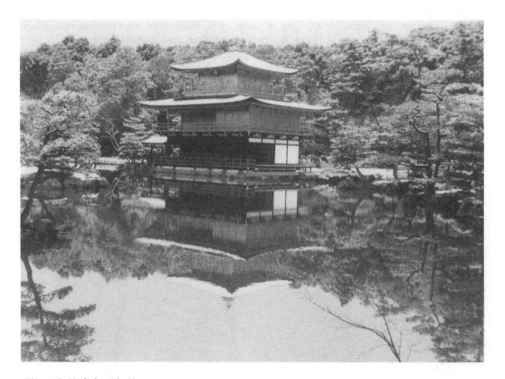

Figure 7. *Kinkaku-ji* in Kyoto

4. WIND TURBINES AND LANDSCAPES

A cultural inheritance is mostly well preserved. Same is with traditional windmills.

However, when we find a windmill in the drawings of European famous artists such as Picasso, Monet, Nolde, Gogh, and so on we understand they felt there is something new, something active, something interesting and something beautiful with the windmill.

Modern wind turbines have changes there designs from the historical windmills, rotating much faster and more noisy. They are actually rotating machines. The scale is also getting taller and taller. But, when we talk about the landscape of wind turbines, it should be very important to analyze and find "something". The positive aspects and negative aspects should be clearly defined and analyzed scientifically. Then most efforts must be taken to solve the negative aspects. It is worth while to do so, because wind energy, as a natural and clean energy resource, has a high potential to provide us comfortable lives as well as save the Earth.

It was ten years age when a friend asked me "Have you seen *Naushika*?". "No." answered I. But the next day I hurried to a video-movies shopping & rental store and borrowed "*Naushika in the valley of wind*". It is a very popular story of animation video-movie.

It is the time when the earth is being destroyed by the highly developed culture. The surface of the earth is almost covered with chemicals and the human being ought to live in the under ground cities. But wind turbines are drawn very positive that create energy from wind. Because I am an research engineer of wind turbines, I felt delighted to find this shot. The animation was one of the best hits among children. At that time, I found that if an artificial obstacle works for the future of the earth, its visual aspect could turn beautiful.

4.1 *National statistics of wind power*

I like t6o review the national statistics of wind power in Japan, so that the situat5ion in Japan is well understood.

As of 1.January, 1997, the total capacity of wind turbine generator systems is close to 14 MW with 70 units including research machines. Installed capacity/number of machines over recent years is shown in Table 1.

Table 1. Installation of wind turbine generator systems in Japan

YEAR	NSTALLED CAPACITY (kW)	TOTAL CAPACITY (kW)	NUMBER OF INSTALLED	TOTAL NUMBER
before 1990	357.5	357.5	9	9
1990	533	890.5	4	14
1991	1475	2365.5	6	19
1992	783	3148.5	5	24
1993	1800	4948.5	9	33
1994	907.5	5856	8	41
1995	3655.2	9511.2	13	54
1996	4408.9	13920.1	16	70

4.2 *National target of wind power generation*

The government decided a guideline of new energy policy in December, 1994, in which wind energy will be promoted up to 150 MW capacity by 2010. As a result of this policy, "Filed Test Program" was newly initiated since 1995 to attain the national target by 2010.

Assuming the average capacity factor of the turbines to be 33.3% very roughly, the expected contribution of wind generation from 150 MW will be actually 50 MW. Such an amount is almost negligible when compared with huge consumption of energy in Japan.

4.3 W*ind energy potential in Japan*

As a complement to the nation wide network for local meteorological observations called AMeDAS, which has about 1000 meteorological stations all over Japan, the government has measured wind characteristics at selected sites since 1983. In 1994, a new wind database of wind resources was completed based on the AMeDAS data at 737 stations out of its network and the complementary data at 38 locations. In total, data from 964 stations were analyzed to

create *Japan WIND ATLAS*, which was published in 1995.

The wind energy potential was also estimated. Three scenarios were considered according to different restricting factors for wind farm construction in the analysis. As a common condition, the sites where their annual wind speed is above 5 m/s at 30 meters height above ground level are considered as practical candidates for wind farm sites. The results are shown in Table 2. The minimum and maximum values correspond to the array conditions of WTGS in a wind farm of 10D x 10D and 10D x 3D respectively, where D is the diameter of a WTGS. According to scenario 2, which is a moderate one, it is expected that a few percentages of the electricity demand of Japan can be supplied from wind.

Table 2 Wind Energy Potential

Scenario	Area Sq. Km (Ratio to whole land %)	Number of units (500 kW WTGS)	Capacity MW (Ratio to total capacity %)	Wind Generation GWh (Ratio to total generation %)
1	23,280 (6.4%)	125,519 - 565,278	not completed	not completed
2	3,599 (1.0%)	18,430 - 70,481	9,220 - 35,240 (4.61 - 17.62 %)	8,916 - 34,127 (1.00 - 3.84 %)
3	759 (0.2%)	2,792 - 13,743	1,440 - 6,870 (0.70 - 3.43 %)	1,325 - 6,537 (0.15 - 0.74 %)

4.4 *Wind turbine generators and landscape in Japan*

NEDO-100 kW turbine was the first large-scaled research wind turbine generator developed under national project, called *Sunshine Project*.

The 100 kW turbine had a two-bladed rotor of 29.4 meters in diameter in down-wind orientation. The hub height is 28 meter and the tower has steel lattice structure as shown in Figure 8.

Although the most attentions were paid on the technical aspects of the research machine, the figure was far from elegant.

Figure 9 shows MINDMEL-I, a research machine of Mechanical Engineering Laboratory in Tsukuba. It has a 2-bladed, variable-speed, teetering rotor of 15 m diameter, and a soft tower. The rated power is 16.5 kW and it has a DC-link system to connect with grid. It equips with a mechanical governor system to perform pitch control of the blades. Such a system is one of the advanced wind turbines, characterized by "fully flexible design" in mechanical, electrical, operational and constructional aspects.

Reduction of the mass on the tower yields better controllability of the system as well as reduces the cost. This results in nicer looking, so believe we.

It is our opinion from the beginning of our R&D of wind turbines that a wind turbine must be beautiful just same as the traditional windmills that many famous artists have found and drawn. It was simply because we thought R&D of wind development could be active if more people become in favor to wind turbines.

Figure 10 is a part of a large picture of WINDMEL-I drawn by children of a kindergarten who once visited our laboratory to see the turbine. They especially like to see the turbine rotating and the sun, three turbines and flowers in the picture are so joyful to find that the children, the little Picassos, are very much fond of wind turbine. This picture is still our treasure hung on the wall of our laboratory.

24

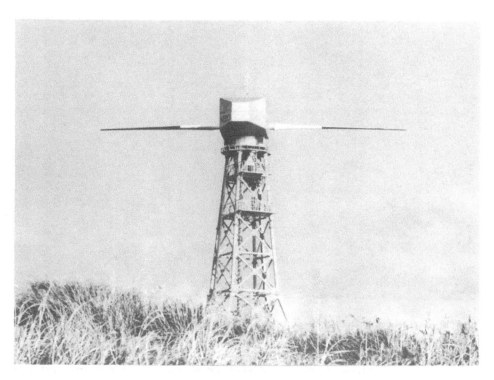

Figure 8. A large-scaled research turbine NEDO100kW on Miyake island

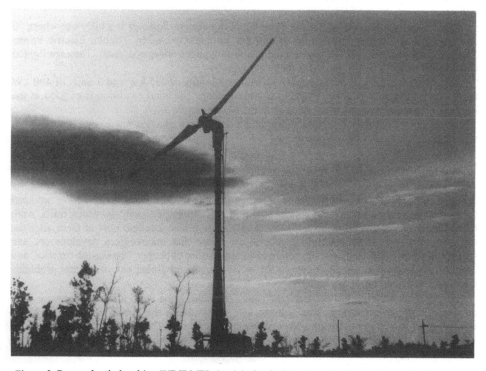

Figure 9. Research wind turbine WINDMEL-I at Mechanical Engineering Laboratory in Tsukuba

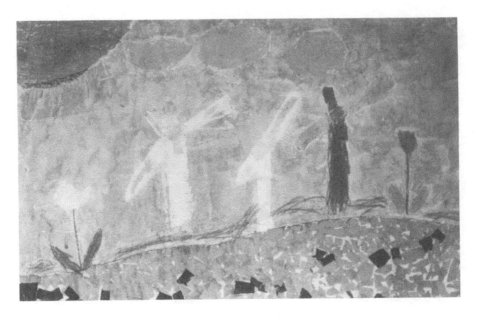

Figure 10. Picture of children of kindergarten

As to Japan, the very issue of landscape of wind turbines are not keen at this moment. It is only because there are no big wind farms and no tall wind machines of MW-class. The total capacity of wind turbine generator systems in Japan is only 14, 000 kW with approximately 70 units all over Japan. Therefore, almost no complain are heard against the visual impact of wind turbines.

Figure 11 shows Tappi Wind Park at Cape Tappi in northern Japan. It is a hilly site where 10 units (5 units of 275 kW and 5 units of 300 kW turbines) owned by Tohoku Electric Power Company and one 500 kW turbine as a national prototype are under operation. They are lighted up in the evening, performing a very fantastic scenery.

Figure 12 shows Miyako Wind Farm consisting of 2 units of 250 kW and 3 units of 400 kW turbines. The site is on Miyako Island of southern Japan. The wind condition is as good as the landscape surrounded by ocean.

Concerning to any kind of complaint from the public, only a few on noise were reported, but no complaint on landscape are heard.

4.5 Special situation of wind energy development in Japan

In Japan, as we have not historical uses of windmills like in Europe, the people have not been so much attached to them. Of course traditional technologies such as water mills were respected, however the storm of industrial modernization has expelled most of them after the second world war. However, many people are aware that the reckless development and industrialization have destroyed the nature and harmed a lot of people. "*Yokka-ich asthma*" and "*Minamata-desease*" are well-known in the world. Local and global environmental problems are one of the most important today.

Now a special situation has occurred in Japan. There are some wind turbines that were built as *symbols of city-activation*. The turbines can bring among the public an image of clean energy, a symbol of activation of a local government and so on. This reflects an expectation for wind turbine that will perform preferable affects on our future life, especially from the view point of ecology.

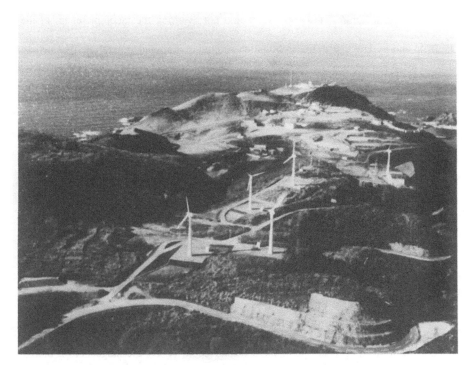

Figure 11. Tappi Wind Park

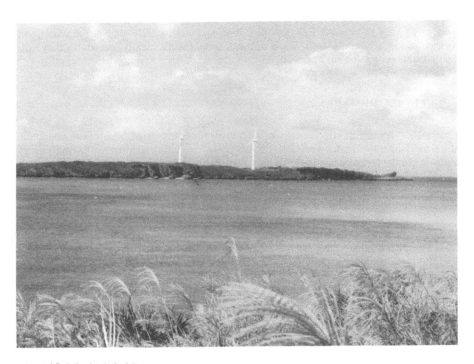

Figure 12. Miyako Wind Farm

Wind energy is renewable and green. Therefore, a wind turbine becomes a symbol of our clean and green life in future. However, we should not overlook the incompleteness of the social system.

We have no energy law that defines obligation of buying the wind generation. The selling price of wind generation is determined through negotiation between a developer and an electric power company. This makes commercial development of wind farm very sever and uncertain. Therefore, a wind turbine can not be introduced without "additional values" something like *symbolization*.

There is another odd example. Some electric power companies have built wind turbines at their "Energy Parks" which are parks for visitors and display the technologies of various power generation systems. This gives good effects on education and public acceptance for energy.

However, when we know that the annual mean wind speed at the park is very low and the rated wind speed is too high to operate the turbine at this site, and when we hear by TV a person of the company report that the cost of energy is very much expensive than the conventional, they have done in a wrong way. As a result, it seems that the wind turbine was introduced to prove to be no more than a symbol to blame and get rid of itself.

As shown above, not all the present situations can be accepted, as long as a wind turbine generator is built to perform other distorted purposes rather than the original of producing clean energy.

4.6 *Importance of technical consideration*

The situation of wind energy development in Japan could be on the stage before that of discussing the landscape. But what is very important on every stage is fine and fair technical considerations. Technical design of a wind turbine must fit to the wind and other external conditions at the site. This lets the turbine perform its original work. The more it works, the more people evaluate wind energy.

It is also the same when we develop wind farms.

Landscape is a very keen issue. But flow distortion and wake interference at the wind farm site must be technically considered. Wind turbines should work ideally, otherwise they will lose their advantages for the environment.

5. CONCLUDING REMARKS

Japan has a short history of wind energy development if compared with European countries. Therefore the landscape is not very keen issue. Most restricting elements of wind energy development are the law of quasi-national park that prohibits building industrial constructions in national parks, incomplete regal systems to promote wind energy development, wrong introduction of wind turbines and so on.

On the contrary, wind turbines are sometimes built as symbol of city-activation and clean future.

This suggests that not every artificial construction will give an unpleasant visual impact. If we look back quickly, there have been a lot of fine artificial constructions such as bridges, temples, fire lookouts and so on. When they function deeply in our public life, they could become beautiful.

As a research engineer of wind energy, I like to express my feeling as follows. Paradoxically speaking, I will be very happy if I will succeed in bringing such a situation where "landscape" is discussed everywhere in Japan.

Selected papers

Wind Energy and Landscape, Ratto & Solari (eds) © 1998 Balkema, Rotterdam, ISBN 90 5410 913 0

Visual compatibility of wind power plants with the landscape: Possible methods for preliminary assessment

C.Andolina
Conphoebus s.c.r.l., Catania, Italy

C.Casale & M.Cingotti
ENEL S.p.A., Ricerca, Polo Energie Alternative, Cologno Monzese, MI, Italy

S.Savio
ISMES S.p.A., Seriate, BG, Italy

ABSTRACT: This paper describes three methods that have been taken into consideration by the Italian utility ENEL, in co-operation with the research companies Conphoebus and ISMES, with a view to evaluating the possible visual impact of wind power plants on the local environment. These three methods refer to as many consequential levels of assessment. The first method is aimed at getting a preliminary evaluation of landscape sensitivity to the insertion of a wind power plant, in order to choose the less sensitive sites among those found as technically suitable. The second method carries out an evaluation of the visibility of a plant from the most significant landscape viewpoints in a chosen area to define the best possible lay-out of wind turbines. As a further step, the third method makes it possible to obtain photo-insertions of the wind power plant into the landscape to depict some realistic scenarios of the area.

1 INTRODUCTION

Wind is a "clean" energy. That does not mean, however, that the location of wind power plants for the production of electric energy, does not have compatibility problems with the environment. The aspects to be considered and evaluated in this respect are various and of different nature: among them, land occupation, visual impact, noise emission, impact with telecommunications and, last but not least, impact with the birds are worth noting. Among the aspects listed, visual impact or impact on the landscape is of particular importance, also in connection with the influence it may have on the attitude of the population and local authorities with respect to the acceptance of a plant on their territory.

It is worth noting that a commercial wind power plant of significant power (in the 5-10 MW range) is formed by a few tens of medium-sized wind turbines whose rotor is 30 - 40 m in diameter and has a hub height above the ground in the same range. Therefore the visual impact, in some cases, can be considerable and a negative perception by the public, due to low consideration of the problem by plant developers, could have a remarkable influence on the future of wind power plant deployment.

Within the framework of its research activities in the wind energy field, ENEL S.p.A., together with the Conphoebus and ISMES companies, is defining control and evaluation methods of landscape implications of wind power plants. These methods are described in this paper and are divided into three consequential observation and study levels:

1. preliminary evaluation of landscape sensitivity of a site to the insertion of a power plant (evaluation aimed at selecting the areas with less landscape problems among a number of sites already defined as suitable for wind resources and other technical requirements);

2. evaluation of plant visibility from the most significant landscape viewpoints and simultaneous check for other technical and environmental limitations through the production of sensitivity maps superimposable to the basic mapping of the area;

3. photo-insertions of the project aimed at depicting some realistic scenarios of the wind plant inserted into the landscape.

2 EVALUATION OF THE LANDSCAPE SENSITIVITY OF A WIND ENERGY SITE

This method, developed at ENEL's R&D Department (Polo Energie Alternative) and based on what had been done by the French in the field of landscape sensitivity evaluation to the insertion of HV overhead lines (in particular the environmental impact study of the Charpenay - St. Maurice l'Exil power line), starts from the assumption that today's landscape, as modified following its transformation by the capitalistic and industrial economy, is a system of shapes and signs that are easy to isolate and are, therefore, quantifiable.

Figure 1. Romantic landscape.

Figure 2. Transformation of the romantic landscape.

Figure 3. Industrial landscape.

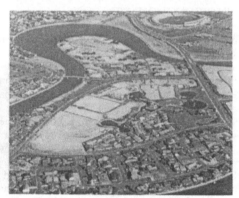

Figure 4. Modern landscape.

Following the change from an archaic and natural landscape to an artificial one (Figures 1,2,3), the essence of modern landscape (Figure 4) can be considered as a structure which nature and man have equally contributed to shape. This includes the possibility to dissect it in its various components, depending on their evocative content, and to identify some indicators suitable for evaluating the possibility to transform it by introducing new shapes bearing a clear evocative content such as, specifically, an array of wind turbines.

2.1 *Evaluation of the morphological and vegetation quality (or "scale") of the site*

The morphological aspect of a site, ascribable to its topography and vegetation (better defined as adaptation capability or scale breaking between works and space), can be identified through the following parameters:

- *Visual scale* (large, medium or small): it is a function of the location of the site visual limits more or less far from the observer;
- *Internal scale* (large, medium or small): it is a function of the dimensions and spatial characteristics of the morphological and vegetation elements forming the site landscape (Figure 5);
- *Readability* (high, medium or low): it is defined as the attitude to offer the impression of an easy-to-read spatial organization of the landscape at a given site;
- *Complexity* (high, medium or low): it is defined as a function of the density (quantity) and of the diversity (quality) of the elements that go to make up a given landscape.

Figure 5. Landscape with a large internal scale. Figure 6. Unchangeable landscape.

The study of the morphological and vegetation quality allows to quantify (Table 1) three increasing numerical indexes (from 1 to 3) of difficulty to the fitting-in or absorption of a plant and to evaluate, according to the combination of the parameters acquired, which of these two project criteria should be pursued.

Table 1. Determination of the morphological and vegetation quality from the site parameters.

Visual scale	Internal scale	Readability	Complexity	Relative index	Suggested project criterion
Small	Small	Low	High	1	Absorption
Large	Large	High	Low	1	Fitting-in
Small/Medium	Small/Medium	Low/Medium	High	2	Relative Absorption
Large/Medium	Large/Medium	High	Low/Medium	2	Relative Fitting-in
Any other combination of parameters				3	None

2.2 *Evaluation of the picturesque quality (or "ambiance") of the site*

The site picturesque quality, also called "ambiance", is defined according to the landscape's ecological, aesthetic and historical peculiarities, depending on its sensitivity to anthropic actions. It is evaluated according to five degrees of appreciation (Table 2) of the cultural coherence between the works and the landscape:

- *Trivialisation degree*: defined as rare, mixed or common;
- *Artificialisation degree*: defined as natural, mixed or artificial;
- *Mutation degree*: defined as unchangeable (Figure 6), mixed or unstable;
- *Innovation degree*: defined as ancient, mixed or modern;

- *Diversity degree*: defined as contrasted, mixed or monotonous.

Landscapes considered respectively rare, natural, unchangeable, ancient and contrasted are positively considered; landscapes considered common, artificial, unstable, modern and monotonous are negatively considered; mixed situations entail a neutral evaluation.

Today, social judgment tends to define, as "picturesque", natural and archaic landscapes and, as "trivial", industrial and artificial ones. Although such a statement may even be questionable, this is an element to be considered when working out a finalized landscape study. Furthermore, if we consider that a wind power plant has a relatively short life cycle as compared to the cultural evolution time in the concept of landscape, this dominant, aesthetically subjective evaluation can be by all means accepted as an objective judgment.

As already said, the picturesque quality (or "ambiance") of the site is evaluated in five degrees of appreciation of the cultural coherence between the plant being built and the landscape. Each degree is associated with a score ranging between -1 and +1:

Table 2. Scores given to the various degrees of appreciation of a site.

Trivialisation degree	Rare	Mixed	Common
Artificialisation degree	Natural	Mixed	Artificial
Mutation degree	Unchangeable	Mixed	Unstable
Innovation degree	Ancient	Mixed	Modern
Diversity degree	Contrasted	Mixed	Monotonous
Score per degree	1	0	-1

The sum of the scores given to the different degrees supplies (Table 3) a series of numbers ranging between -5 and +5, from which the relative index of the picturesque quality is inferred:

Table 3. Determination of the picturesque quality from the site scores.

Score sum	Relative index of picturesque quality
<0	1 (favourable)
=0	2 (neutral)
>0	3 (unfavourable)

2.3 Evaluation of the degree of landscape sensitivity of the site

The degree of landscape sensitivity of the site is obtained (Table 4) from the sum of the relative indexes obtained from the elements previously considered. The degree of sensitivity, in an increasing scale ranging between 1 and 3, is therefore a function of the landscape's absorption capacity (or, on the contrary, of its neutrality to the breaking of the scale between the plant proposed and the space) and of its ambiance, considered in respect of the symbolic-cultural relationship between the plant and the landscape.

Table 4. Determination of the degree of landscape sensitivity from resulting sensitivity indexes.

Resulting sensitivity index	Degree of landscape sensitivity
<4	1 (low sensitivity)
=4	2 (medium sensitivity)
>4	3 (high sensitivity)

The evaluation of the sensitivity degree represents a partial goal of the study and the judgment so obtained is just to be considered as an indication (Figure 7). Cases may occur where a high degree of sensitivity can be "watered down" by the possibility to implement suitable design solutions. For a final judgment on the site, account should therefore be taken of its inborn design features, arising from a thematic reading of the landscape. The possible design criteria indicated by the method are absorption and fitting-in.

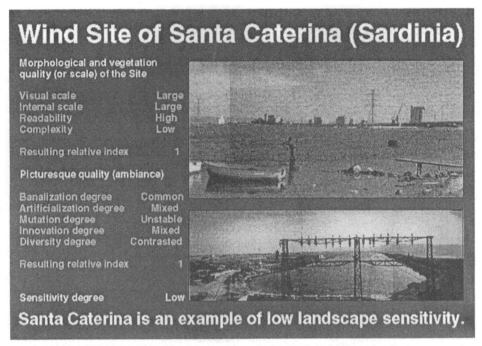

Wind Site of Santa Caterina (Sardinia)

Morphological and vegetation
quality (or scale) of the Site

Visual scale	Large
Internal scale	Large
Readability	High
Complexity	Low

Resulting relative index 1

Picturesque quality (ambiance)

Banalization degree	Common
Artificialization degree	Mixed
Mutation degree	Unstable
Innovation degree	Mixed
Diversity degree	Contrasted

Resulting relative index 1

Sensitivity degree Low

Santa Caterina is an example of low landscape sensitivity.

Figure 7. Summary of the results of landscape sensitivity evaluation for the site of Santa Caterina.

2.4 *Absorption techniques*

The capability of visually absorbing a new structure is mainly a feature of closed and contrasting places, of complex, wavy landscapes, of ravines and of all those places whose morphology (reliefs, vegetation, geology) is such as to be in contrast with the formal regularity and the recognizeability of a technological structure. Absorption must absolutely be considered in the case of natural and unspoiled environments with a limited field of vision which, due to symbological conflict, do not allow fitting-in.

Absorption techniques consist in limiting the sight of the structures through natural or artificial vegetation screens, controlling heights and positioning (to be evaluated on a case by case basis) and camouflage of components; i.e. all that can be devised in order to let the plant be noticed as little as possible. However, absorption is hardly pursuable with moving structures which, for energy production reasons, must generally be installed in well exposed places. It can therefore be stated that, for wind power plants, absorption is hardly pursuable. On the other hand, due to their location, wind energy sites have seldom the requirements necessary for absorption.

2.5 *Fitting-in techniques*

The capability of containing and symbolically integrating the elements of a new structure is mostly a feature of those places where the predominant symbology is not conflicting with that of the new structure. Reference is here made to those places where a certain anthropisation level is already existing and, in particular, to agricultural plains with mechanized production, industrial or port areas, mining landscapes, and suburban areas. In any case a good fitting-in can be obtained in landscapes featuring a sufficient readability and geometrical regularity.

Fitting-in techniques often rely upon the design of structural elements in the attempt to draw the highest benefit from an adequate plastic image. In the particular case of wind power plants, fitting-in techniques must be much more often delegated to the plant lay-out, which must be as regular as possible and must fit within the infrastructural mesh or the "design" of the environment. In the wind energy field, fitting-in is often pursuable and preferable.

2.6 *Design contrivances to be implemented in all cases*

Whatever the result of the landscape study carried out according to the above method or, more exactly, should the study fail to give unambiguous indications about the design to be chosen (in fact it is very frequent that the landscape is not readable enough for fitting-in nor complex enough for absorption), it is however advisable to comply with some general practical contrivances arising from many years of international experience on wind projects. These common sense techniques, often related to the two mentioned above, can be implemented both on the plant and on the project area and can be found in almost all specialized publications.

3 EVALUATION OF PLANT VISIBILITY

The methodology developed by Conphoebus for the evaluation of the visibility of a wind plant is based on the "intervisibility between points of a digital terrain model" analysis technique. This technique is applied through optional software modules of the ARC-Info GIS (Geographical Information System) developed for operation on three-dimensional terrain models (whether they are DTM - Digital Terrain Models or DEM - Digital Elevation Models).

The methodology can supply three different information levels:

1. visual impact sensitivity maps of the area around a wind power plant whose lay-out has already been designed;

2. exclusion maps (to be used when designing the plant lay-out) i.e. areas of the territory to be preserved from all visibility;

3. three-dimensional views of the territory from chosen viewpoints, with the possible digital insertion of the wind turbines provided for in the project for a direct evaluation of the visual impact of the plant.

3.1 *Model creation*

In order to apply the methodology it is necessary to have a digital model of the territory under study which is suitable, in terms of detail, for representing its real characteristics (Figures 8,9).

Practically, an orographically complex territory needs a more detailed digital model than one featuring slow and gradual orography variations. Therefore, if in the former case a DEM with a cell size of approximately one metre has to be prepared, in the latter a cell size in the tens of metres range, if not higher, will suffice.

A high precision digital terrain model can be obtained through a photogrammetric rendering based on stereoscopic air pictures taken at low altitude or through ground surveys. These techniques are particularly costly, therefore, where a high level of precision is not required, it is common practice to get the digital terrain model from altitude contour lines drawn on topographic maps derived from recent aerophotogrammetric flights (e.g., from the CTR, regional technical maps on a 1:10,000 scale or, where available, from municipal technical maps on 1:2,000 or 1:1,000 scale).

According to this practice, altitude contour lines on the maps are first "digitized" (through a table or a digitizer) entering them into the geographical information system in a vector format, then they are processed via software for generating a DTM or a DEM. When using this technique, attention must be paid that the altitude contour lines digitized from the maps are more frequent with the increasing complexity of the orography to be described.

 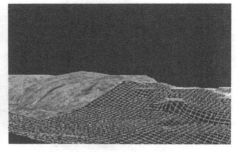

Figure 8. The site of Caltabellotta (Sicily). Figure 9. Digital terrain model of the site.

The quality of a digital terrain model can be checked by comparing the software-generated altitude contour lines with those of the original map used when generating the model. If there are no substantial differences between the altitude contour lines, the digital terrain model can be considered as satisfactory.

On the digital terrain model so obtained it is possible to perform the intervisibility analysis and to generate visibility and/or exclusion maps.

3.2 *Visibility map generation*

The first option the system offers is the generation of the visibility map (Figure 10) of a plant whose lay-out has already been defined and where the dimensional characteristics of the wind turbines are known.

Map generation is obtained through the following steps:

1. definition of the observation points, according to the individual wind turbine positions, through the preparation of a suitable geographically-referred thematic map (points cover);

2. association of the dimensional characteristics of the individual wind turbines (hub height, rotor diameter) to the corresponding representation points on the thematic map;

3. definition of the visibility evaluation height (man height, average building height in an area, etc.);

4. description of the intervisibility barriers (vegetation, buildings, etc.), in terms of position and dimensions through the preparation of a suitable geographically-referred thematic map (polygons cover).

The visibility map is generated by ranking the territory (divided in cells equivalent to the digital terrain model cell size) according to the intervisibility with the points corresponding to the wind turbine positions. Practically, for each wind turbine, a binary (0/1) matrix is produced corresponding to the intervisibility condition between the territory cell and the wind turbine position. The condition of intervisibility takes into account point co-ordinates, altitude offsets defined in respect of the altitude of the ground, and possible barriers in between. From the sum of the values contained in all the matrices produced, each corresponding to a wind turbine, the final matrix can be obtained which contains the number of wind turbines visible from the territory cells considered.

The association of a gradually changing colour scale with the territory matrix values, gives a geographically-referred visual sensitivity map which can be superimposed to the basic mapping of the territory.

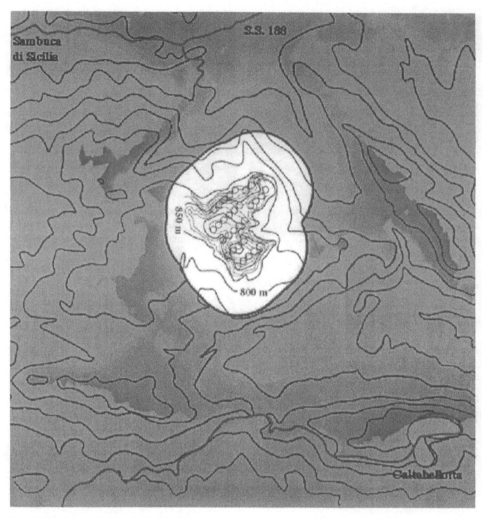

Figure 10. Visibility map of Caltabellotta's plant (darker areas represent the points from which the plant is more visible).

The work of superimposing the visibility map to the basic mapping and to the thematic maps dealing with the different topics of interest in impact evaluation (roads, towns, scattered houses, etc.) is made easier by the ARC-Info software, which allows three-dimensional display of thematic maps by using the previously generated digital terrain model.

3.3 Exclusion map generation

The second option offered by the system is the production of exclusion maps to be used when preparing the plant lay-out, together with other environmental and technical limitations to be considered.

The necessary steps to produce exclusion maps are similar to those previously described, except for the definition of observation points. In fact, in this case, points are chosen depending on the areas to be preserved from visual impact. For areas which cannot be defined by a single point (roads, towns, preservation areas), it is possible to supply the line or polygon that better describes the area. The points forming the line or polygon, supplied in a thematic map (cover),

are dealt with as single observation points and the relevant visibility areas contribute to generate the total map.

In this case too, for each area to be preserved, a binary (0/1) visibility map is produced, taking into account the same parameters as above. Individual maps will contribute to producing a total exclusion map.

3.4 *Three-dimensional view generation*

The third option offered by the methodology relates with the production of three-dimensional views of the territory with the possible insertion of plant components. Contrary to other visual evaluation tools, this process, being based on the digital terrain model, is totally free from the availability of basic pictures and therefore from limitations linked to the camera position. The photographically realistic outcome of generated images is obtained by using geographically-referred air pictures of the terrain "draped" on the digital model. Wind turbine insertion in the terrain image is made through an external rendering motor.

4 PHOTO-INSERTIONS

The purpose of the photo-insertion methodology developed by ISMES is to allow the creation of artificial scenarios showing the picture of the wind energy site as it will look once the project has been completed.

The final processing product is a series of pictures which "materialize" the wind plant from carefully selected viewpoints, thus allowing to act on the project beforehand, in other words when it is still possible to adjust the machine lay-out, in order to control the plant's visibility level and visual impact.

The procedure developed can be summarized as follows:

1) Acquisition of the project lay-out, as it has been drawn according to the necessary technical requirements, and identification of the territory area to be modelled;
2) territory modelling (DEM) and construction of the mathematical model of the power plant;
3) definition of photographic viewpoints;
4) acquisition of pictures by on-site surveys;
5) photo-insertion;
6) final retouching;
7) printing.

4.1 *Territory modelling*

From the basic mapping of the area of the territory to be modelled, terrain altitudes, roads and all those elements which may prove significant for the calibration of picture insertion into the model, are acquired (Figure 11). The terrain model (DEM) (Figure 12) is then generated and subsequently integrated with the territory elements and with the model of the power plant (wind turbines, service building, machine substations, roads, etc.).

4.2 *Definition of photographic viewpoints*

The criteria affecting the choice of photographic viewpoints (Figure 13) can be many and are finalized to the object of the study: environmental impact, feasibility evaluation or other. Generally, places with high traffic density or high population concentration are considered sensitive, as well as towns in the vicinity of the power plant, places of historical, artistic or naturalistic interest; in brief, all those places where excessive plant visibility could be a problem. Besides these scenarios, further points can be defined in the near vicinity of the power plant or inside it to allow plant viewing in its different aspects.

Figure 11. Insertion of the photo into the model.　　　Figure12. Terrain model with Caltabellotta's plant.

Figure 13. Photographic parameters to be recorded.　　　Figure14. Photo-insertion of Caltabellotta's plant.

The theoretical suitability of the points identified on the model is controlled through a first series of virtual simulations. We talk about theoretical suitability since the terrain numerical model is anyhow strongly affected by the lack of visual barriers actually existing in the territory, such as trees, forests, fences, different road conditions, etc. Only an on-site survey can confirm the choices made and allow possible modifications or adjustments. In order to guarantee a good connection between the numerical model and the pictures, a careful recording of the shooting point, the aiming direction and the camera characteristics is essential.

4.3 Picture treatment

Pictures can be treated with different systems according to the quality of the final result required and of the budgeted costs. The cheapest and quickest way, giving nevertheless acceptable results, is direct transfer of the negative on a photo-CD; for more sophisticated works, the job is given to a good specialist of colour developing and printing and, subsequently, to an expert in scanning with a professional equipment (generally a photo-lithographic one). Regardless of the alternative chosen, the final result (raster image) must in any case be handled by a computer graphics specialist for eventual balancing, colour and contrast correction, and image cleaning operations.

4.4 Insertion of the pictures into the model and retouching

The work of inserting the pictures into the numerical model is rather easy when all pictures and their related data have been acquired with the necessary care. Once the picture has been inserted, the terrain model is deleted from the numerical model to allow the production of the "rendering" of the model of the plant alone (Figures 14,15).

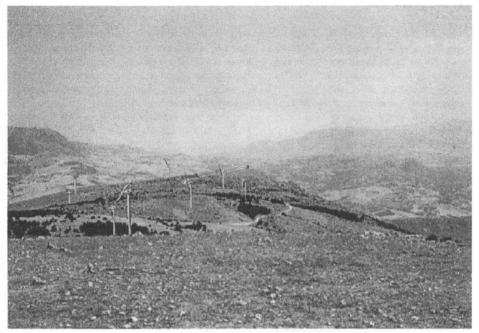

Figure 15. Photo-insertion of Caltabellotta's plant providing a closer view from a point inside the plant area. The availability of various pictures taken outside and inside the area allows to control the development of the project.

The final retouching is a merely aesthetic operation allowing the production of an "artist fake", which can only be made by an expert with specific painting skills.

4.5 *Transfer and printing of the final product*

The final transfer of the result on paper is the most critical step of the whole process since it can significantly reduce the quality level of the work performed. The system guaranteeing the best quality of the final product is the four-colour printing process, to be entrusted to a photolithographer; this is also the most expensive system.

Today colour printers can also be used (ink-jet, laser, phaser, sublimation) which give acceptable results with lower costs. Should one wish to transfer the content of the file on a slide, services are available to cover this need at acceptable costs and high quality.

The use of the simulation process, as can be guessed, requires rather high costs and specific skills; only a continuous use could allow to reach the best methodology calibration and create the most cost-effective conditions.

4.6 *Computer support*

Finally, concerning the supporting hardware and software, there are several possibilities on the market. As hardware support, even a properly configured PC (at least a 486 DX4/100, 32 Mb RAM and 1.2 Gb hard disk) could be enough, with a good graphic adapter and good performance (1024x768 pixel, 16 million colour resolution). As for the software, some integrated packages are available (AutoCad with 3DStudio could be a possibility); as an alternative, other software tools can be used, provided the data are transferred in standard format (e.g. DXF).

REFERENCES

Cingotti, M., C. Casale & G. Botta 1996. A practical method for evaluating landscape sensitivity to insertion of wind power plants. *Proceedings of the EWEA Conference on integration of wind power plants in the environment and electric systems, Rome, 7-9 October 1996*: 2.4. Rome: ISES Italia.

Andolina, C., & M. Cingotti 1996. The GIS in computer aided wind turbine generators environmental impact evaluation. *Proceedings of the EWEA Conference on integration of wind power plants in the environment and electric systems, Rome, 7-9 October 1996*: 2.5. Rome: ISES Italia.

Savio, S. 1996. Visual impact of wind turbines on the landscape. *Proceedings of the EWEA Conference on integration of wind power plants in the environment and electric systems, Rome, 7-9 October 1996*: 2.7. Rome: ISES Italia.

Wind Energy and Landscape, Ratto & Solari (eds) © 1998 Balkema, Rotterdam, ISBN 90 5410 913 0

Design as if people matter: Aesthetic guidelines for the wind industry*

P.B.Gipe
Paul Gipe & Associates, Tehachapi, Calif., USA

ABSTRACT: Opinion surveys show that wind has high public support, but a worrisome NIMBY factor. This support erodes once specific projects are proposed. Because support is fragile and can be squandered by ill-conceived projects, the wind industry must do everything it can to insure that wind turbines and wind power plants become good neighbors. One means for maximizing acceptance is to incorporate aesthetic guidelines into the design of wind turbines and wind power plants.

1. WHY DESIGN FOR AESTHETICS

Public opinion surveys on both sides of the Atlantic have consistently shown strong support for the development of wind energy. Typically two-thirds to three-fourths of those polled support wind development even in areas with existing wind turbines. However, surveys by Thayer in the Altamont Pass, and by Arkesteijn and Wolsink in the Netherlands show a tendency for those favoring wind energy to become less supportive once specific projects are proposed and wind's local impacts become more apparent.

Thayer, Consumer Attitude and Choice

Figure 1. Wind and the NIMBY response.

*
Portions of this document have been adapted from Wind Energy Comes of Age. Copyright 1995 by John Wiley & Sons. All rights reserved.

In a survey of residents in California's Solano County Robert Thayer and his team from U.C.Davis identified NIMBYs as those who found a technology acceptable in their county, though they would not accept it within five miles of their home. Most of those surveyed in Solano County found wind energy desirable--somewhere. Only 9% thought wind plants were completely unacceptable, whereas opinion was more polarized about nuclear and fossil fuels. One fourth found fossil-fired plants unacceptable in the county; nearly half found nuclear plants unacceptable. But wind drew the greatest NIMBY response (Thayer 1989). See Figure 1.

In his surveys of the Altamont Pass, Thayer found that it is the visual intrusion or the loss of visual amenity that elicits the greatest concern. Though wind plants create other environmental impacts, the principal impact is clearly visible for all to see. There are no containment buildings around wind plants to shield their inner workings from view. Like Thayer in California, Maarten Wolsink has observed the NIMBY phenomenon in the Netherlands. There Wolsink found that a negative view of wind turbines on the landscape is the major factor determining opposition to wind energy. Other, though much less significant, factors are the disbelief that wind turbines will make a difference in improving air quality [usefulness], and the fear that the wind turbines will harm residents (Wolsink undated). Opposition is primarily determined by a negative reaction to seeing wind turbines on the landscape. But, says Wolsink, people unconsciously realize that opposition on aesthetic grounds is subjective, and is, therefore, often dismissed by public officials. They then rationalize their opposition by citing concerns such as noise, shadow flicker, and birds, which can be objectively evaluated. But visual impact remains the root cause of opposition (Wolsink 1989). Thayer found in his Solano County survey that the visual quality of wind energy garnered less support than any other aspect of wind energy, even though respondents still preferred wind energy over other technologies. See Figure 2.

POWER PLANT PREFERENCE

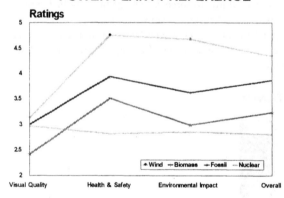

Thayer, R. Consumer Attitude and Choice

Figure 2. Power plant preference

The knowledge that a turbine will actually exist in the near future, seems to make people slightly less positive, says Wolsink. This is a near universal response, whether nearby residents speak Dutch, English, or American. In the Netherlands, 90% of those surveyed reacted positively to wind energy. This support, says Wolsink, is tenuous and is limited by the distance between the respondent and the nearest turbine. The closer people live to proposed turbines, the less likely they are to endorse a proposed project. To further ward against complacency in the wind industry about the strength of its support, Wolsink warns that the other 10% are unsupportive from the start. Though only a small minority of residents ever consider taking

action, Wolsink points out that it only takes one determined adversary to delay a project. Local political support is crucial, says Wolsink, but not sufficient alone for success. Without political support, projects seldom proceed. With it, projects can still be stymied by vocal opposition. Wind energy's impacts on the community only become prominent in the public's mind when a specific project is proposed. Wolsink's surveys find that the public's broad endorsement of wind energy seldom plays a role when individuals weigh the merits of specific projects (Wolsink undated). See Figure 3.

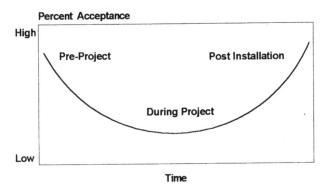

Figure 3. Acceptance of wind energy over time.

Opinion shapes policy and aesthetics, or how the public views the wind industry, shapes opinion. Thus, engineers, turbine designers, project planners, and developers must incorporate aesthetic factors into their deliberations to insure maximum acceptance of wind energy. By striving to maximize acceptance, wind's advocates can better disarm wind's critics. To succeed, says Thayer, future wind-power plants must somehow enfranchise their 'visual consumers'-- those neighboring residents who must look at the wind turbines in their landscape. Thayer's comment reflects the outlook that visual resources belong to the public and their use implies an obligation to use the public resource wisely. Though there may be no way to eliminate all objections to the appearance of wind turbines on the landscape, there is some consensus on how to minimize these objections. The guidelines can be as simple as those of Energy Connection's Arkesteijn, who summarizes the lessons he has learned from developing projects in the Netherlands: build an aesthetically attractive project, and keep the turbines turning (Westra & Arkesteijn1992). Or as simple as that used by the Logstør district council in Denmark: all turbines should look alike, and they should all rotate the same way (Gubbins 1992).

2. PROVIDE AESTHETIC UNIFORMITY

The most significant means for improving public acceptance is by providing visual uniformity. Even when large numbers of turbines are concentrated in a single array, or there are several large arrays in one locale, visual uniformity can create harmony in an otherwise disturbing vista. Visual uniformity is simply another way of saying that the rotor, nacelle, and tower of each machine look similar. They need not be identical. There are four different types of wind turbines among the 100 machines at Tændpibe-Velling Mærsk on the west coast of Denmark.

Yet all the turbines appear similar: they all have three blades, white nacelles, white tubular towers, and their rotors spin in the same direction. As a result Tændpibe-Velling Mærsk is one of the world's most pleasing wind power plants.

2.1 *Avoid mixing turbine types and tower types*

Riverside County's WIMP study, for example warned against extensive mixed arrays (WIMP 1987). If a project uses a wind turbine with three blades, all turbines installed nearby should also sport three blades. If the turbine uses a truss tower, all turbines nearby should also use truss towers. If the nacelle has a distinctive shape, all turbines should use a similar nacelle. Likewise, all the turbines should spin in the same direction.

2.2 *Avoid mixing towers of different heights*

It is equally important that all towers be of consistent height, unless part of a whole as in a wind wall. The CalPoly team that examined the use of wind energy in the Angeles National Forest suggests that turbines on towers of varying height are not only acceptable when in a uniform pattern, but can also add visual interest to an array (Fulton & Koch 1984). But towers of seemingly random heights destroy any uniformity that otherwise might exist in a array. The WIMP study complained that the sole distraction from the horizontal mass of machines on the Whitewater Wash near Palm Springs is the array of Carter turbines, which stick out on guyed towers twice the height of the others around them (WIMP 1987). These turbines and 300 others have since been removed.

3. KEEP THEM SPINNING

When wind turbines are seen spinning, they are perceived as being useful and, therefore, beneficial. Observers are more quick to forgive the visual intrusion if the wind turbines serve a purpose; this they can only do when they are spinning. When significant numbers of turbines do not turn when the wind is blowing, the simple expectation of the observer is violated, says Thayer (Thayer 1987). Even those opposed to wind energy often note that they would moderate their position if the turbines worked more often.

3.1 *Remove inoperative turbines*

Reviewing comments from respondents in his Altamont survey, Thayer found that inoperative turbines equaled or exceeded siting, design, and scenic character in causing negative responses. Thayer concluded from this that the single most significant action California wind companies could take to boost public acceptance of wind energy was to keep their wind turbines operating as much as possible by quickly fixing broken turbines, and removing those that were unrepairable (Thayer 1988). Yet by 1991, there were still enough derelict turbines near Palm Springs alone for the Edison Electric Institute's Charles Linderman to plead with attendees of AWEA's annual conference: "Please get those inoperative machines down, to avoid the misinterpretation that wind still doesn't work well." By mid-1997 more than 500 wind turbines of the 3,500 at one time operating in the San Gorgonio Pass have been removed.

4. BURY INTRAPROJECT POWER LINES

From his surveys in California, Robert Thayer recommends that developers bury all power

lines and integrate extraneous equipment, such as transformers, into the turbines themselves or remove them from the site (Thayer 1988). The latter is now possible with the advent of larger turbines. When used with tubular towers, the transformers and control panels can be installed inside the towers, as is done on offshore and harbor breakwater installations. British architects agree with Thayer and with the exception of continued use of pad mounted transformers these measures have become common practice at British wind plants where nearly all ancillary structures are removed from hill top sites to avoid cluttering the skyline.

5. HARMONIZE STRUCTURES

British wind projects go beyond Thayer's recommendation and construct ancillary buildings of local materials to harmonize their structures with those that have become an accepted part of the landscape. Both Renewable Energy Systems at Carland Cross in Cornwall and EcoGen at New Town in Wales use native stone for the façades and slate for the roofing of their substations, to match traditional building styles. In another example, Italy's national research laboratory, ENEL, has used flagstones to pave access to its turbines at Acqua Spruzza in the Appenines.

6. CONTROL EROSION

Environmentalists' distaste of erosion, apart from the increased siltation of stream beds, alteration of stream courses, and increased flooding that accompany it, results from the scars it leaves on the land. The rill and gully erosion, seen in the Tehachapi Pass cuts deep into the surface of the landscape. More galling than the erosion itself is the abuse of the resource it represents, because accelerated erosion is unnecessary and can be avoided. The wind industry must control erosion or it will certainly suffer further at the pen of activists such as Audubon's Steve Ginsberg, to whom the erosion "is just one of many egregious examples of how wind energy is ripping up the Tehachapis, and its [the industry's] lack of true environmental concern (Ginsberg)."

6.1 *Minimize or eliminates roads*

Wind companies can reduce the risk of serious erosion by minimizing the amount of earth disturbed during construction, principally by eliminating unnecessary roads, allowing buffers of undisturbed soil near drainages and at the edge of plateaus, assuring revegetation of disturbed soils, and designing erosion-control structures adequate to the task. The single most reliable technique for limiting erosion is to avoid grading roads in the first place. Glenn Harris, a biologist for BLM's Ridgecrest office, suggests that driving overland, rather than grading roads, to install and service turbines will significantly lessen erosion damage. Instead of using wide roads graded to bare earth, British, German, and Danish wind plant operators use farm tracks to service their wind turbines. This "tread lightly" practice minimizes erosion and the scarring it creates.

6.2 *Avoid steep slopes*

Erosion is most troublesome and road scars most visible when roads are carved into steep slopes. In general, avoid construction on steep slopes to minimize the scarring from road construction and the cut and fill slopes that result.

7. AVOID BILLBOARDS

All signs near a wind turbine or at a wind plant should solely serve to inform the public about the wind turbines and their place on the landscape. Operators should avoid using wind turbines as a means for elevating advertising billboards to new heights. Billboards, like any other extraneous structure, detract from the sublime quality that wind turbines should impart to the viewer. Billboards add visual clutter to the landscape.

7.1 *Avoid corporate logos on nacelles*

Wind turbines need not broadcast advertising for their manufacturer across the countryside. Society begrudgingly accepts the visual intrusion of wind turbines into the landscape for the purpose of producing clean, renewable, wind-generated electricity not the promotion of the wind developer or wind turbine producer. The public is less willing, and can even be offended by a company's advertising logo emblazoned on the side of a hundred nacelles each the size of a large truck (lorry).

8. PAINTING AND OBSTRUCTION MARKING

Wind turbines will always be visible on the landscape where they rest. This is a fact that can't be avoided. No amount of camouflage will make wind turbines invisible. In general, the color of wind turbines should avoid sharp contrasts with the surrounding landscape. Often a light tan works best in arid environments, while light gray or off-white works best in temperate climates. Though the wind industry can't make wind turbines disappear, every effort should be made to avoid heightening contrast. Aircraft obstruction marking, by intent, seeks to increase contrast with the landscape. Designers must limit the height of wind turbines and should avoid sites near airports where aviation regulations require obstruction marking either with alternating bands of red and white paint or flashing lights.

9. LIGHTS

Operators should douse security lighting at their wind plants and substations to decrease the contrast between the wind plant and the nighttime landscape of rural areas where wind turbines are typically installed. Nighttime security lights are non-essential and can be activated as needed by motion detectors such as used by Southern California Edison in light sensitive environments.

10. ALWAYS DRESS THEM

Wind turbines should never go out in public without proper attire. All wind turbines should include a streamlined nacelle cover to soften the lines between the rotor, nacelle, and tower. A wind turbine without a nacelle cover is like a car missing it's hood (bonnet) or a businessman without his pants (trousers). The viewer quickly senses that something is amiss and is then prone to view the wind turbine critically.

11. USE OPEN SPACING

To avoid the dense visual clutter typical of California's wind turbine landscapes designers

should use greater spacing among the turbines than that found in California. The public finds open arrays less threatening than the dense forest of turbines seen on the floor of the San Gorgonio Pass near Palm Springs.

12. USE PROPER PROPORTIONS

Wind turbine designers should consider the appearance of their work on the landscape as part of their design criteria alongside cost-effectiveness and productivity. Rotor, nacelle, and tower should form part of an aesthetic whole when assembled into a wind turbine. Wind turbine designers and wind power developers alike should avoid considering the wind turbine and its various tower options as a mix and match set. Turbines and towers should form an aesthetic unit and should be designed with particular tower sizes and shapes in mind.

13. MAINTAIN GOOD HOUSEKEEPING

A long list of items that can be used to reduce the visual clutter and disorder typical of California wind plants falls under the rubric of general housekeeping. Some, such as visual density or the preference for three-bladed turbines, are unique to wind energy. Most are not. They are the prosaic prescriptions for living in a civilized world that our parents teach us as children. We learn to pick up after ourselves, and generally to consider the effects our actions have on others. For managers of wind plants, this translates into respect for the environment and the community of which they are a part.

13.1 *Keep Sites Tidy*

Fastidious site managers care enough to ensure that the turbines, where numbered, are identified with a crisp, legible stencil rather than a slovenly spray-painted scrawl. They care enough to require technicians to pack their litter out with them at the end of the day, instead of allowing it to blow across the countryside. And they are never too busy watching the bottom line to notice the day-to-day details that govern how the public views them and wind energy.

13.2 *Clean nacelles and towers*

Responsible managers and wind turbine designers alike also ensure that nacelles contain all oil or fluids which are likely to leak. If they do leak, these managers promptly clean the turbine and tower, returning the site to its pristine condition. Operators know that no manager at a nuclear power plant or an auto assembly line in a Western country would long keep their job if they permitted oil to pool on the shop floor. A wind plant is no different. Operators and employees alike understand that the public intuitively judges management by how they execute such simple chores as housekeeping, for if the company shows little concern for the obvious, how much do they care about less visible tasks, such as the safe disposal of hazardous wastes.

13.3 *Remove all junk and debris*

The public judges wind power plants in their entirety, not just the turbines themselves. If operators allow an accumulation of wind turbine blades, nacelles, cable spools, disused tools, and other machinery it sends a signal to the public that the operator is careless with a public resource: the visual amenity. The public expects wind energy to be a clean source of energy. If there are abandoned cars or broken wind turbines littering the site this expectation is violated and the public becomes less sympathetic to the wind industry's use of the visual resource.

14. INFORM PUBLIC OR PROVIDE ACCESS

Wind turbines are not inherently dangerous and every aspect of a wind plant should convey the sense that wind energy is more benign than other forms of energy. Wind turbines and wind plants should be welcoming. Designers can accomplish this by eliminating fencing and warning signs, and by providing points of public access, footpaths among the turbines, and informational kiosks. By using a public resource, the landscape's visual amenity, wind developers bear an obligation to inform the public how they are using this public resource responsibly. The wind industry can do so by providing access and by building visitors centers. These need not be elaborate and can take the form of simple kiosks or even simple signs that provide basic information about the wind plant, how it works, and the contribution it makes.

15. SUMMARY—BE A GOOD NEIGHBOR

In general, the proscriptions for optimizing aesthetic acceptance can be summarized by noting that designers, developers, and operators should make every effort to be a good neighbor. Only when the wind industry places as much importance on being a good neighbor as on aerodynamic efficiency will the public welcome wind turbines into their backyards.

REFERENCES

Fulton, R., Koch, K. & C. Moffat 1984. *Wind Energy Study, Angeles National Forest*. Graduate Studies in Landscape Architecture, California State Polytechnic University, Pomona, Calif., 64.

Ginsberg, S. *The Wind Power Panacea: Is There Snake Oil in Paradise?*, Audubon Imprint, Santa Monica (Calif.) Bay Audubon, 17,1: 1-5.

Gubbins, B. 1992. *Living with Windfarms in Denmark and The Netherlands*. North Energy Associates, Northumberland, England, September, 7.

Thayer, R. & C. Freeman 1987. *Altamont: Public Perceptions of a Wind Energy Landscape*. Center for Design Research, Department of Environmental Design, University of California, Davis, Calif., 25-26.

Thayer, R. & H. Hansen 1988. Wind on the Land, *Landscape Architecture*, March, 68-73.

Thayer, R. & H. Hansen 1989. *Consumer Attitude and Choice in Local Energy Development*. Department of Environmental Design, University of California-Davis, 17-19.

Westra, C. & L. Arkesteijn 1992. Physical Planning, Incentives, and Constraints in Denmark, Germany, and the Netherlands. Paper presented at *The Potential of Wind Farms, European Wind Energy Association Special Topic Conference*, Herning, Denmark.

WIMP. Phase III 1987. *Wind Implementation Monitoring Program. See the Visual Element*, Draft Report, Riverside County, Riverside, Calif., October, C-4, 12-15.

Wolsink, M.. *The Siting Problem: Wind Power as a Social Dilemma*. Department of Environmental Science, University of Amsterdam, The Netherlands, undated.

Wolsink, M. 1989. Attitudes and Expectancies about Wind Turbines and Wind Farms. *Wind Engineering*, 13,4: 196-206.

Wind Energy and Landscape, Ratto & Solari (eds)© 1998 Balkema, Rotterdam, ISBN 90 5410 913 0

Wind farm lay-out and wind turbine design in relation with the landscape

R. A. van Beek, R. E. T. van Roosmalen & C. Bakker
Adviesbureau E-Connection BV, Delft, Netherlands

ABSTRACT: Recently the attention for visual appearance of wind turbines and wind farms in the landscape has increased. Visual aspects tend to be more and more restricting the realisation of onshore wind projects. As a lot of opportunities concerning the design of wind farms and wind turbines are unknown, E-Connection carried out two closely related research projects. The starting-point of the first project is the lay-out of a wind farm. Starting-point of the second project is the wind turbine design. In both cases the research is related to the landscape.

1 INTRODUCTION

In recent years the attention for the visual appearance of wind turbines and wind farms in the landscape has increased. This development does probably not only take place in the Netherlands but also in other (European) countries. At the moment visual aspects tend to be more and more restricting realisation of onshore wind projects. Likely this is caused by the increasing number of wind farms and also by the size of the wind farms and wind turbines themselves. Especially in a country like the Netherlands, characterised by its dense population, increasing application of wind energy will strongly have to compete with other forms of land-use, for example landscape.

The social acceptance of wind turbines in the landscape mostly is determining for the feasibility of a wind farm. The acceptation is highly dominated by the visual appearance of the wind farm in the landscape. In order to improve the social acceptance it is necessary to have a view of the possibility's for wind farms in the landscape. Therefore two closely related research projects, commissioned by NOVEM (Netherlands Agency for Energy and the Environment), have been carried out to investigate the possibility's for (innovative) applications of wind energy in the Dutch landscape.

2 LAY-OUT OF A WIND FARM

2.1 *Aim of the research*

Until now about 45 wind farms have been realised in the Netherlands. Here wind farms are defined as wind projects consisting of four wind turbines and more. An inventory of these existing wind farms has indicated that the lay-out of these wind farms is mostly based on mainly (wind)technical aspects. This is the so called practical and pragmatic approach, which almost in every case has lead to a linear lay-out of the wind farm. The orientation of these linear formations in the landscape is determined by strictly formulated spatial limitations.

Analysis of the visual aspects of present wind farms and interviews with different (landscape) architects have learned that the time has come to approach the lay-out of a wind farm in a more integral and expressive way. The particularity and (visual) quality of a wind farm is still under-exposed and a lot of possibility's are not applied. According to their opinion more integral and expressive designed wind farms can and will contribute to an improved social acceptation. The aim of this research based on these findings is formulated as presenting possible future wind farms with a new style lay-out, and investigate the public's reaction. The result has to inspire and stimulate in a way that future wind farms in the Dutch landscape will get developed in a more creative and well-thought way.

2.2 Designing wind farms

To get a view of the possibility's concerning the lay-out of a wind farm, three agency's for landscape architecture have been asked to develop several wind farms. For that purpose four different locations have been selected, as specified by two utility companies involved in the project. This in order to create the possibility of actually realising a wind farm designed by this study. Each agency is asked to design different wind farms for every location. The designers are guided by a frame of reference based on practical experience gained on present wind farms and visions on future wind farms (interviews).
The design study resulted in a variety of formations for future wind farms. Besides traditional placing concepts also various concepts introduce innovative ways of placing wind turbines in the landscape. These new placing concepts concern the actual formation of the wind turbines but also unknown additions to wind farms like for example colours and lighting of the turbines as well as forms of multiple land-use.
Remarkable is the strong preference to linear formations despite the scope for more deviant formations. Also striking is the importance of designing wind farms based on not only the structure and characteristic features of the existing landscape but especially how it is perceived by the potential observers.

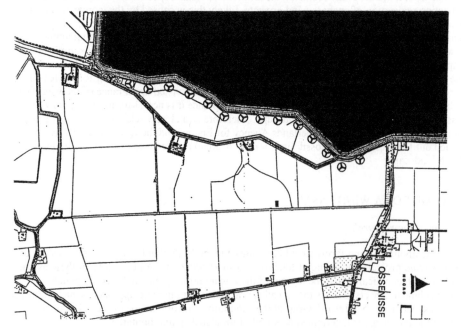

Figure 1. Wind farm on location, designed by a functional and practical approach.

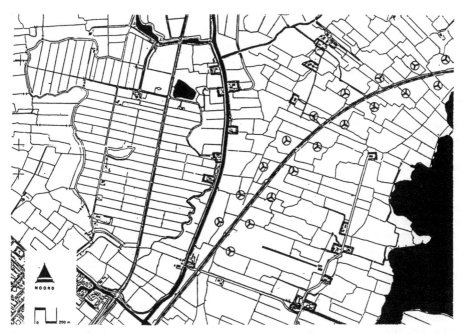

Figure 2. Wind farm on location. Designed by the 'added design' approach, effected by the application of coloured lattice towers in harmony with the open landscape.

2.3 *Visualisation*

Because abstract design studies do not give a real impression of wind farms in the landscape it is not possible to investigate the perception of different formations based on 2-dimensional models. To get a realistic view on the visual impact of the designed wind farms in the landscape, computer supported visualisations are almost indispensable. Recently E-Connection has developed a visualisation-method which gives a technically correct and very realistic view of a landscape with a future wind farm.

The different wind farms designed by the agency's for landscape architecture are visualised on a A3-format picture. Starting point for each visualisation was one view-point, based on the possible information about the 'relation' between landscape and wind farm obtainable from the regarding formation. This visualisation stage has lead to 41 divergent pictures of possible future wind farms in the Dutch landscape. These visualisations are a suitable input required for an objective investigation on the appreciation of different characteristic features of wind farms.

2.4 *Results*

A view on the public opinion and the perception of different characteristic features regarding future wind farms is realised by a survey. During this survey a panel is asked to give their opinion on the different designs showed in the visualisations. The survey has given information about the perception to detailed features concerning the wind turbines and formation but also information about the perception to the orientation of a wind farm in the landscape.

The attitude towards wind farms seems to be still pretty conservative, but on the other hand renewal concept are totally not rejected on first hand. The unacquaintance with this kind of innovative applications of wind energy seems to be decisive for the neutral and conservative attitude. Based on the survey and the results of the design study we made a parallel between designing wind farms and architecture. The kind of architecture differs a lot depending on the chosen approximation which is determined by the needs and means. This leads to three possible approximations for realising a wind farm:

- 'No design'; The final lay-out is based on functional and practical grounds.
- 'Added design'; A functional and practical lay-out with some aesthetic and architectural additions, to increase the visual value.
- 'Integral design'; A lay-out based on mainly aesthetic and visual grounds with a strongly integral approach.

Designing wind farms following only one and the same approach is unacceptable and will be perceived with a negative attitude. A landscape scattered with wind farms designed by one approach will lead to a uniform, boring and visual unattractive appearance. In order to obtain and increase social acceptance it is necessary to design wind farms grounded on different approaches which leads to a landscape featured by diversity and will watch over the necessity of levelling within the landscape. Despite the slightly conservative attitude of the public, landscaping asks for wind farms designed by an integral approach besides the existing 'no design' and in some cases 'added design' approached wind farms. Choosing the right approach for the right location requires attention. As not every location seems to be suited for arbitrary approach, a high level view (regional/national) will be necessary in order to realise future wind farms in a well thought way.

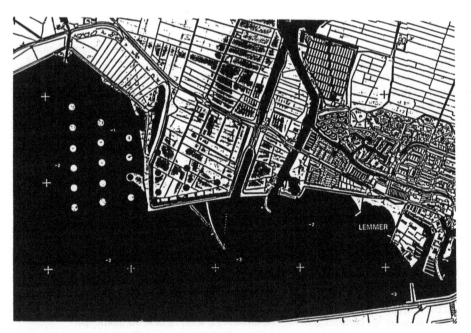

Figure 3. Wind farm designed by the 'integral design' approach. An orange coloured and triangular shaped cluster, indicating the city Lemmer hidden in the 'armpit' of the IJsselmeer.

3 WIND TURBINE DESIGN

3.1 *Aim of the research*

This project is aimed at two objectives. The first objective is an evaluation of the design of existing wind turbines. The second objective explores the possibilities for wind turbine design in the near future. Both objectives are aiming at investigating the public's reaction on the presented wind turbine models. The main focus is to determine which characteristic feature, if any, is most important.

Furthermore we are interested in the combination with a number of different landscapes: which kind of landscape fits best with a certain turbine model.

3.2 *Designing wind turbines*

The material we use for gaining public reactions consists of specially designed turbine models. These models contain the latest technical developments but are focused on the visual appearance only and do not consider technical aspects. Design could therefore be interpreted as styling within technical possibilities.

Besides some studies on technical developments and trends, also a background reference on form theory is needed.

The technical study produces the distinctive elements or features of the turbine which are available to be combined. This material defines a playground. The form theory gives some clues how to deal with the material and how to look at a form. Two approaches are suitable for this project; combining and changing the different elements to a whole or creating a form with a certain 'look or feel' associated with a wind turbine.

Two designers with different background (one industrial designer and one architect) developed a wide range of models based on the two approaches. Like any shape, a wind turbine has got some kind of expression whether it is modest or neutral or very dominating. Our aim was to develop models on the edge of the possibilities; to be as extreme as possible.

3.3 *Visualisation*

To create a uniform presentation of the models, they were modelled with a 3D programme on a computer and presented in the same scenery. All models are seen from the same angle, distance and the wind direction is always from the left. Furthermore all models are put together before any selection could take place. In this way we avoid excluding certain usual models.

3.4 *Selection*

In order to get a workable set of turbine models for the public's reaction, a representative pre-selection out of the fifty models is needed. A group of industrial designers arranged the models in twelve clusters, based on the look of the models, ranging from traditional to innovative. Each cluster defines its own boundaries by the models containing it. One or two representative wind turbines of each cluster were selected and shown to the public.

The validity of the cluster is dependent on the skills of the group of designers. Although these clusters mean a reduction of judged models, when properly done they are an added value to the models.

In this way we collect information about the opinion of all similar models; on the assumption that once you know which model is appreciated, you know which others will do to.

3.5 Results

With this model overview we can judge commercially available wind turbine models by trying to fit them into one of the clusters and comparing them with its representative. When this model is not appreciated we can give recommendations for newer models or modifications of the present ones. The following result of this project could even be more interesting:
The way we confront the public with our sometimes rather unusual models, is very similar to what car manufacturers tend to do with their 'concept cars'. These extreme and 'futuristic' cars are shown at the public on car exhibitions. When a certain style is widely appreciated, later models contain the same style, albeit mostly less expressive. This kind of investigation provides knowledge and opinions about (wind turbine) models before they are even built.

The first, not yet validated, results show that the most expressive models were heavily judged beautiful or ugly in the same amount. They arouse the most extreme but controversial reactions. Surprisingly some models based on technical new designs were not seen as innovative; but the more integrated a turbine looks, the more innovative it becomes.
The public survey made very clear that there is no such thing as a unanimously beautiful design. The 'best' model gained the lowest 'ugly' scores. So 'modesty' or 'neutrality' seems to be rewarded or at least not rejected. Some of the new designs scored quite well in this sense. Landscape plays a less important part in this project, but some turbines could be placed in any landscape, others were strictly appreciated in one kind of landscape.

These preliminary results give an indication of what the public appreciates but should not be interpreted as strict guidelines when designing new models. There should always be early adapters and innovative models! Diversity is a must.

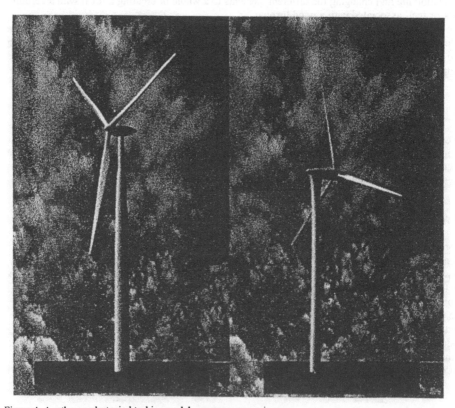

Figure 4. A rather modest wind turbine model versus an expressive one

Wind Energy and Landscape, Ratto & Solari (eds) © 1998 Balkema, Rotterdam, ISBN 90 5410 913 0

Visual tools for wind farms development

S. Avolio & C. Ferrara
Ansaldo-WEST SpA, Rome, Italy

ABSTRACT: The paper illustrates the importance of visual tools in the development process of wind power plants. One of the most important assets for the development of a windfarm is a good and deep knowledge of the territory, both the one that will be directly involved by the plant and the near/far neighborhoods. To this purpose local surveys are of course of mandatory relevance, but usually is also necessary to have reliable model to utilize for office work. Modelers are the historic classic approach, and still unreplaceable, but today computer tools are becoming more and more efficient and suitable to the purpose. Several commercial software packages are commonly used to simulate the orography of the areas of interest, generally through the use of the so-called grid files. These packages, together with some simple interface software that can be necessary to utilize basic data from one package into another, are used as visual tools to present the results of wind resources calculation runs performed through specific computer programs (e.g. WAsP). A windspeed contour map image can be created and overlaied on the relating 3D orographic model to improve the knowledge of the flow field on the area. Other software applications are able to create photorealistic views which are very helpful to evaluate the visual impact level related to the insertion of a windfarm in the landscape.

1 INTRODUCTION

The wind farms development work is very important for the exploitation of the wind energy resource. The development of a wind power plant needs some preliminary studies and assessments, which involve several evaluation fields. Only after adequate technical and economic, as well as environmental and regulatory considerations, the windfarm can be inserted successfully into a complex territorial system, taking into account several factors which influence the final placement of the wind turbines.

The starting and essential phase is just the wind farm site selection, which requires, of course, a good and deep knowledge of the morphological characteristics of the territory (slope, elevation, accessibility, surface roughness, hydro-geological nature of ground) and a reliable description of the wind conditions on the area (wind rose, annual mean wind speed, turbulence intensity, Weibull distributions, etc.).

However this analisys cannot be independent from other important activities, to be carried out contemporary, by consisting of surveys on site to check the real feasibility. A lot of information must be collected concerning the position of roads, buildings and electric lines, the land use, and the presence of naturalistic, archeological or historical constraints. This work must always be coupled with continous consultations and meetings with the relevant planning authorities (municipality, province, region, government) in order to obtain the necessary authorisations, and with the landowners to manage the leasing contracts for the site.

In order to overcome difficulties encountered by the developers during the entire windfarm development process, several commercial software packages, which allow to visualize a territory situation on a computer image overlaying different dataset related to the same geographic area, can give a significant contribution.

This information, available or collected during the project advancing, can be shown either as 2D or 3D images. They can contain the following items:

- terrain height contour lines;
- wind energy, wind speed, noise level or any other phisical quantity contour lines;
- boundary lines around remarkable areas such as:
 - surface roughness;
 - exclusion zones for environmental, architectural or regulatory constraints;
 - ownership;
 - municipality territories;
 - land uses;
- roads or electric grid;
- geographical position of meteorological masts, buildings, wind turbines, TV or radio transmitters, electric grid connection nodes.

The analisys of the generated models is very useful to optimise the final arrangement of the wind turbines; it allows to find the best compromise between technical, logistic and environmental requirements positioning the machines on the most efficient place within the available and suitable areas selected for the plant installation.

2 TERRAIN MODELLING

At the beginning the wind plant designer create a DTM (Digital Terrain Model) (Figure1), a numerical file which is the necessary input of many wind resource calculation software. This is often obtained by digitizing the height contours and/or roughness-change lines from a 1:10000 scale standard topographical map fixed on a tablet. This file, saved as a map file [.MAP], a format readable by WAsP (a standard wind resource calculation sotware developed by RISØ National Laboratory, Denmark), is then converted, through some utilities, to a grid file [.GRD].

The first visual tool examined is the SURFER package, a grid based contouring and surface plot program whose powerful 3D capabilities can be applied to model any kind of terrain. SURFER uses as input just a grid file. This one contains a series of Z values located on a rectangular regularly spaced array of (X,Y) locations. For GIS (Geographical Information Systems) applications the (X,Y) locations represents the geographical coordinates in the selected frame of reference, generally the UTM (Universal Transverse Mercator) coordinate system, while the Z value is the corresponding terrain height, if an orographic map is considered, or any other phisical quantity whose distribution is to be assessed in relation to the same geographic extent.

A grid file produces a contour map, a two dimensional representation of three dimensional data. Contours define lines of constant Z, or in other words, lines of constant elevation or value, across the extent of the map. Contour lines are drawn as straight line segments between the grid lines in the grid file. The point where a contour line intersects a grid line is based on an interpolation between the Z values at the neighboring grid nodes. The smoothness of contours on a contour map is partially a function of the number of X and Y lines in the grid file: reduction of the number of lines in the X and Y directions can result in more angular contours on the contour map.

The grid files are loaded also to generate three dimensional rapresentations called surface plots, displayed with any combination of X,Y or Z lines. When using X,Y lines to represent the surface, the surface appears as a mesh over the top of the surface; when Z lines are used, a 3D contour map is drawn. The orientation of a surface plot can be changed using several 3D views.

Another representation can be an image map or a shaded relief map, generating a different kind of plot.

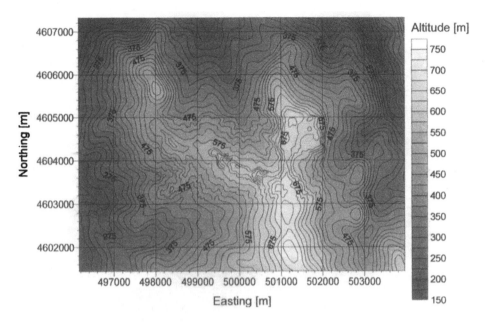

Figure 1. Two dimensional terrain height contour map

A grid file can be also converted to an XYZ data file, with grid nodes listed in separate rows, with the X coordinate in Column A, the Y coordinate in column B, and the corresponding Z value in Column C.

3 BASE MAPS

Base maps are files used by visual tools to show geographic information on a map. They can be in several formats, either vector files, Windows metafiles, or bitmap files.

Vector files consist of points, polygons and polylines and are used to draw objects at precise (X,Y) locations on a map. Through them a lot of objects can be plotted, such as boundary outlines (e.g. a province or municipality outline), streams, roads, buildings or any other type of object on a map.

Windows metafiles contain line drawing information for reproducing vector drawings. Metafiles can be stretched and scaled without any loss of resolution, but cannot be edited in SURFER.

Bitmap files consist of raster images that cannot be edited in SURFER but can produce effective background images for other maps. Raster images are displayed as an array of dots or pixels on the screen.

4 WIND RESOURCE MAPS

A very useful application during the wind farm development process is the evaluation of the wind energy potential expected on the site. This target can be reached using a wind energy resource sotware package. In this paper WAsP, the danish RISØ software, is considered. The WAsP output, taking account of meteorological measurements on site combined with the orographic characteristics of the area, can be converted to a grid file in which Z value nodes are the magnitude of wind speed or wind energy, depending on the user's option selected. Therefore a

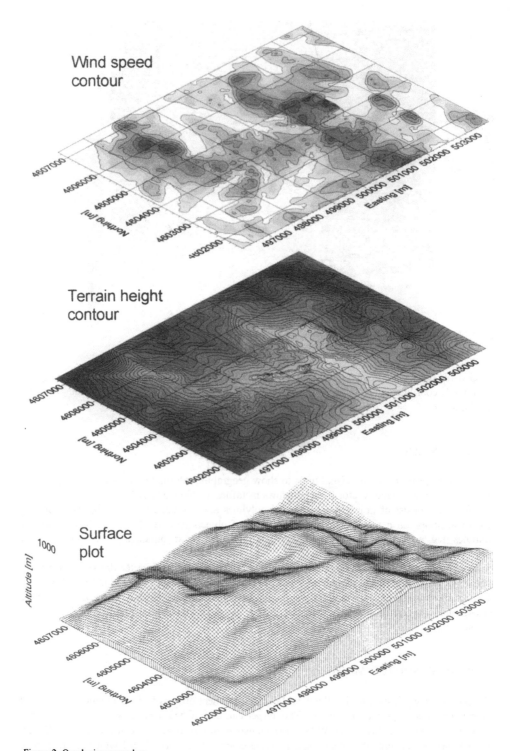

Figure 2. Overlaying procedure

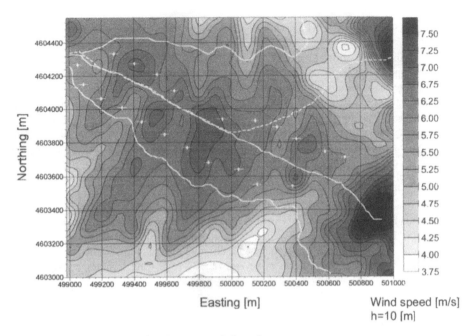

Figure 3. Two dimensional wind farm layout over wind speed contour map

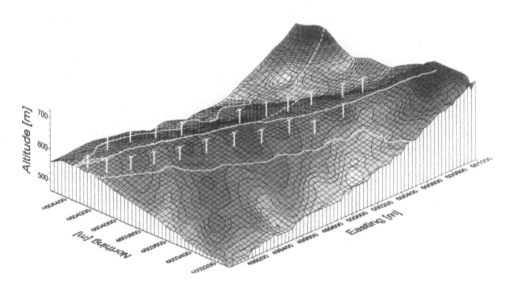

Figure 4. Three dimensional wind farm layout over wind speed map molded on DTM

correlation between the high wind energy potential areas and their geographical extent can be made. Consequently the wind turbines are placed on the most efficient locations generating a high performance preliminary layout of the windfarm. Finally the layout so produced has to be checked taking into account all environmental or regulatory constraints, or verifying the minimum distances from roads, buildings, electric lines, etc. To perform this need a very useful help comes from the overlaying procedure, described below.

5 OVERLAYING PROCEDURE

Overlaying method (the software equivalent of superimposing several drawings made on a transparent support) lets the user combine several maps of related data (Figure 2). Contour, surface and base maps can be combined in overlays obtaining either two or three dimensional plots. When contour or base maps are overlaied on a surface plot, the maps are "molded" over the top of the surface. Therefore the two dimensional wind speed distribution, saved as a grid file, and generated as a contour map (Figure 3), is shaped over the three dimensional wireframe representing the terrain surface. The result is then shown as a three dimensional contour map and the developer can visualize the site wind energy potential distribution, improving the understanding of terrain effects on the wind flow (Figure 4). A color-filled wind speed contour map can be obtained loading a user defined color level file.

These plots can be integrated by further geographical information overlaying post maps or classed post maps. Post maps place a symbol at the (X,Y) location specified in a data file, which can be an ASCII or a worksheet file. Classed Post maps use different symbols to represent different ranges of data. Each range is assigned a different symbol allowing the user to display subsets of data inherent to the position of several objects (e.g. wind turbines, villages, meteo masts, etc.).

6 VIRTUAL LANDSCAPES

For less technical purposes photorealistic simulations of sites can be obtained from other packages. This is the first investigation a developer is able to do for a preliminary idea of the site. A virtual landscape representing a new geographic area to be checked can be created before proceeding to survey on site.

Apart from some general 3D photorealistic modelers (using ray tracing and texture mapping), a more specific package, specifically designed in order to produce "real picture" of landscapes, is VISTAPRO, using as input USGS DEM (United States Geographical Surveyor-Digital Elevation Map) files. Elevation points are provided along north-south profile lines, and use a 30 meter spacing between adjacent data points and adjacent profile lines. Point locations are referenced to the UTM coordinate system. By means of fractal tecniques, specific textures are added to the 3D view, in order to render the landscape in the most appropriate way. Specific rendering colors and textures can be changed to give different feelings of the area, including seasonal and daily situations; animations can also be made like going through the territory.

7 CONCLUSIONS

Even without the use of more complicated general GIS systems it is possible to find visual tools able to contribute significantly to:

* reach a satisfactory knowledge of territory situation;
* integrate the documentation for the wind farm project;
* show the results of the assessments carried out during the development process.

Wind Energy and Landscape, Ratto & Solari (eds) © 1998 Balkema, Rotterdam, ISBN 90 5410 913 0

Optimising the layout of a wind park in terms of energy output and environmental intrusion

A.Georgiopoulos, N.Lymberopoulos & D.Tryfonopoulos
Technical Department, CINAR S.A., Athens, Greece

ABSTRACT: The increasing number of wind parks, usually installed at highly conspicuous sites, in connection with the sensitivity of the public on environmental issues, has lead to some problems on their social acceptability. The sustainable development of wind energy must thus secure local support, which can be achieved by informing residents on the future look of their area. At the same time, the layout of a park directly affects the park's energy output and economic viability.

To that end, the Wind Park Wanderer (WPW) tool has been developed to help the designer reach the optimum point in terms of energy output and cash flows on one hand and environmental intrusion on the other. The tool runs on a powerful hardware platform comprising commercial and application software and is fully operated through a graphic user interface. The installation of a 3MW wind park is addressed using the WPW tool and three scenarios in terms of turbine size and number of turbines are hereby examined with respect to their visual and noise impact on one hand and energy and cash flows on the other.

1 INTRODUCTION

The installed capacity of wind turbines has recently exceeded 2,500 MW in Europe alone, which is but a small percentage of the existing wind potential. A number of problems concerning the social acceptability of wind park installations have recently been raised, mainly caused by the rapid increase of the number and size of the machines installed, in connection with the increasing sensitivity of the population on environmental issues (Arkesteijn 1991). In many cases installation projects faced difficulties with the residents and consequently with the local authorities which lead to delays or even cancellations (Robert 1988). These problems, which can be at a local or national level, need to be addressed early on in order to avoid undermining the potential of this type of renewable energy technology.

Research on these social acceptability problems led to the conclusion that although wind energy is a very popular source of energy and wind parks are most favoured by the public than any other form of power plants, there is significant opposition by residents living near such installations (high NIMBY factor) (Wolsink 1991). The main cause for this opposition is the visual impact of the park, followed by the noise generated. Better aesthetic design of wind parks has been suggested, taking into account not only the machine appearance but also the way that the park set-up matches with the specific terrain. Additionally, it is important to keep the local residents informed about the future look of their area and secure their acceptance of the installation at an early stage.

Similarly, from the developer's point of view, the set-up of a wind park is in direct relation to its economic viability since the wind potential, machine shading, erection cost and noise levels are affected by the arrangement of the machines. Thus, in designing a

Figure 1. Digital terrain model of potential site.

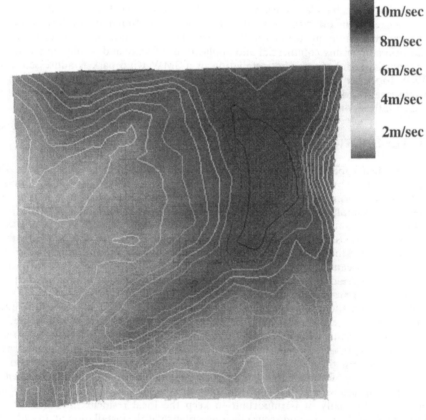

Figure 2. Average wind speed at 30m agl in m/sec.

wind turbine installation, the optimum point should be reached with respect to energy production and cash flows on one hand and environmental intrusion on the other. To that end, Geographical Information Systems have recently been used to manipulate layers of information for siting wind parks and to produce images for visual impact assessment (Andolina 1996, Kidner 1996), while the present tool has been developed in order to integrate both the technical and environmental impact aspects of wind park design in one single environment (Lymberopoulos 1996, Panagiotidis 1996)

2 OBJECTIVES IN DEVELOPING THE WPW

The Wind Park Wanderer (WPW) software tool was developed with the previous notion in mind. It has the potential to allow the generation of various scenarios for the configuration of wind turbine installations in terms of visual impact, energy production and cash flows for the potential site, in such a way so as to simplify the designers work when it comes to reaching the compromise between wind park efficiency / financial viability and environmental impact. The major objectives that were set on the character and the features of the tool were:

- The implementation in a single object oriented environment of all the procedures required for the design of a wind park installation
- The operation of all the functions of the tool through a graphics User Interface
- Interactive, high quality, real time animation of the wind park

The developed tool's functionality may be split into two parts, the mathematically intensive fluid dynamics or energy calculations that constitute the Scientific part of the tool and the graphics intensive Visualisation part (Lymberopoulos 1996).

In the *scientific part*, the user specifies the terrain topography and the wind rose of the area in order to estimate the wind resource of the area under consideration using the AIOLOS-T code (Lalas 1994) suitable for complex or flat terrain sites. Once the calculation is complete, the wind speed contours can be viewed on the terrain. The number and type of wind turbines that will be installed in the park can then be specified. Information on the performance and dimensions of each turbine is retrieved from the respective wind turbine data base. Wind turbines are placed automatically or manually on the terrain. The annual energy production can then be calculated (Voutsinas 1993) that takes into account the shading of the machines and this information can be used to perform cash flow analysis for the investment. Lastly, the noise levels can be estimated through a propagation model that uses hemispherical noise propagation over a reflective surface and includes air absorbency. The noise contours can then be displayed on the terrain.

The park layout is transferred to the *visualisation part* of the tool which allows the user to create images of the potential wind park installation. Lighting conditions are determined from the geographic longitude and latitude for the particular site plus the date and time of the day. Views of the park can be produced from any fixed position and viewing angle specified by the user. Additionally, the tool allows the user to "pan" his camera or take virtual walks around the park, where the rotors of the wind turbines can be either parked or rotating. General conformance has been observed between photographs of existing sites and the images produced by the WPW (Panagiotidis 1996), with the turbines displaying correct position relative to the landscape and to each other.

The creation of images for proposed wind parks and the capability of animation, in addition to the calculation and display of noise, allows the assessment of the environmental impact of various park layouts. Additionally, for any configuration of turbines the WPW software is able to determine the energy and the financial outputs, by executing the appropriate software in the same single working environment. The user can thus readily modify the size, number, positions of the wind turbines, the height of their towers etc., trying to minimise the visual and the noise impact while at the same time checking the effect on energy and financial viability of the particular wind project.

Figure 3. View of virtual wind park of 10x300kW turbines from a distance of 1.2 km. The position of the observer relative to the WTs is shown on the lower picture.

3 THE CASE OF A 3MW WIND PARK

The WPW software tool has been applied to a hypothetical 3 MW wind park to be placed, due to land access limitations, along a 50 hectare piece of land covering a mountain ridge that spans from a height of 420 to 580m asl, having a SW to NE direction. Figure 1 shows the Digital Terrain Map of the specific site. The following three scenarios were examined :
a) 10 Wind Turbines of 300kW rated power each (30m rotor diameter)
b) 5 Wind Turbines of 600kW rated power each (42m rotor diameter)
c) 3 Wind Turbines of 1MW rated power each (55m rotor diameter)
Typical information produced by the WPW is presented in the accompanying figures and tables.

3.1 *Siting and visualisation of wind turbines*

Following the specification of the wind rose for the area, the wind resource was calculated, as displayed in Figure 2 in the form of average wind speed (m/sec) at 30m agl. It is evident that the wind turbines (WTs) would need to be installed along this ridge for maximum energy production, under the constraints of minimum distances between WTs imposed by the shading criterion. Figures 3, 4 and 5 show the view of the park for scenarios a, b and c respectively from a distance of 1.2 km looking NW. The position of the wind turbines (circles equal to two rotor diameters) relative to one another and to the observer (square) are displayed in the lower part of each figure.

3.2 *Noise generated by the park*

The noise levels have been estimated using a model based on hemispherical noise propagation over a reflective surface, including air absorbency. The generated noise for the particular site and for each scenario is presented in Figure 6, in the form of contours of noise intensity dB(A).

3.3 *Energy production calculation*

The results of the energy production calculation, based on the estimated wind resource and the WTs positions displayed in Figures 3, 4 and 5 is shown in Table 1

Table 1. Energy production from the potential wind park of 3MW rated power

Wind Park scenario	a	b	c
Number and size of WTs	10x300kW	5x600kW	3x1,000kW
Rated Power Installed (MW)	3	3	3
Total Annual Energy (MWh)	10,755	10,700	9,700
Capacity Factor (%)	41	40.7	36

3.4 *Financial indexes*

The various costs that were assumed for each wind park scenario in the calculation of the Internal Rate of Return (IRR) and the Pay Back Period (PBP), are shown in Table 2.

Figure 4. View of virtual wind park of 5x600 kW turbines from a distance of 1.2 km. The position of the observer relative to the WTs is shown on the lower picture.

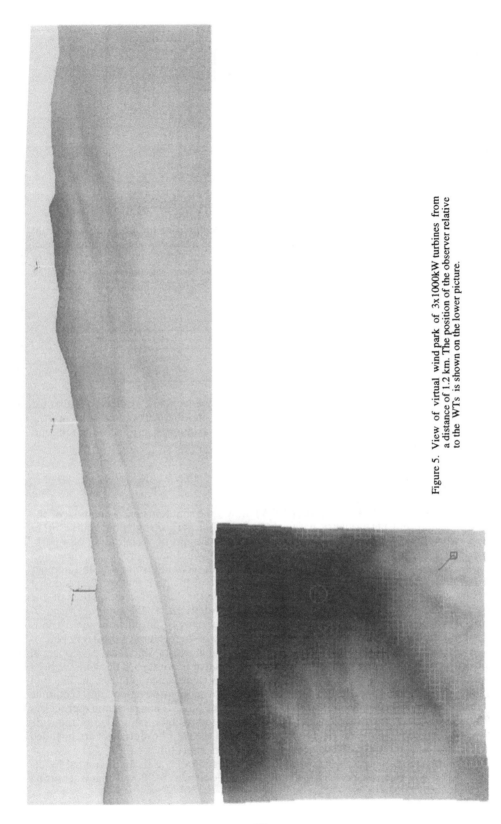

Figure 5. View of virtual wind park of 3x1000kW turbines from a distance of 1.2 km. The position of the observer relative to the WTs is shown on the lower picture.

Table 2. Analysis of costs for each wind turbine scenario (kECU)

Wind Park scenario	a	b	c
Wind turbines	2,700	2,850	3,000
Transport	200	170	250
Civil works	185	210	170
Foundation	200	200	180
Construction	190	205	190
Electronic equipment	320	300	270
Connection with grid	250	250	250
Other costs	75	75	75
Total	4,120	4,260	4,385

Based on the energy production and cost figures presented in the previous tables and assuming operation & maintenance costs equal to 60.25 kECU/annum, a selling price of 6cECU per kWh, an interest rate above inflation equal to 11% and a period of amortisation of 15 years, the following indexes have been calculated by the WPW software.

Table 3. Financial indices for each examined scenario

Wind Park scenario	a	b	c
IRR (%)	11	11	8
Pay-back period (years)	7.3	7.1	8.6

The main conclusion that can be drawn from the current economic evaluation is that for the wind characteristics and access of the particular site, the 600kW machines are the most interesting for the developer in terms of maximum energy production and minimum pay-back period.

4 CONCLUSIONS

The use of the Wind Park Wanderer (WPW) allows the simultaneous estimation of the environmental and performance parameters of a wind park installation, unlike other tools that dedicated solely to either performance calculations or visualisation of a park. The WPW software tool has been applied to a 3MW wind park, producing views and noise calculations for three different scenarios, in terms of wind turbine size and number of turbines. These figures and especially the animation of the park that can be produced on the computer screen or on video, are useful for the subjective estimation of the environmental impact of a potential installation. Additionally, the tool was used to calculate the wind resource, calculating in turn the energy production and various economic indices for the three configurations, that are of importance to the developer.

A software tool was thus designed and developed that assists wind farm developers in the design stage of a wind park. Most of the tasks related to wind park design have been integrated in this tool, including analysis of the park's environmental intrusion. The tool allows the user to optimise the park in terms of energy production and economic viability on one hand and environmental impact on the other. Time consuming processes related to the park design such as production of photomontages, estimation of the wing potential, the energy output, the noise generated and the cash flow analysis are included in the same package and can thus be performed in very short times.

The initial development of the Wind Park Wanderer tool was partially funded by the EC JOULE II Programme of DG XII under the topic Renewable Power Plants, contract No JOUII-CT93-0389.

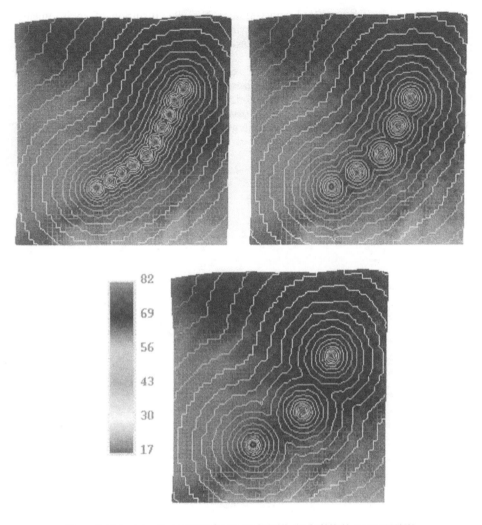

Figure 6. Noise intensity in dB(A) for (a) 10x300kW, (b) 5x600kW, (c) 3x1000kW.

5 REFERENCES

Andolina C., Cingotti, M. 1996. The GIS in computer aided wind turbine generators environmental impact evaluation, *Proceedings of Conference on "Integration of Wind Power Plants in the Environment and Electric Systems"*, paper 2.5, Rome

Arkesteijn, L.A.G., & Westra C.A. 1991. The visual impact of wind turbines, *EWEC Proc.*, pp705-709 , Amsterdam

Kidner, D. B. 1996. Minimising the visual impact of wind farms: the potential of geographical information systems, *Proceedings of Conference on "Integration of Wind Power Plants in the Environment and Electric Systems"*, paper 2.6, Rome

Lalas D.P., Panagiotidis T.C., Tryfonopoulos D.A. 1994. A hybrid micrositing model for wind flow simulation over complex topographies, *Proceedings of EWEC*, pp285-291, Salonika

Lymberopoulos N., Belesis M., Wood M., Voutsinas S. 1996. An integrated audio-visual impact tool for wind turbine installations, *EUWEC Proc.*, pp 165-169, Goteborg

Panagiotidis T.C., Belessis M., Lymberopoulos N. 1996. Inclusion of environmental aspects in the design phase of a wind park, *Proceedings of Conference on "Integration of Wind Power Plants in the Environment and Electric Systems"*, paper 4.1, Rome

Robert, L. & Thayer Jr. 1988. The aesthetics of wind turbines in the United States: Case studies in public reception, *ECWEC Proc.*, pp470-476, Herning

Voutsinas S.G., Rados K.G. 1993. A method for the aerodynamically optimal design of wind parks, *15th BWEA Wind Energy Conference*, pp231-237

Wolsink M. 1991. Publicity about wind energy: Analysis of newspaper content, *EWEC Proc.*, pp931-935, Amsterdam

Wind Energy and Landscape, Ratto & Solari (eds) © 1998 Balkema, Rotterdam, ISBN 90 5410 913 0

Wind power plant and park facilities in Monte Arci, Sardinia

F. Spanedda
Sassari, Sardinia, Italy

ABSTRACT: On a volcanic plateau in Sardinia, both the Italian Electricity Board (ENEL) and the Local Region are developing two different projects : a wind power plant with 40 turbines the former, a regional park the latter. Both projects originated from the distinctive features of the site, its windy climate and its historical and natural values. The simultaneous presence on one site of great natural beauty and good wind-power suitability is very common, and gives the method here shown a wider importance.

This project aims at surpassing a design based on strictly functional parts.

It tries to develop a strategy working on interactions between the physical shape of the landscape and the complementarity of the briefs, taking advantage of the experience of artists who, over the last twenty years, have taught us to look at the landscape and its development in a different and more critical way.

1 INTRODUCTION

Most projects concerning the environment and the landscape today require several fields of specialisation.

The choice of the site and design of renewable energy plants has to be decided not only from a technological point of view but also from the aspects of landscape transformation.

Renewable energy (and mostly wind energy) plants need more land than traditional systems. Trying to hide their visual presence or to avoid disturbing earth during construction would, of course not be entirely possible, but everything would be done to avoid land erosion and scarring of the landscape. Hopefully these plants will function for a long time, and their foundations and service roads will remain as long-lasting tracks on the land.We have then to consider the question of what is permanent and what not, what is fixed to the ground and what can be replaced. We need not only to extend our project to a wider area, but to consider a wider period of time involved.

We should not allow these large areas to have only one use for such a long period of time.

We should avoid scarring the landscape after dismantling certain elements of the power plant. The remaining elements will not scar the landscape but could be reutilised within other projects.

Recent architectural research into urban structures has investigated the modification of urban landscapes, introducing concepts like permanence, structures, reutilisation, making the statement that the landscape is the result of continuous work by its inhabitants.These concepts could be usefully adapted to the design of whole part of non-urban landscapes, considering interaction between man and nature.

The history of architecture is full of examples of great landscape transformations developed in order to assure the provision of energy, water, and transportation systems.

The great lesson to be learnt is not only their immediate usefulness, but also in their permanence, their capability to survive their use and be reused, to house new functions and to

mark definitively the character and the image of a landscape.

Roman countryside with its aqueducts, the ramparts and the walls of ancient fortifications, transformed in housing in the Renaissance or in roads, parks and places of leisure in the last century are examples of the duration of important landscape transformations.

During the last twenty years, artists have researched a lot in this field, repeatedly inquiring into the boundaries of natural and man-made environment, showing us the capabilities of industrial and abandoned landscapes, the value of bridges, motorways, streets as mechanisms that can be used in order to study detailing and modification of the landscape .

An important work under this point of view is "Broken Circle and Spiral Hill" built by the American artist Robert Smithson in 1971 in a sand quarry fallen into disuse in Emmen, Holland (Figure 1).

Smithson transforms a scarred landscape in a piece of new aesthetical value. Land reclamation and kinetic experiences are condensed in a new shape of the shore line visible from a spiral path that climbs up a new artificial hill made from earth. The two shapes, circle and hill, have a dialectic relationship : the one is the observation point for the other, one is horizontal, but its spinning movement recalls a vertical axis of rotation, while the other is vertical but its form is the result of the climbing of a horizontal path. Furthermore it emphasises and explains its historical and geological context : the act of moving earth and digging channels is the origin of the surrounding Dutch landscape; its materials ,sand, earth and water are exposed to observation and become the centre of the perception.

This kind of sensibility for the landscape is shared by several young Sardinian artists, whose work emphasises its geological and topographic peculiarities, like in the work of Monica Solinas (Figure 2).

These approaches are important for us. Not for the formal aspect but because the form and disposition of these objects are the result of a careful observation of the surroundings and a comprehension of their dynamics and uses.

The work presented here pays attention to the various kind of gazes given on the landscape recently.

Although this starts from a real situation, it aims at specifying a method, a kind of process that underlines the centrality of the site in the development of the projects, emphasising the principles of coordination, cooperation and synergy better as those of zoning and subdivision.

The field of renewable energy must concern architects because it concerns their own themes : landscape transformation or conservation, land use, permanence or innovation,composition or installation (tracing paths, arrangement of pre-defined spatial structures, etc.)

2 THE PROJECT

2.1 A glance at the landscape

The landscape of Monte Arci presents certain peculiarities common to a large number of Sardinian landscapes.

Firstly, the dominance of the geological landmarks : they often have meaningful names, (like the "Trebine", a complex of three flat-topped rocks arranged like a tripod on the western side of the plateau) and are reference points for orientation and to establish administrative boundaries.

Then, the strong subdivision of the land in three well recognisable zones :
- the dense urban settlements showing a clear and compact structure ; this has been recently altered, but remains still clearly visible;
- the fields, marked by a close subdivision of private properties made of dry-stone walls and shrubs; in spite of the apparent weakness of the materials this subdivision has a strong character of permanence;
- the *saltus*, a wild open field historically dedicated to the gathering of firewood and other civic uses; the only important signs in this latter zone are the geological landmarks, the woods and occasionally the roads linking the settlements.

Figure 1. Robert Smithson, Broken Circle / Spiral Hill, Emmen, The Netherlands, summer 1971.

Figure 2. Monica Solinas, Dall'Azzurra Vetta dell'Olimpo, Ofelia. Mulineddu, Sardinia, 1997.

75

2.2 Features of the ENEL Project (as it stood in 1992)

The 12.4 MW power plant projected by ENEL locates 40 windmills in 180 ha. on the top of the plateau, respecting simple rules. The most important of these is that the 33m. windmills must stand at least at a distance of 210m. from each other. Their position is a compromise between wind-efficiency and respect for the preexisting goat tracks and a fire stop strip made by the rangers.

Other elements of the project are the four anemometers (40 m. high) and the control and visitor room. The control room will be used only in the first few years to monitor the functioning of the power plant.

The typical attitude of the engineering project to be self-referencial and to tend towards "inner" optimisation is clearly visible : it focuses only on its own rules, and can't recognise other rules and hierarchy within the surrounding landscape. Its need to minimise the visual impact is not an inner requirement, but an attempt to avoid ambientalist struggles and leads to a misinterpretation of the preexisting tracks .

I would suggest that the windmills for their huge dimensions and their capability to be seen from far will become in any case a peculiarity of this landscape as the rock faces are, thus cannot be bounded to random and weak tracks.

2.3 Features of the Local Region Project

This project covers a wider area than that of the power plant.

In order to give new value to the small urban settlements at the feet of the plateau, a number of facilities are proposed, spread across the countryside. Only simple briefs are specified, the location and the design of these facilities is left to the local administration.

The physical features of the plateau are the starting point of this proposal, but they soon disappear in bureaucratic complication.

Furthermore, the park proposal shows a conservative attitude which could be valuable for places of great natural beauty, but would not necessarily be extended to the entire plateau.

2.4 Assembling the functional briefs : locating the elements in space

Our project will not cover the whole extension of the park proposal, neither will it be limited to the power plant : the plateau with its natural features, functional briefs and the elements of the power plant and of the park proposal are the materials under discussion.

The most suitable position for the windmills is along the thresholds, tracing panoramic paths. The windmills will follow the boundaries of the plateau, underlining its huge dimensions. Some variations in their placement will mark exceptions such as gates, intersection with paths, etc..

The layout of the wind power plant follows these criteria :
- the disposition of the windmills follows the contour-lines and is generally related to the geological elements (rock-faces, thresholds...)
- the location and the design of the elements of the project result from the merging of the functional briefs of the power plant and of the park: all of them have a double function, operating to produce energy and to give the visitor a deeper knowledge of the structure of the plateau.

We drastically reduce the number of elements to be built, thus reducing erosion, waste of energy and money, and giving them a deeper significance.

The network of maintenance paths is at the same time a public network of paths, formed by three types that mark the boundaries between different zones of the park (better protected zones or less protected ones), providing beautiful sights of the valleys or of the other plateau, or to the sea, or simply showing the different strata by which the ground is composed, through the reshaped foundation pits.

The starting points of the nature paths are marked by anemometers 40 m high.

The control building becomes part of the "Museum of ethnography and land uses" proposed

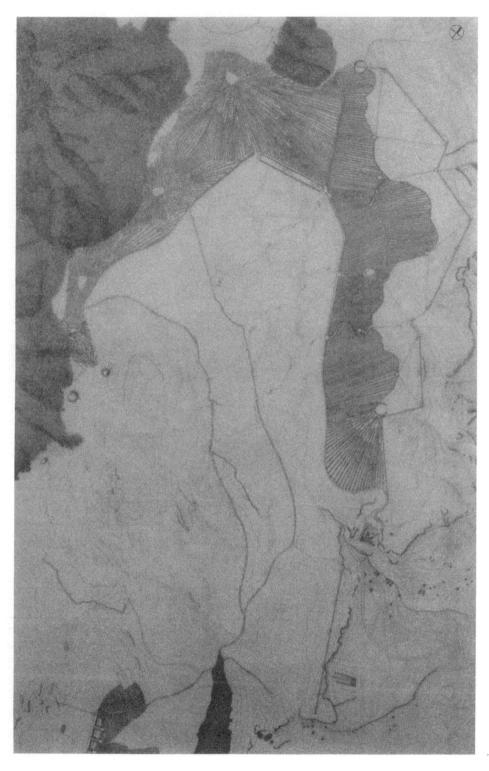

Figure 3. General site plan.

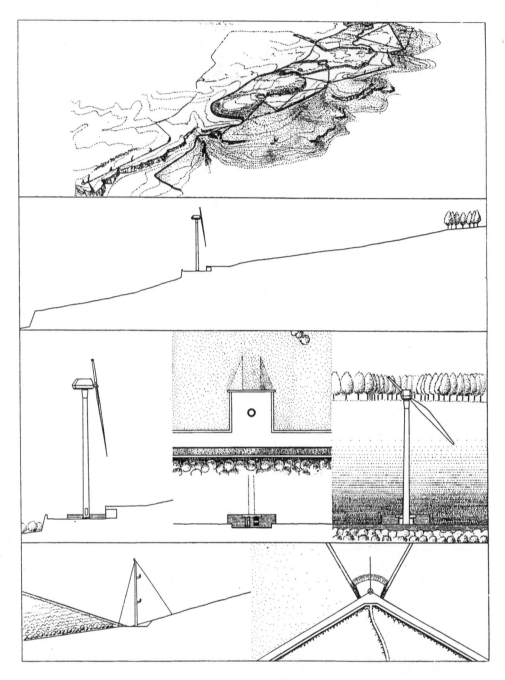

Figure 4. The eastern front. Perspective drawing, general section, plan, section and elevation of the foundation of the Medit windmill, details of the anemometer marking the entrance to the nature paths.

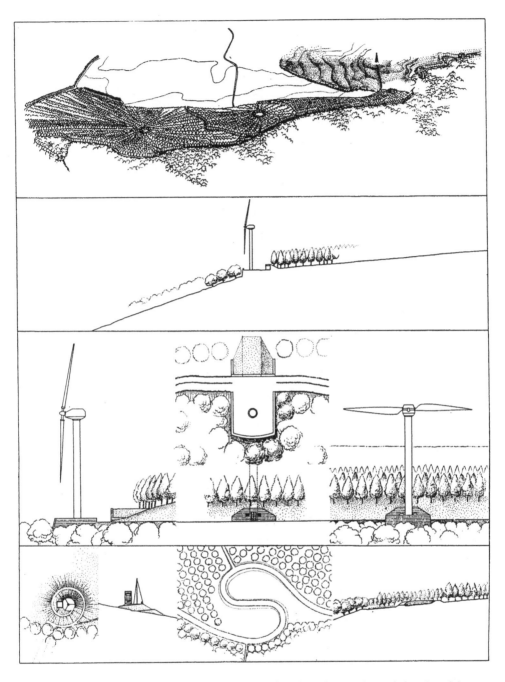

Figure 5. The western front. Perspective drawing, general section, plan, section and elevation of the foundation of the Medit windmill, details of the look-out tower and of the paths.

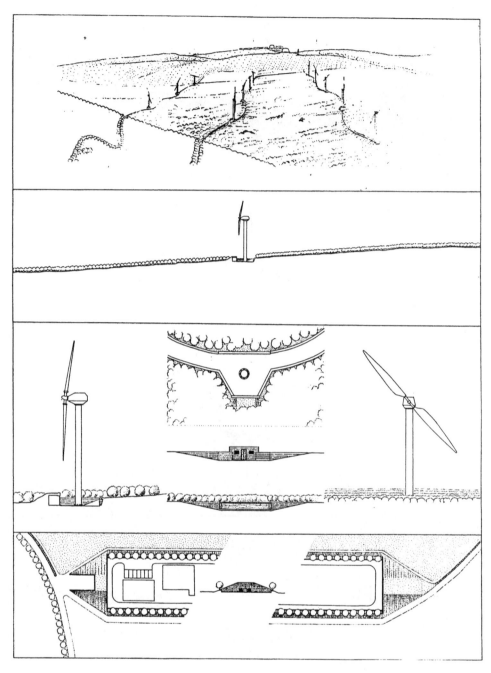

Figure 6. The middle of the plateau. Perspective drawing, general section, plan, section and elevation of the foundation of the Medit windmill, details of the rangers facilities.

among the park facilities.

All the buildings of the power plant, the basements of the windmills and the other park facilities are designed with great care, and illustrated with plans, sections and perspective drawings.

2.5 Assembling the functional briefs : arranging the elements after their duration

The different durations of the elements of the wind plant are reflected in the design.

The first class is constituted by the digs and the bases of the foundations, the buildings, that will leave long lasting scars on the surface of the plateau .

The second class involves the longer-lasting technological components, such as paths and cables, requiring less frequent maintenance.

The elements of the third class are the windmills, anemometers, control instruments, that have a technological life of about 25 years, and will be replaced and upgraded.

This leads to additional strata on the plateau.

The lower one is the "soil project" which assures a permanent relationship with the geology of the plateau and fixes some relevant points for the land-use such as boundaries, access etc. It houses the long-lasting elements, that is the foundations of the windmills, their transformers, and all the buildings and parking sites.

The middle stratum houses all the "connection devices" paths, cables, etc.

The most superficial stratum organises the elements with a shorter duration: windmills, anemometers.

Materials and shapes of the elements follow this order and thus a progression from the modelled, the raw, the weathered, the heavy, the "primitive" structure working with compression, (earth, trachyte stone, Cor-Ten steel) as in the roads and buildings in the first and second stratum, to the precisely arranged, the smooth, the clean, the light, the "modern" structure working with bending (white coloured steel).

2.6 The eastern front

The eastern side of the plateau faces the small town of Ales, and the villages of Pau and Villaverde (Figure 4).

This side is marked by rock-faces, up to 30 meters high, and the slopes are scattered with oxydian, a black volcanic glass, a very important material, which was widely used in producing cutting-tools in the prehistoric age.

The plan of the park considers these slopes to be of great natural value (and perhaps of archaeological interest) and should be protected.

Steep nature paths will climb from the valley to the top.

The power plant consists of four rows with four windmills each, placed on different levels above the rock-faces. They are bound by a path which provides beautiful sights and also maintenance access for the windmills. It crosses the contour lines with a easy slope and remains at the same level along the rows. The edge of this path to the valley is a stone wall, that allows no entrance into the protected area outside the nature paths.

Two anemometers mark the intersection of these paths to the long easy path. The first row on the rock face of Conca Mraxi, 60 m. high, acts as a sign for the park, and is clearly visible from the road leading from the motorway to Ales.

The transformers are located under a linear rampart that covers the foundation platforms too, emphasising on the ground, with its sharp and straight form, the alignment of the windmills.

The visitor will walk from rock-face to rock-face, helped by the anemometers to find his way down to the nature paths.

This side has an entrance to the park complex, the "Museum of ethnology and land use" sited in a little pass along the road from Ales to Monte Arci. The museum is both one of the facilities planned by the Local region and the control building of the power plant.

This allows the museum to show visitors the wind plant as part of the continuous use of the

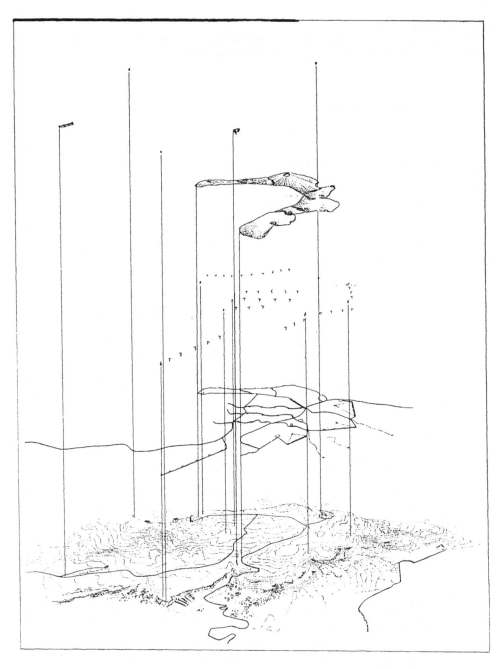

Figure 7. General axonometric : the buildings, the wood, the windmills, the network of paths and the nature paths, the plateau

"saltus" over the centuries. The control building could later become a part of the museum.

2.7 The western front

The western side of the plateau faces the sea. Its edge is a series of "C" shapes that slope gently downward to the hills. The prominent geological feature here is the complex of the "Trebine" (Figure 5).

The slopes are covered by a wood of *Quercus Ilex*, that begins immediately after the threshold.

The windmills follow the shape of the ridge , and are located on one contour line in each "C". Visitors are guided to walk on the same level, a "horizontal section" of the plateau, thus emphasising the presence of the straight line between sea and sky and the wavy geometry of the terrain.

The foundations are covered by stone-paved platforms with a stone parapet which allows maintenance and a panoramic view of the coast. The transformers are hidden in the slope, only a retaining stonewall with doors is visible to the public.

The path on the ridge ends with an anemometer.

A nature path starts from here and spirals down between the Trebine, stressing their circular disposition in the form of a tripod.

2.8 The middle of the plateau

Twelve windmills are located following three contour lines on the gentle slope to the south in the middle of the plateau (Figure 6).

Their maintenance paths link the eastern front to the western. They allow the visitor to wander freely across the plateau, not necessarily walking along its edges.

The regular disposition of the windmills along the contour lines and the perception of the distant windmills located on the western and eastern edges permits easy orientation and marks the huge dimension of the site.

While the paths along the fronts offer interesting views of the surrounding landscape, emphasising the relationship between them and the other landmarks, these paths give a detailed view of the superficial geological structure of Monte Arci.

The maintenance paths slope through the cut rock of the foundation pits, where the transformers are located.

Thus a progression from the dark stone strata and the oxydian pebbles of the east to the lighter basaltic strata of the west becomes visible.

3 CONCLUSIONS

Places suitable for the construction of wind power plants are often places of great natural beauty, whose development requires several fields of specialisation.

Such interventions in the countryside must be aware of technical evolution as well as to the recent ways of looking at the landscape introduced by other disciplines, such as art, landscape design, architecture, urban studies.

The design of such a great extension of land required for a wind power plant could try to merge different functional briefs, in order to obtain a complex object, an assemblage that responds with few elements to a greater number of needs : electric power production, orientation, landmark etc.

This object must be designed in order to ensure its different elements various duration in time.

In this case if the windmills are replaced with newer models, they will always occupy a clear location within the general structure; if the power plant is dismantled, the paths and boundaries will have a meaning within the general structure of the park.

4 REFERENCES

Angioni, G. & A. Sanna 1988. *Sardegna.* Roma-Bari: Laterza.

Banham, R. 1988. Tennessee Valley Authority : l' ingegneria dell' utopia. *Casabella* 542/3: 74-81.

Corboz, A. 1985. Il territorio come palinsesto. *Casabella* 516: 22-27.

Dematteis, G. 1985. *Le metafore della terra* . Milano: Feltrinelli.

Descombes, G. 1988. *Il territorio transitivo - Shifting sites.* Roma: Gangemi.

Gregotti, V. 1966. *Il territorio dell' architettura.* Milano, Feltrinelli.

Gregotti, V. 1987. Un terreno per l' ingegneria. *Casabella* 538: 2.

Gregotti, V. 1988. L' architettura della nuova ingegneria. *Casabella* 542/3: 2.

Gritti, J. 1981. Le paysage, un regard programmé. In J.-P. Pigeat (ed.), *Paysages : 44-53* Paris : Centre Georges Pompidou.

Hobbs, R. 1982. *Robert Smithson : a retrospective view.* Ithaca: Cornell University.

Maciocco, G. 1991. *La pianificazione ambientale del paesaggio.* Milano: Franco Angeli.

Mossa, V. 1957. *Architettura domestica in Sardegna..* Cagliari: Carlo Delfino Editore.

Krauss, R. 1986. *Richard Serra, sculpture.* New York: The Museum of Modern Art.

Secchi, B. 1987. Condizioni generali e progetti di ingegneria. *Casabella* 54: 14-15.

Wind Energy and Landscape, Ratto & Solari (eds) © 1998 Balkema, Rotterdam, ISBN 90 5410 913 0

Comparative study of visual impact on agricultural constructions and windfarms in Spain*

I.Cañas – *E.T.S. Ingenieros Agrónomos, Universidad Politécnica de Madrid, Spain*

C.Lago – *Instituto de Energías Renovables CIEMAT, Spain*

L.García & M.Ruiz – *E.T.S. Ingenieros Agrónomos, Universidad Politécnica de Madrid, Spain*

F.Maseda – *Escuela Politécnica Superior, Universidad de Santiago de Compostela, Spain*

ABSTRACT: The article studies the visual impact assessment of the wind turbines and their comparison with agricultural constructions. It seems that the agricultural constructions have few problems with the integration on the landscape. The visual impact assessment methodology has been widely used . The method is able to assess the landscape quality in a score range of 0-100 points, and the visual impact has a range between -20 (lost of landscape quality) to +20 (increase of landscape quality).

35 agricultural constructions have been chosen , which are representative sample of the main Spanish landscapes and agricultural constructions: food factories, stock farms, tanks and silos, irrigation farming elements, storage, villages, etc

We have analysed 17 Spanish windfarms using 35 selected photographs, which are located in the best windy areas of Spain. The wind turbines are distributed in a wide range from 150 to 600 kW of rated power.

1 INTRODUCTION

Among transformation landscape, farm buildings and the new installations as windfarms. have a special importance because the have to be located away from villages and their desing is conditioned by new materials, cheaper than others, but anaesthetic.

Really this is a problem because usually the new constructions are located in lanscapes that, sometimes, are good or very good, though there are some regulations, at different levels: national, regional or local. These are not capable of making complete regulations because there are a great variety of landforms, materials and typologies. So the only way is that all of those in the design process: the landowners, the developers, the local planning authorities, the designers and the communities in general have a standard method to estimate the visual impact of new constructions.

It is well-known that we are still in the early days of environmental study and more so in the research of landscape. But it is necessary to improve our knowledge. First we have to able to make assessment of landscape and secondly we have to able to assess the different factors that determine the correct integration of farm buildings and windfarms in landscape.

In rural ecosystems the harmony between development and landscape has been possible thanks to the slow transformation of these societies and the heavy weight of tradition. This internal cohesion is being broken down due to the technological advances which have created materials and typologies never seen before, new designs, a lack of sensibility and the growth of transport and communications have increased the pressure of this development. So it is necessary to protect our visual resources.

* *Financed study by Xunta de Galicia with the research project number XUGA 29102A94*

2 METHOD

In the method that we propose, has been determined that the factors that intervene to assess the landscape aesthetic. Has been gathered physical and aesthetic attributes.

The physical attributes are:

1.- Water: type, banks, movement and quantity.

2.- Land form: type.

3.- Vegetation: cover, diversity, quality and type.

4.- Snow: cover.

5.- Fauna: presence, interest and visibility.

6.- Uses of soil: type and population density.

7.- Views: range and type.

8.- Sounds: presence and type.

9.- Smells: presence and type.

10.- Cultural resources: presence, type, visibility and interest.

11.- Elements that alter the character: intrusion, fragmentation, break horizon line and view covering.

The aesthetic attributes are:

12.- Form: diversity, contrast and compatibility.

13.- Colour: diversity, contrast and compatibility.

14.- Texture: diversity, contrast and compatibility.

15.- Unit: structural lines and proportion.

16.- Expression: affectivity, stimulation and symbolism.

The value of one landscape depends on all of these attributes and it could be between 0 and 100, for this reason the sensibility of the method is very high. Besides, as the attributes are separated it is possible to know which are the factors that make high the quality of one image.

The cards are prepared to be filled easily and quickly. If the person wants to make it, it is also possible to complete the information with some comments or remarks that could help to understand the sensation of the viewers or others interesting notices.

The visual impact is known thank two values. One of them must be the landscape without the construction and the other one with it. The difference between these two numbers must give us the value of the visual impact. Sometimes this difference will be very great and could change the global classification of the landscape. The intervals of the global classification are:

< 20 points	Degraded
20 - 32 "	Poor
32 - 44 "	Mediocre
44 - 56 "	Good
56 - 68 "	Outstanding
68 - 80 "	Very good
> 80 "	Excellent

A description of the completed method appears in the monographs titled: "Introducción al paisaje" and "Valoración del paisaje", both of them have been written by Ignacio Cañas (1992).

3 RESULTS

3.1 *Windfarms studies*

The landscape valuation with windfarm or without windfarm are :

Table 1.- Total Resources with Windfarm or without Windfarm

WINDFARM	T.R. witn Windfarm	T.R. without Windfarm	IMPACT
Cabo Villano (2)	48,45	50,08	1,36
La Capelada (4)	56,09	56,77	0,63
El Perdón (8)	47,21	51,66	4,13
S. Martín UNX (9)	47,25	55,00	7,75
Aragón (14)	42,43	44,04	1,45
La Muela II (16)	50,00	51,50	1,50
Tarifa (19)	37,00	41,50	4,50
S.E.A. (21)	44,36	47,37	2,41
Kw Tarifa (23)	40,89	44,38	2,82
PEESA (24)	48,00	52,53	3,25
Granadilla (26)	42,51	47,79	5,25
Agaete (27)	38,00	44,75	6,75
Bco de Tirajana (30)	34,00	39,75	5,75
Juan Grande (31)	29,00	34,00	5,00
Cañada de la Barca (32)	32,98	33,20	0,25
Cañada del Río (33)	33,17	45,23	0,25
Los Valles (35)	65,00	66,25	1,25
AVERAGE	42,44	46,73	2,16

LANDSCAPE WITH WINDFARM DISTRIBUTION

LANDSCAPE WITHOUT WINDFARM DISTRIBUTION

AGRICULTURAL CONSTRUCTIONS DISTRIBUTION

The landscape evaluation with agricultural buildings or without agricultural buildings are :

Table 2.- Total Resources with Agricultural Buildings and without Agricultural Buildings

AGRICULTURAL CONSTUCTIONS	T.R. with A.C.	T.R. without A.C.	IMPACT A.C.
Food Factories	18.58	27.27	7.87
Stock farm	31.25	36.50	5.25
Tanks and silos	23.00	30.12	6.40
Irrigation farming elements	28.00	32.86	4.86
Storage	24.72	32.31	6.74
Villages	17.97	27.60	8.20
AVERAGE	23.45	30.95	6.44

Table 3.- Landscape valuations

LANDSCAPE VALUATION	t.r. without w.	t.r. with w.	Impact w.	t.r. wihtout a.c.	t.r. with a.c.	impact a.c.
Degraded				26,1505	16,4254	8,5531
Poor	31,2665	29,6519	1,66	32,1103	25,8452	6,0233
Mediocre	42,5933	37,9321	2,0743	41,2917	34,8765	6,3203
Good	52,1583	48,3258	2,9849	56,9994	50,3748	6,625
Outstanding	60,0628	61,1226	1,0573			
Very Good	68,5	69	0,5			

Landscapes valuations with windfarms or without windfarms , and with agricultural buildings or without agricultural buildings, are :

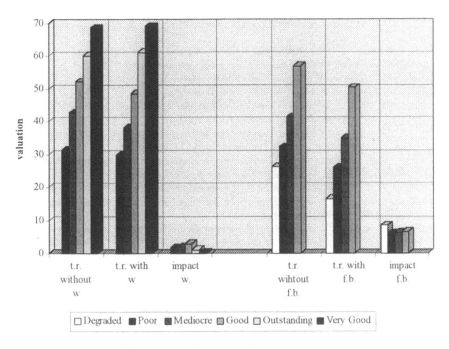

Graphic 1.- Landscapes comparisons

4 CONCLUSIONS

The conclusions could be divided in two parts. The first of them refers to the method:

1.- The method con seen be estimate public opinion.

2.- The time necessary to learn the method is not excessive.

3.- The results obtained by other trained people are very similar to ones obtained by the authors.

4.- It may be possible to estimate the visual impact of agricultural building on the landscape.

It is also possible to obtain conclusions of the application to the photographs with farm buildings and windfarms and of the analysis and studies made with them.

5.- The average of landscape valuation with agricultural construction is a poor landscape, and the average of landscape valuation with windfarm is a mediocre landscape. The landscape quality with windfarm is higher than the landscape quality with agricultural construction.

6.- The visual impact of Agricultural Construction is higher than the visual impact of Windfarms.

5 REFERENCES

Aspinwall and Company. 1994. *Nature conservation guidelines for renewable energy projects*. English Nature.

Brik Nielsens Tegnestue ; Landscape Architects M.A.A. 1996. *Wind Turbines & The Landscape. Architecture & Aesthetics*. Danish Energy Agency's Development Programme for Renewable Energy

Bosley, P. ; Bosley, K. 1990. "A multifaceted study : Environmental issues impacting on wind energy developments". *Proceedings of the European Community Wind Energy Conference*. Madrid, Spain, 10/14 September.

Cañas, I. 1992. *Integración de las construcciones agrarias en el paisaje : el color*. Doctoral thesis.

Cañas, I. 1993. "Estimación del impacto paisajístico de las carreteras". *Informes de la construcción*. Vol. 45 n° 425-426.

Cañas, I & Ayuga, F. 1995. "Agricultural Buildings and landscape. Color evaluation". *XII C.I.G.R. World Congress and AgEng'94*. Conference on Agricultural Engineering.

Cañas, I. 1995a. *Introducción al paisaje*. Lugo (Spain) : Unicopia ed.

Cañas, I. 1995b. V*aloración del paisaje* . Lugo (Spain) : Unicopia ed.

Cañas, I. et al. 1996. "Impacto producido por las construcciones agraarias sobre el paisaje : Una metodología para su estimación". *Informes de la construcción*. Vol.47 n° 441-442.

Cañas, I ; Fanjul, M. ; Ruiz, M. 1996. "Las vías forestales y el medio ambiente". *III International Congress of Engineering Projects*. Barcelona and Terrassa (Spain) 12/14 September.

Cañas, I ; Ayuga, F. ; Ortiz, J. 1996. "Visual impact assesment for farm buildings projects". *International Conference Agricultural Engineering*. Madrid (Spain) 23/26 September.

Hernández, M. 1995. *Valoración del paisaje y del Impacto Visual de las construcciones agrarias en el Páramo Leonés (Páramo Alto)*. Proyecto Fin de Carrera presentado en la Escuela Técnica Superior de Ingenieros de Montes. Madrid (Spain). No published

Hohmeyer, O. 1990. "Latest results of the international discussion on the social cost of energy- How does wind compare today ?". *Proceedings of the European Community Wind Energy Conference*. Madrid, Spain, 10/14 September.

Hovedrapport. 1996. *Vindmoller I Harmoni med Landskabet*. Logstor kommune. Moller & Gronborg AS.

IVAM. 1993. *Visual Impact of Wind turbines. A review of the know-how available in the European Community*. University of Amsterdam (Holland).

Lubbers, F. ; Pheifer, L. 1993. "Final results on the research programme concerning the social and environmental aspects related to the windfarm project of the dutch electricity generating board". *Proceedings of the European Community Wind Energy Conference*. Lübeck-travemünde, Germany, 8/12 March

Martin, H. 1990. "The contribution of the social sciences to wind power research environmental ideology and public perception". *Proceedings of the European Community Wind Energy Conference*. Madrid, Spain, 10/14 September.

Novoa, J. 1995. *Valoración del paisaje y del Impacto Visual de las construcciones agrarias en el Páramo Leonés (Páramo Bajo)*. Proyecto Fin de Carrera presentado en la Escuela Técnica Superior de Ingenieros de Montes. Madrid (Spain). No published

Otero, I. et al. 1996. "Valoración del paisaje y del impacto paisjaístico de las construcciones en el Páramo Leonés". *Mapping*. N° 30, pp 42-57.

Otero, I. et al. 1996. "Valoración del paisaje y del impacto paisjaístico de las construcciones en el Páramo Leonés". *Informes de la construcción*. Vol. 47 n° 441-442.

Trinick, M. 1993. "A comparative analysis of planning control and environmental assessment for wind farm development in The United Kingdom, Germany, Denmark and The Netherlands". *Proceedings of the European Community Wind Energy Conference*. Lübeck-travemünde, Germany, 8/12 March

Wolsink, M. 1990. "The siting problem : Wind power as a social dilema". *Proceedings of the European Community Wind Energy Conference*. Madrid, Spain, 10/14 September.

Wind Energy and Landscape, Ratto & Solari (eds) © 1998 Balkema, Rotterdam, ISBN 90 5410 913 0

Wind farm site selection in Sardinia considering environmental and landscape aspects

M. Berrini, V.Tiana & S.Woess-Gallasch
Istituto di Ricerche Ambiente Italia, Milano, Italy

A.Casciu
Area Progetti srl, Cagliari, Italy

ABSTRACT: In the framework of the EU JOULE/APAS project "EPURE" Ambiente Italia applied a methodology for the selection of wind farm sites in the region of Sardinia. It is a desk based macrositing approach with the aim to arrive at a first selection of sites. In a first step a GIS based information system has been established, which allows to exclude non suitable areas for wind installations for the whole territory of the main island of Sardinia and to define possibly economic sites. Also, environmental and landscape aspects have been considered, by excluding especially sensitive areas and by indicating areas of high environmental value. The energetic potential of the selected sites has been estimated and their economy has been evaluated by estimating the internal rate of return. The resulting sites are preliminary ones. In a next step outside of this project, the sites have to be analysed in detail by applying an on-site survey.

1. INTRODUCTION

The following contribution is based on a research experience, developed in the framework of a DGXII JOULE/APAS Project (Rialhe et al. 1996) entitled "Economic Potential of Renewable Energy" (= EPURE). The aim of the project has been - among others - to develop a methodology, at regional scale, in support of economic wind farm siting, taking also care of environmental and landscape aspects and planning constraints. The applied procedure is a desk-based one with the aim to arrive at a first estimation of the wind potential for the Region of Sardinia by applying a macrositing approach. The methodologic approach has been developed by Ecoserveis (Assimacoupolos, Corominas, Voivontas 1996) the Spanish partner of the EPURE project in cooperation with Ambiente Italia and the other partners. The project is also based on another previous study, carried out by Ambiente Italia in the framework of a DGXII Joule II project (Pagani et al.1995) titled "Sustainable, Alternative, Fluent Energy-based Mediterranean Economic Development" (= SAFEMED).

The selected case study concerns the Region of Sardinia. Sardinia is one of the Italian regions where information on the wind potential is available and where many of the first Italian wind turbines have been installed. In the "SAFEMED" study, a kind of energy plan for Sardinia with special regard to the development of renewables, a wind map has been elaborated which has then been used in the EPURE project.

For the estimation of the economic potential of wind energy in the region of Sardinia, the EPURE project covered the following working steps:
- the establishment of a GIS based information system for site selection,
- the selection of potentially economic sites
the application of a tool which allows to calculate the energy yield and to evaluate the economy of the selected sites.

FIGURE 1

EPURE PROJECT

Map 13 - Synthesis Map
Suitable Areas for Wind Installations in Sardinia
with Identification of Potentially Economic Sites
(Map 11 plus Map 12)

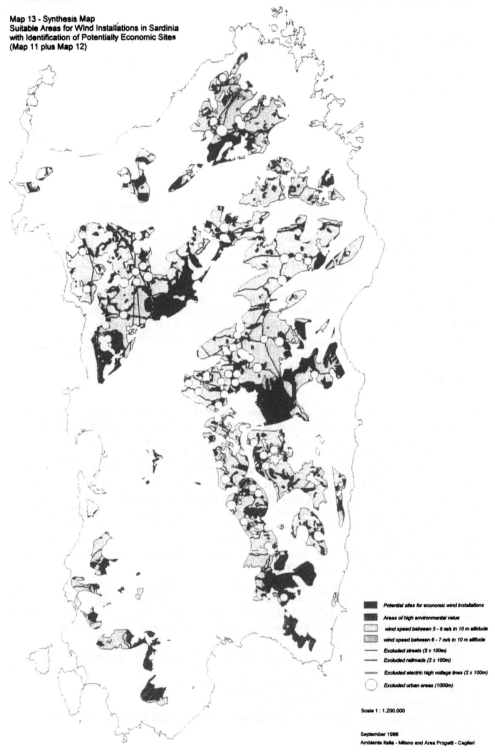

Potential sites for economic wind installations

Areas of high environmental value

wind speed between 5 - 6 m/s in 10 m altitude

wind speed between 6 - 7 m/s in 10 m altitude

Excluded streets (2 x 100m)

Excluded railroads (2 x 100m)

Excluded electric high voltage lines (2 x 100m)

Excluded urban areas (1000m)

Scale 1 : 1.200.000

September 1998
Ambiente Italia - Milano and Area Progetti - Cagliari

In accordance with the scope of this workshop the emphasis in the following contribution is on the first point. Concerning the second and third one some short information will be given.

2. ESTABLISHMENT OF A GEOGRAPHICAL INFORMATION SYSTEM

Starting with the wind map for Sardinia as already elaborated in the SAFEMED project, many other informations that are necessary for defining suitable areas for wind installations and for mitigating potential constraints have been collected and documented in form of the following specific maps:

- Map 1: wind resource map,
- Map 2: inhabited and urbanized centres and areas, touristic inhabited areas,
- Map 3: infrastructures (streets, railways, airports),
- Map 4: military areas,
- Map 5: forests,
- Map 6: different types of protected areas, not suitable for wind installations,
- Map 7: areas of high environmental value,
- Map 8 : areas with slopes higher than 70 %,
- Map 9: high tension electric grid (380, 220 and 150 kV lines),
- Map 10: altitude lines,
- Map 11: a synthesis map with exclusion of non suitable land uses,
- Map 12: map with identified sites for economic wind energy development,
- Map 13: a second synthesis map in which map 11 and map 12 are overlaid.

Maps 1 to 11 have been elaborated by the Sardinian partners of Ambiente Italia, the Area Progetti srl., in Autocad and have been transferred in MAP-INFO by Ambiente Italia. Map 12 and 13 have been realised directly in MAP-INFO by Ambiente Italia.

Map 1, the map containing the wind resources, is a result of the SAFEMED project (Pagani et al. 1995), elaborated by Area Progetti srl. The information on wind resources which has been put together in that map derives from the following different sources:

- ENEL, the Italian energy board (measurement campains and elaboration of a wind map);
- Airforce Meteorological Department,
- Institute of Atmospheric Physics in Rome,
- Cesen Study (elaboration of a map for Sardinia based on European Wind Atlas)
- Cagliary Universitiy, Institute of Atmospheric Physics (28 measure stations, elaboration of a wind map).

The wind map indicates areas with wind resources between 5 and 6 m/s and between 6 and 7 m/s in 10 meters altitude. Costal wind resources are no more documented in this map. They have been already excluded in the prepared wind map of the SAFEMED project because of strict environmental protection. The whole coast area of Sardinia is protected and enters in the area of type1 of the regional landscape plans (more details see below under map 6).

Map 2 points out inhabited areas, urbanized centres and touristic centers, which have been excluded in the synthesis map 11, respecting a distance of 1000 meters for mitigating possible noise intrusions. It comprises also the borders of the communities and of the provinces.

Map 3 documents different infrastructures such as streets (highways, national streets), railways and airports. These infrastructures have also been excluded in the synthesis map11. The safety distances taken into consideration are 100 m for streets and railways and 2500 meters for airports. Traffic infrastructures give also important information on site access of potential wind farm sites.

In map 4 military areas are documented and have been excluded in synthesis map 11. Map 5 shows the forests in Sardinia; they have been totally excluded in synthesis map 11. Map 6 documents 2 different types of areas non suitable for wind installations:

- areas of type 1 as documented in the regional landscape plans;

- protected areas (areas of type H) based on Decree no. 2266/1983.

The regional landscape plans (based on national laws no. 1497/1939 and no. 431/1985 and on regional law no. 45/1989 and approved by the regional Decrees no. 266-279/1993) indicate three different kind of areas, for which different levels of environmental protection are defined. Areas of type 1 have the highest level of environmental protection and the installation of a wind farm in such an area is not recommended. Areas of type 2 are less sensitive and more interventions are allowed, criterias to be respected and limits are defined. Areas of type 3 include declined areas, which have to be restored and recovered.

In areas of type 1 the integrated conservation of their natural, archeological, historical and geomorphological elements has to be secured. The alteration or modification of these elements and their sites should be prevented. Accepted interventions are their conservation, protection and restoration and the construction of light infrastructures for didactic, recreative and scientific activities (e.g. paths, observation huts). A special position have public infrastructures, which are not entirely excluded, but need a special authorisation (based on national law 1497/1939). As renewable energy plants, to which belong wind farms, are established by national law no. 10/91 as of "public interest and usefulness", the construction of wind installations in areas of type 1 is not definitively prohibited. Nevertheless we have decided to consider these areas for a integrated conservation as not suitable for wind installations and therefore these areas have been excluded in the synthesis map. Areas of type 1 are including e.g. the most protected parts of regional parks and reserves and sites of international importance (e.g. birdlife sanctuaries based on the Ramsar Convention) and of special protection, but also archeological sites of high importance.

The protected areas based on Decree no. 2266/1983 (areas of type H), which include also archeological areas, have not been excluded, because of their large variation of more and less important sites, the variation of their dimension and because of their large number. We have underlined the need of a more detailed investigation on them in a following step. Nevertheless, the selected potentially economic sites for wind installations, which have been later identified, (see point 3), do not coincide with these areas.

Map 7 includes two different kinds of areas of high environmental value:
- areas of highest landscape and geomorphologic interest as documented in a map on geomorphologic elements for Sardinia, which has been elaborated by the "Progemisa Spa" on behalf of the Region of Sardinia, and
- proposed new natural parks and reserves, as identified by regional law no. 31/89.

The geomorphologic map of Progemisa subdivides the whole Sardinian territory in four different interest classes concerning landscape and geomorphologic elements. In map 7 the first class of highest environmental interest has been included. Only in case that these areas coincide with areas of type 1 as defined in the regional landscape plans (see under map 6), they have been excluded in the synthesis map no. 11. Both types of areas are documented in the synthesis map as areas of high environmental value.

In map 8 areas with slopes higher than 70 % are indicated. They do usually not coincide with areas of wind class 1 and 2. Otherwise they would have been excluded.

Map 9 documents the high tension electric grid (380, 220 and 150 kV). The grids have been excluded in synthesis map 11 considering a safety distance of 100 m. The 150 kV line gives also important information on possibilities for grid connection of potential wind farm sites.

Map 10 shows altitude lines and gives information on the orographic situation. As Sardinian mountains are mainly characterised by gentle geomorphologic forms (besides the coast, which is already totally excluded for wind installations), mountain tops and ridges have not been excluded in synthesis map 11.

In map 11, the synthesis map, all non suitable areas for wind installations documented in maps 2 to map 9 have been, as mentioned above, excluded (e.g. inhabited areas, certain infrastructures, military areas, forests, protected areas of type 1, etc). Map 11 documents the areas which can be considered to be principally suitable for wind installations, but still without taking care of some important economic factors (see figure 1). The remaining areas are classified
- as of high environmental value and other areas
- and in areas with a main annual wind speed between 5 - >6 m/s and between 6-7m/s.

94

The areas of high environmental value (based on map 7) do not exclude the installation of wind farms. But when realising a project in such an area, it is necessary to study more in detail how and if it is convenient to integrate a wind farm. The planning process and the permission procedures can be expected to be more time and money consuming: more agreements and mitigation measures may be asked by the involved authorities.

3. SELECTION OF POTENTIALLY ECONOMIC SITES

In map 12, potential sites for an economic wind energy development have been identified on basis of the established GIS. The scope of this step is to define potentially economic sites, which have access to necessary infrastructures, such as roads and electric grid. The following conditions have been respected during that process, which are different for areas of wind class 1 and 2:

- All selected sites in areas of wind class 1 have been located closely to a 150 kV line or to a village (where an electric line can be expected) and in vicinity to a road; maximal distances are 1-2 km to a road and 1km to an electric line (higher distances to grid and roads increase investment costs essentially). All selected sites in areas of wind class 1 are not sited in an area of high environmental value, because economy of these sites can be expected to be already quite limited and higher planning costs can be crucial in that case.

- In areas of wind class 2 a higher rate of electricity production and, consequently of income allows to sites longer distances to grids and roads and higher planning costs. Areas of wind class 2 in map 11 are generally located in Sardinia only in higher regions of the mountains and are usually very isolated, far away from roads, villages and grids. So in areas of wind class 2 only five sites have been identified with acceptable distances to an access. Nearly all of these sites are located inside of areas of high environmental interest.

Altogether 92 sites have been identified, of which 87 are located in areas of wind class 1 and 5 in areas of wind class 2. All sites together include an area of 247 km2. In map 13 the potential sites have been overlaid with synthesis map 11 (see figure 1).

4. ESTIMATION OF THE ENERGY YIELD

The estimation of the energy yield is based on the tool prepared by Ecoserveis, the Spanish partner of the EPURE project. The following assumptions for the calculation of the energy yield have been considered:

- the mean annual wind speed in 10 m altitude is 5,5 m/s for sites of wind class 1 and 6,5 m/s for sites of wind class 2;

- the considered wind turbine is a modern 250 kW one, available on market (rated power: 250 kW, rotor diameter: 29,7 m, hub height: 31,5 m);

- in dependance of specific site conditions, it was possible to choose between 4 types of wind turbine configurations (a reticular with equal distances of 10 rotor diameters, a reticular with equal distances of 8 rotor diameters, one row of wind turbines, two wind turbune rows);

- a mean annual disponibility of the wind turbines of 90 % has been fixed.

The identified 92 potential sites include an area of 247 km2, on which approximately 794 MW can be installed.The total annual electric energy yield of all 92 sites has been estimated to be 1.746 GWh. The currently installed electric capacity (1995) in Sardinia is 2.761 MW, total electricity production was 8.982 GWh and the consumption 9.702 GWh. So, in case of a realisation of the identified wind potential, nearly 20 % of the current electricity production could be substituted.

An estimation of total avoided annual air emissions by realising the whole identified wind potential shows, that yearly

- 6.575 tons of SO2,

- 2.649 tons of NOx,
- 26 tons of PST and
- 1.005.467 tons of CO2

can be avoided. The estimation is based on specific air emissions for 1 kWh electric energy of the Italian public grid (produced by the mix of ENEL's power plant park in 1994) and of 1kWh electric energy produced by a typical wind farm (see Tab. 1). These values have been calculated by Ambiente Italia within the framework of the SAFEMED Project (Pagani et al. 1995) on basis of a Life-Cycle Analysis.

Tab.1: Estimation of yearly avoided air emissions by substituting 1.746 GWh of electric energy from public grid by electric energy produced by wind farms in Sardinia.

	SO2 t/year	NOx t/year	PST t/year	CO2 t/year
Mix-el-Italy 94	6645	2783	73	1049798
Wind Farms (1.746 GWh/year)	70	134	47	44331
annual avoided emissions	6575	2649	26	1005467

5. ECONOMIC ANALYSIS

The economic analysis of the identified potential sites has been elaborated on basis of an economic analysis tool prepared by Ecoserveis (Barcelona, Spain) and ITC (Rugby, UK) in the EPURE project (Rialhe et al. 1996) . It has been adapted for the Italian situation by Ambiente Italia. Thus the Italian tariff system, the CIP Directive no. 6/1992 has been considered for the calculation of the income (tariffs of 1995). No investment subsidy has been considered. As economic measure the Internal Rate of Return (IRR) has been calculated for each site.

The economic analysis shows for the different sites IRR values between 6 % and 14 %. The IRR values of the 87 sites in wind class 1 range between 5 % and 10%. Thus for some sites economy is limited. Only 4 sites have an IRR value of approximately 10 %, 33 sites have an IRR value of approximately 8 % or higher and 86 sites show an IRR value of approximately 6% or higher.

The IRR values of sites with wind class 2 are ranging between 12 % and 14 %. The economic situation of these sites is with IRR values significantly over the 10 % is very positive, but only 5 sites have been identified.

Economy is on one hand depending on existing wind potentials, technology, access conditions etc., but on the other hand on the specific economic conditions such as cost parameters, tariffs and subsidies, which vary from country to country. In Italy the economic conditions are currently not very favourable for renewables. Subsidies are very limited. The only secure element was the tariff for electric energy produced by renewables, as fixed in the CIP Directive No.6/1992, which guaranteed for the first eight years a premium price based on the concept of "avoided costs". Unfortunately also this tariff has been meanwile abandoned for new renewable projects and thus also for new wind projects.

SUMMARY AND CONCLUSIONS

The established GIS information system for Sardinia allows to arrive to wind areas suitable for the installallation of wind farms. Many of possible negative impacts of wind farms on other land uses have been mitigated by excluding certain areas and infrastructures and by respecting certain security distances and buffer zones. Also most sensitive natural and cultural areas and landscape

elements - as defined in the regional landscape plans - have been excluded and areas of high environmental value have been indicated in the synthesis map.

The resulting sites are preliminary ones, based on a desk based macrositing approach. Next step outside of this study should be an on-site survey, which allows to evaluate in detail which and how the preselected sites can be best used for energy production by respecting planning constraints and mitigating impacts as far as possible. Also a wind measurement campaign with special regard to the preselected sites could be very useful to receive more detailed information on the wind resources.

REFERENCES

Pagani R. et al. 1995. *Sustainable, Alternative, Fluent Energy-based Mediterranean Economic Development (SAFEMED)*. 3 Vol. EU-Joule II Project (internal report). Milan: Istituto di Ricerche Ambiente Italia.

Rialhe A. et a. 1996. *Economic Potential of Renewable Energy (EPURE)*. EU-APAS Project (internal report). Paris: INESTENE.

Assimacopoulos D., Corominas J., Voivontas D. 1996. A GIS decision support system for the evaluation of renewable energy potential: a wind energy potential case study. In *WIP Renewable Energy Databases: Exploiting their Full Potential. Proc. of the First European Workshop, Harvell, 4-5 Nov. 1996: 112-117*. Munich.

Wind Energy and Landscape, Ratto & Solari (eds) © 1998 Balkema, Rotterdam, ISBN 90 5410 913 0

Nocturnal collision risks of birds with wind turbines in tidal and semi-offshore areas

S. Dirksen & J. van der Winden
Bureau Waardenburg bv, Culemborg, Netherlands

A. L. Spaans
Institute for Forestry and Nature Research (IBN-DLO), Wageningen, Netherlands

ABSTRACT: The risk of birds colliding with wind turbines is known to be highest during dark nights. We studied the flight patterns and altitudes of waders and diving-ducks in tidal and semi-offshore areas, using radar. The birds flew mainly at present-day wind turbine heights (<100 m), both during the day and during darkness. During darkness, waders roosting inland did so more often in or close to shallow water and less in fields away from water than during the day. Observations of wintering diving-ducks near a line of turbines suggest that the collision risk for this species group is probably low. During moonless nights, fewer birds approached the wind farm than during moonlit nights. Of those which approached the turbines, fewer birds passed in between the turbines and more birds turned away from them than during moonlit nights. This data indicates that turbine lines may act as flight path barriers. This should be taken into account in the planning of wind farms.

1 INTRODUCTION

Many birds migrate annually, often covering long distances between their breeding areas and wintering sites and back. In addition, birds show daily feeding, drinking and roosting flights over relatively short distances. In both cases, the birds may collide with wind turbines when crossing wind farms. In general, collision risks are highest at night, in particular when the nights are dark and the weather circumstances are bad (Winkelman 1992a, 1992b). In areas with a high bird density, the collision problem often leads to a controversy between bird protectionists and planners of wind farms, resulting in a delay or cancellation of wind farm planning programmes.

In terrestrial habitats, the collision risk is rather low (*e.g.* Winkelman 1992a), mainly because birds change their flight path in time or escape from collision by turning away just before the turbines (Winkelman 1992b, 1992c). Whether this also holds in tidal, and (semi-)offshore areas, habitats which are very attractive for planning wind farms, is not well known. This paper deals with four studies aimed at filling some of the gaps in our knowledge. Firstly, we studied spring migration of waders passing the Dutch coast with head winds en route to their northern breeding areas. Secondly, we studied flight patterns and altitudes of waders in a tidal area and of diving-ducks in a semi-offshore situation. Thirdly, we investigated the flight behaviour of diving-ducks approaching a semi-offshore wind farm. The studies on flight patterns and altitudes of waders and diving-ducks are part of a national programme on the impact of wind farms on bird life launched by the Netherlands Agency for Energy and the Environment (Novem) in 1994. The studies on spring migration of waders and the flight behaviour of diving-ducks were conducted for the Dutch electricity company Energie Noord West (ENW).

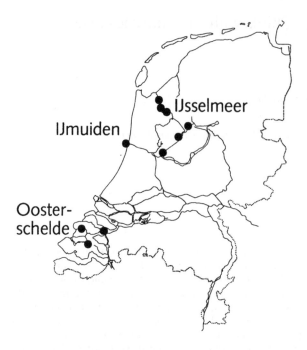

Figure 1. Map of The Netherlands, indicating the three study areas and the locations of the radar observations (dots).

2 STUDY AREAS AND METHODS

We studied spring migration of waders passing the Dutch coast at the IJmuiden northern breakwater during April and May 1995 (Figure 1). We selected observation days with head winds in which birds fly within short distances from the coast and at a low altitude during daytime. We investigated local movements of waders to inland roosts bordering the Oosterschelde estuary between the winters of 1994/1995 and 1996/1997, and those of diving-ducks in Lake IJsselmeer during February-March 1995 (Figure 1). The IJsselmeer study was followed by a case-study on nocturnal flight behaviour near a line of four middle-sized (500 kW) wind turbines situated in between inshore resting areas and offshore feeding sites of diving-ducks in Lake IJsselmeer during the winter of 1995/1996 (Figure 1). The Oosterschelde estuary forms an important staging area for passing and wintering waders (*e.g.* Leewis *et al.* 1984, Schekkerman *et al.* 1994, Meininger *et al.* 1995). Lake IJsselmeer is well known for its large numbers of diving-ducks (*e.g.* Slager 1987, De Leeuw 1997). During darkness, radar observations were combined with the registration of calling birds and visual observations. We used two types of ship radar, a Furuno FR 8050 radar for the observations of flight paths and a modified Furuno FR 8250 for measuring flight altitudes (*cf.* Cooper *et al.* 1991, Dirksen *et al.* 1996a). Observations were made during both moonlit and moonless nights. At IJmuiden, radar observations were conducted during the entire period of darkness. In the Oosterschelde and IJsselmeer areas, the observation periods covered the entire period during darkness in which birds passed between feeding and resting areas.

For further methodological information we refer to the original reports and papers from these projects: Spaans *et al.* (1995), Dirksen *et al.* (1995, 1996a, 1996b), Van der Winden *et al.* (1996).

3 RESULTS

3.1 *Spring migration of waders*

Before dusk, waders passed the IJmuiden breakwater at relatively short distances from the seashore on all three observation dates, albeit in varying numbers. On 27 April, only Bar-tailed Godwits and a few Knots passed, on 6 and 11 May the species composition was more diverse (mainly Oystercatchers, Grey Plovers, Knots and Bar-tailed Godwits). Most birds passed at altitudes below 30 m (visually estimated).

Based on the observations of calling birds, the birds continued their northward migration during darkness on all three dates. On 27/28 April, calling birds were heard 23 times ($N = 7.5$ hrs), on 6/7 May 45 times ($N = 6.7$ hrs) and on 11/12 May 25 times ($N = 6.7$ hrs). On 27/28 April, Bar-tailed Godwits predominated (18 of 23 calls), on 6/7 and 11/12 May Grey Plovers (15 of 70 calls), Oystercatchers (27 calls) and Dunlins (10 calls) did so. So, the species composition during the night was comparable to that during the previous day in both months. Calling birds were heard throughout the night.

The radar observations revealed that birds passed the breakwater up to 2200 m from the shoreline (2000 m from the radar). However, most flocks passed within the first 700 m from the shoreline. The number of flocks decreased with the distance from the shoreline (Figure 2). Most bird echoes could not be identified to the species level. Those that could included both passing waders and roaming Herring and Lesser Black-backed Gulls from neighbouring breeding colonies. No birds were detected at heights above 105-135 m (waders up to 90 m, gulls up to 50 m). Most birds were observed below 50 m (Figure 2).

3.2 *Local movements of waders and diving-ducks between feeding and roosting areas*

Preliminary observations identified ten inland areas bordering the Oosterschelde estuary as preferred roosting sites for waders. Between November 1994 and April 1995, 1-4 observations were made at each site during spring tides, both during daytime and during the preceding or following night. Roosting sites situated in or close to shallow water bodies were used in all 14 cases at nocturnal high tide. This occurred several times in higher numbers than at high tide during the day. For roosts situated away from water this occurred only once per six cases (Fisher exact probability test, $P < 0.001$). In that case, the number of birds were much smaller than at high tide during the preceding day. This data clearly indicates that waders prefer sites in or close to shallow water bodies when roosting inland during darkness. This may lead to a different distribution of roosting waders during daytime and darkness. At night, birds flew from the flats to the roosts in the same periods relative to the tidal cycle as during the day.

Visual and radar observations on flight altitude were made at four of the ten sites (Figure 1). During the day, most birds passed the dikes between the estuary and the inland roosts below 75 m (visual estimates). Some flocks flying to roosts much further inland passed at altitudes well above 100 m. During darkness, almost all birds flew to and from roosts at altitudes below 100 m (Figure 3). Oystercatchers appear to fly, on average, at lower altitudes than the other species (mainly Grey Plovers, Dunlins, Bar-tailed Godwits and Curlews).

Diving-ducks were present in thousands to tens of thousands at all six study sites (Figure 1). In the northern part of the lake, Scaups predominated at two of the three sites (>99% of all diving-ducks), while Tufted Ducks comprised 90-95% of all diving-ducks present at the other localities. Other species regularly seen included Pochard (up to 5% at any site), Goldeneye and mergansers (one site only). The birds roosted either under the lee of dikes or in sheltered waters bordering the lake and fed on zebra mussels (Scaup, Tufted Duck, Pochard, Goldeneye) and fish (mergansers) in the open water up to 10-15 km from the dikes bordering the lake. Mergansers and Goldeneyes fed during the day and roosted during the night. Tufted Ducks, Pochards and Scaups showed a reverse rhythm.

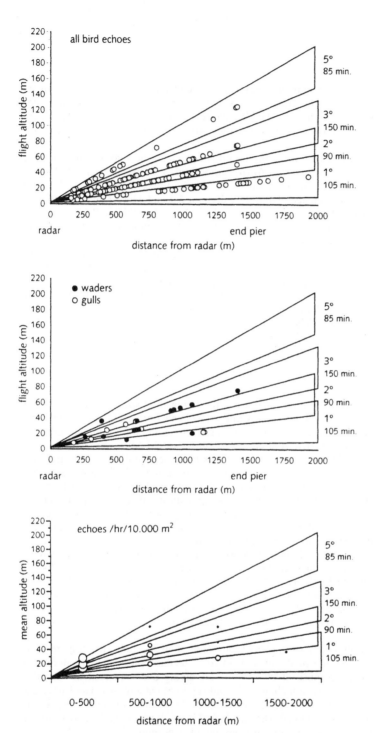

Figure 2. Results of radar measurements at IJmuiden on one of the observation dates (6/7 May 1995, 22.17-05.00 hr). Above: all echoes; middle: echoes of waders and gulls; below: echo density for each distance class (size of circles indicates number of echoes). Radar angles to horizontal plane and the length of the observation periods for each angle of the radar beam are given at the right. Echoes are plotted on the central line of the radar beam; the diameter of the beam shows the range of altitudes measured.

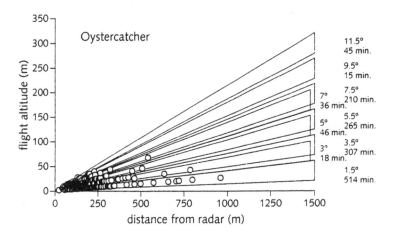

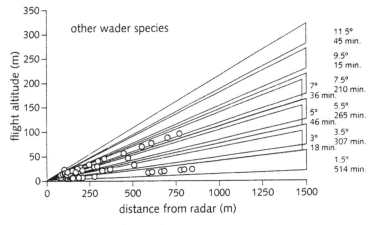

Figure 3. Results of radar measurements at one of the observation sites at the border of the Oosterschelde estuary (spring 1996, autumn/winter 1996/97, all data combined). Above: Oystercatcher; below: all other wader species. Radar angles to horizontal plane and the length of the observation periods for each angle of the radar beam are given at the right (for further explanation see Figure 2).

Goldeneyes and mergansers flew mainly during daylight, Scaups predominately during dusk and dawn (Figure 4), Tufted Ducks and Pochards mainly during darkness (Figure 5). At two localities, we also observed birds passing the radar beam between the evening and morning peaks. At one of these sites, some of the movements originated from roaming gulls. At the other site, however, some echoes may have originated from diving-ducks wandering at the feeding grounds. Therefore the radar observations indicate that birds may fly above Lake IJsselmeer during the entire period of darkness.

Flight altitudes were variable, but all species flew to and from the feeding areas at altitudes below 100 m (Scaups: Figure 4, Tufted Ducks and Pochards: Figure 5). Scaups passed mainly below 50 m, Tufted Ducks and Pochards mainly below 75 m, Goldeneyes and mergansers below 30 m. During darkness, Scaups flew at higher altitudes than during daylight (up to 75 m and 50 m, respectively). When crossing dikes, most Tufted Ducks and Pochards flew at altitudes below 75 m compared with altitudes below 50 m when crossing open water.

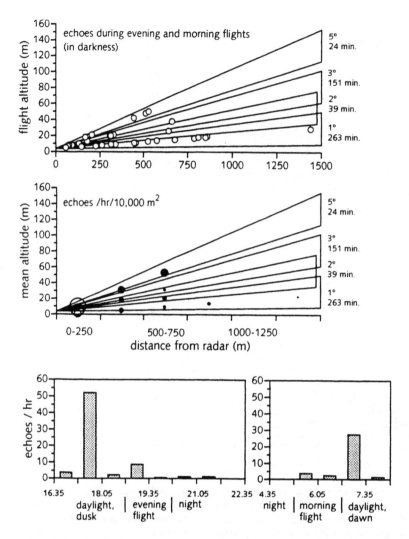

Figure 4. Results of radar measurements for Scaups at one of the observation sites in the IJsselmeer area (23-26 February 1995). Above: all echoes during darkness (left) and during daylight, dusk and dawn (right); middle: as above but for echo density per distance class of 250 metres; below: distribution of flight activities over total observation period (echoes during night include also unknown species). Radar angles to horizontal plane and the length of the observation periods for each angle of the radar beam are given at the right (for further explanation see Figure 2).

3.3 Nocturnal flight patterns of diving-ducks near a semi-offshore wind farm in Lake IJsselmeer

In November 1995, 400-600 Tufted Ducks and Pochards roosted along the dike opposite the wind farm during the day at distances of 500-1500 m from the turbines. In March 1996, there were 600-800 birds present. The ducks were equally distributed along the dike, suggesting that the wind farm did not disturb the ducks at these distances. This result corresponds with the findings of Winkelman (1992d), who found a disturbance distance of up to 150 m for diving-ducks in Lake IJsselmeer. Birds mainly flew to the feeding grounds after dusk and returned to the roosts just before dawn. So, most flight movements occurred during darkness, just as in a situation without turbines (cf. 3.2).

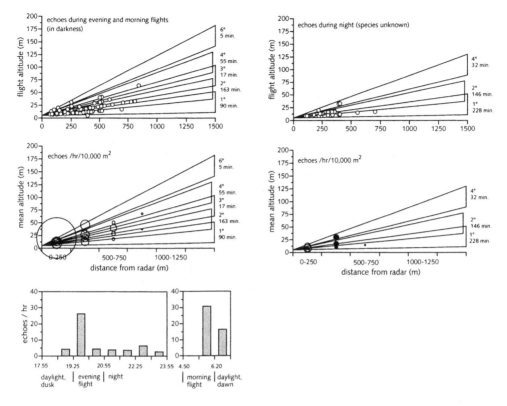

Figure 5. Results of radar measurements for Tufted Ducks and Pochards at one of the observation sites in the IJsselmeer area (10-13 March 1995). Above: all echoes during the first and last one and a half hours of the night (left) and during the rest of the night (right); middle: as above but for echo density per distance class of 500 metres; below: distribution of flight activities over total observation period (echoes during rest of the night include also unknown species). Radar angles to horizontal plane and the length of the observation periods for each angle of the radar beam are given at the right (for further explanation see Figure 2).

During moonlit nights, we recorded twice as many echoes in the turbine sector as in the equally-sized control sector (202 against 114). The reverse was seen during moonless nights (turbine sector 40 echoes, control sector 81 echoes). In both types of night, the main flights were perpendicular to the dike (moonlit nights 84% perpendicular to the dike, 16% parallel to the dike; moonless nights 69% and 31%, respectively). In the control sector, the proportion of flights perpendicular to the dike did not differ between moonlit and moonless nights (81% and 73%, respectively, χ^2 test, n.s.). In the turbine sector, however, the proportion of flights perpendicular to the coast differed signficantly in relation to the phase of the moon (moonlit nights 87%, moonless nights 60%, χ^2 test, $P < 0.001$).

The birds passed the line of wind turbines in various ways (Figure 6). Most birds passed it on the outer side, both during moonlit (82%, $N = 103$) and moonless nights (73%, $N = 11$). During moonless nights, only 9% of the birds crossed the line by passing between the turbines (against 18% in moonlit nights), whilst 18% turned away from the turbines (against 0% in moonlit nights). The differences in flight distribution between moonless and moonlit nights are statistically significant (Kruskal-Wallis test, $P < 0.001$).

105

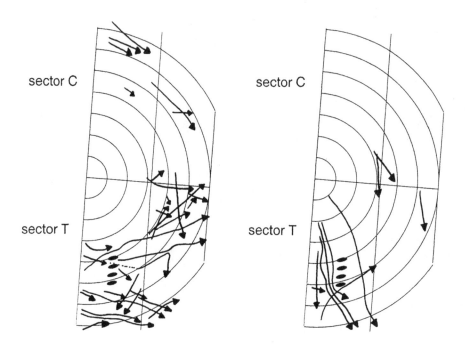

Figure 6. Examples of flight paths of Tufted Ducks and Pochards near a line of four wind turbines (ovals) in a semi-offshore situation. Left: moonlit night (29 March 1996), right: moonless night (23 November 1995).

4 DISCUSSION

The results of our study may provide some tools for planners of wind farms in tidal and semi-offshore areas. Firstly, our results show that waders feeding in tidal areas do not always use the same inland high tide roosts during darkness and during the day. During darkness, they prefer to roost in or close to shallow water. Roosts situated on farmland away from water are regularly used during the day but seldom at night. This means that during the day and during darkness waders may use different flight paths when moving between tidal flats and inland roosts. When planning wind turbines near tidal areas the nocturnal situation should therefore be taken into account before actual locations for turbines are assigned.

Our results further show that daily movements of waders in tidal areas and of diving-ducks in semi-offshore areas are in general below a height of 100 m, both during the day and at night. The same results were found for other species groups in land situations by Winkelman (1992b, 1992c). We therefore believe that local movements of birds are predominately at present-day wind turbine heights, irrespective of species and landscape. In contrast, the flight altitude of birds during seasonal migration may vary between one metre and several kilometres. On average, nocturnal migrants fly higher than diurnal migrants, and are therefore assumed to have a lower risk of colliding with wind turbines than birds flying during darkness between feeding and roosting areas. The IJmuiden study, however, shows that waders passing the Dutch coast during spring migration with head winds continue their migration at low altitudes during the late evening and at night. In spring 1997, during an ongoing study along the Afsluitdijk between the provinces of Noord-Holland and Friesland, we observed comparable behaviour by waders, gulls and thrushes on migration. Buurma & Van Gasteren (1989) came to the same conclusion for nocturnal autumn migrants of various species tracked by radar at night at Hook of Holland. These observations indicate that in semi-offshore situations the seasonal migration of birds at night may also take place at wind turbine height.

Our observations on flight altitudes suggest that local waders and diving-ducks may run the risk of colliding with wind turbines during darknessin tidal and semi-offshore areas. This also

holds for nocturnal migrants in semi-offshore areas when large numbers of birds pass the coast. Our observations on the nocturnal movements of Tufted Ducks and Pochards near a semi-offshore line of four wind turbines perpendicular to the roosting and feeding flights of the birds suggest, however, that diving-ducks either see or are otherwise aware of the turbines. During moonlit nights, for example, ducks approaching the line of turbines crossed the line by passing between the turbines. During moonless nights, the birds appeared to avoid the turbine area by flying more parallel to the line of turbines. Of those which approached the turbines, a larger proportion turned away from the turbines at short distances during moonless nights. This data suggests that local wintering diving-ducks can cope rather well with wind turbines in semi-offshore situations, leading to a lower collision risk than expected when no evasive behaviour was shown. Winkelman (1992b, 1992c) came to the same conclusion for land birds in a terrestrial situation. It is possible that habituation plays an important role in local wintering birds. Whether migrants passing a wind farm react in the same way remains therefore uncertain. The behaviour of the ducks during moonless nights indicate, however, that a line of turbines can act as a flight path barrier for birds when the line is inbetween the feeding and roosting areas. By interrupting long lines the barrier effect can probably be diminished. This should be taken into account by the planning of wind energy projects in such situations.

Acknowledgements We thank dr. Herbert Biebach, Max-Planck-Institut für Verhaltens-physiologie, Erling-Andechs (BRD), for the loan of the Furuno FR 8250 radar. Without his co-operation the flight altitude measurements would not have been possible. We also thank Leo M.J. van den Bergh for his contribution to the field work.
The studies were financed by: Novem, on behalf of the Ministry of Housing, Physical Planning and the Environment, the Directorate Zeeland of the Ministry of Transport, Public Works and Water Management, the provincial governments of Noord-Holland and Zeeland, and the following electricity companies: ENW, Delta Nutsbedrijven and PNEM.

REFERENCES

Buurma, L.S. & H. van Gasteren 1989. (*Migratory birds and obstacles along the coast of the Dutch province of South Holland: radar observations from Hoek van Holland and victims of the electric power line over the Maasvlakte compared, also in relation to the allocation of windturbines*). The Hague: Koninklijke Luchtmacht.

Cooper, B.A., R.H. Day, R.J. Ritchie & C.L. Cranor 1991. An improved marine radar system for studies of bird migration. *J. Field Ornithol.* 62:367-377.

De Leeuw, J.J. 1997. *Demanding divers - Ecological energetics of food exploitation by diving ducks.* Groningen: Rijksuniversiteit.

Dirksen, S., A.L. Spaans & J. van der Winden 1995. *Nachtelijke trek en vlieghoogtes van steltlopers over de noordelijke havendam van IJmuiden, voorjaar 1995.* Bureau Waardenburg report 95.26. Culemborg: Bureau Waardenburg / Wageningen: Instituut voor Bos- en Natuuronderzoek (IBN-DLO).

Dirksen, S., A.L. Spaans & J. van der Winden 1996a. (Nocturnal migration and flight altitudes of waders at the IJmuiden northern breakwater during spring migration). *Sula* 10:129-142.

Dirksen, S., A.L. Spaans, J. van der Winden & L.M.J. van den Bergh 1996b. *Vogelhinder door windturbines. Landelijk onderzoekprogramma, deel 2: nachtelijke vlieghoogtemetingen van duik-eenden in het IJsselmeergebied* (with summary). Bureau Waardenburg report 96.18. Culemborg: Bureau Waardenburg / Wageningen: Instituut voor Bos- en Natuuronderzoek (IBN-DLO).

Leewis, R.J., H.J.M. Baptist & P.L. Meininger 1984. The Dutch delta. In P.R. Evans, J.D. Goss-Custard & W.G. Hale (eds), *Coastal waders and wildlife in winter*: 253-260. Cambridge: Cambridge University Press.

Meininger, P.L., C.M. Berrevoets & R.C.W. Strucker 1995. *Watervogels in de zoute delta, 1991-94.* The Hague: Rijksinstituut voor Kust en Zee.

Schekkerman, H., P.L. Meininger & P.M. Meire 1994. Changes in the waterbird populations of the Oosterschelde (SW Netherlands) as a result of large-scale coastal engineering work. *Hydrobiologia* 282/283:509-524.

Slager, B. 1987. *De beschikbaarheid van driehoeksmosselen* (Dreissena polymorpha) *voor duikeenden in het IJsselmeergebied*. Lelystad: Rijksdienst voor de IJsselmeerpolders.

Spaans, A.L., J. van der Winden, L.M.J. van den Bergh & S. Dirksen 1995. *Vogelhinder door wind-turbines. Landelijk onderzoekprogramma, deel 1: verkennend onderzoek naar nachtelijke vliegbewe-gingen in getijdegebieden*. Bureau Waardenburg report 95.43. Culemborg: Bureau Waardenburg / Wageningen: Instituut voor Bos- en Natuuronderzoek (IBN-DLO).

Van der Winden, J., S. Dirksen, L.M.J. van den Bergh & A.L. Spaans 1996. *Nachtelijke vliegbewegingen van duikeenden bij het Windpark Lely in het IJsselmeer*. Bureau Waardenburg report 96.34. Culemborg: Bureau Waardenburg / Wageningen: Instituut voor Bos- en Natuuronderzoek (IBN-DLO).

Winkelman, J.E. 1992a-d. *De invloed van de Sep-proefwindcentrale te Oosterbierum (Fr.) op vogels, 1-4: aanvaringsslachtoffers, nachtelijke aanvaringskansen, aanvlieggedrag overdag, verstoring* (with summaries). RIN-report 92/2-5. Arnhem: Instituut voor Bos- en Natuuronderzoek (IBN-DLO).

Wind energy exploitation current status in Greece: Economic and social impacts

C.S.Pippos & D.P.Antonopoulos
Renewable Energy Sources Section of the Greek Ministry of Development, Athens, Greece

ABSTRACT: The efficiency of the legislative measures concerning the promotion of the wind power plants in Greece is clearly proved by a significant increase in the number of applications by investors in the sector. In particular, the Ministry of Development examines over than 70 applications for installation licences, whose total capacity exceeds the amount of 440 MW. Considering these applications, it is estimated that there will be installed approximately 300 MW of wind parks up to the year 2000.

1 INTRODUCTION

Greece has a significant Renewable Energy Sources (RES) potential. RES contributed 4,0% to Total Primary Energy Supply (TPES) in 1995. The total RES capacity installed, the main application the areas and the energy production for 1995 is shown in Table 1.

The relative contribution of each RES to total energy generated from RES exploitation in 1995 is shown in Table 2.

Table 1. RES applications, installed capacities and 1995 Energy Production in Greece

Source	Main applications	Total installed capacity	Energy produced(1995) (ktoe)
Solar Thermal	-hot water systems	2,05 X 106 m²	106
Photovoltaics	-autonomous systems -small island grids	over 550 kWp	0,017
Wind	-island grids	27,365 MW	2,91
Biomass	-net electricity generation -net heat production	900 MWh 21.887 TJ	522,97
Geothermal Heat	-greenhouses	21,65 MWth	2,74
Small Hydro (<10 MW)	-mainland grid -autonomous systems	41,7 MW	8,16
Large Hydro (>10 MW)	-mainland grid	2.482 MW	303,1

Source: CRES/Information Systems Division (March, 1997)

Table 2. Relative contribution of each RES to total
energy generated from RES exploitation in 1995.

Source	%
Biomass	55.3
Hydro	32.9
Solar	11.2
Wind	0.3
Geothermal	0.3

Source:CRES/Information Systems Division,1997

According to 'The recent European Renewable Energy Study II' (TERES II, 1996) the overall contribution of renewable energy sources to the greek TPES given the present policies could be as high as 8,21% by 2005. National forecasts expect a 300 MW installed capacity from wind parks in the next four years. In the electricity sector, lignite accounts for 73% of total generation and the rest is covered by oil power plants and large hydro-power systems, with the other renewables playing only a marginal role. The Public Power Corporation (PPC) is until now the dominant player in the energy market in Greece, maintaining a monopoly (up to 2001) on transmission and distribution as well as on large-scale generation of electricity. As such, it remains by far the most important user of RES technologies.

Until recently, the legislative framework for promoting Renewable Energy Sources (RES) and Rational Use of Energy (RUE) applications was defined by the Development Laws 1262/82 and 1892/90, but also the first Law 1559/85 for the regulation of cogeneration and electricity generation from RES. These allowed for a financing of investments in RES, as well as for electricity generation by entities other than the Public Power Corporation, such as co-generators, auto-producers and local authorities.

2 THE GREEK RENEWABLE ENERGY SOURCES POLICY

2.1 Law 2244/94

The results obtained throught previous Law 1559/85 concerning the use of RES for electricity generation were not satisfactory. Main reasons for this were: limitations on generating capacity placed on auto-producers, the fact that only local authorities could invest in RES solely for selling electricity, complex licensing procedures and low prices paid to RES electricity producers. To improve the situation, Law 2244/94 was introduced.The main provisions of this Law are:

- Enactment of autoproducers (for self-consumption and exclusive sale of any excess of electricity to PPC) and independent producers (the whole electricity produced is exclusively sold to PPC).
- Substantial liberalization of electricity production using RES plants, with maximum capacity of 50 MW, except for the small hydro plants, whose maximum capacity cannot exceed 5 MW.
- Enactment of the possibility for autoproducers to compensate electricity supply from the PPC network, with electricity they supply to PPC using RES.
- Limitation in the number of the required licences and of the bureaucracy involved for their issue.
- Substantial improvement of the tariff regime for sales to PPC of elecricity produced using RES.
- Promotion of the new institution of Regional and Local Energy Centres and Offices, under the coordination of the Centre for Renewable Energy Sources (C.R.E.S.), as the national centre for the promotion of renewable energy sources and rational use of energy.
- Promotion of electricity and heat cogeneration using conventional fuels or industrial byproducts, by means of implementing agreements between PPC and third parties or

establishment of PPC daughter companies, which may operate in joint venture with third parties.

2.2 *Curtailments manner of power produced by wind generators in weak grids*

After the issue of the installation licences of the first wind parks in Crete, there has been arised the necessity for a regulation of the relevant curtailment manner in order to avoid grid instability. After negotiations between the Public Power Coporation (PPC) and private producers, it has been drawn up a document, which accompanies the contract of purchase of electric energy between the two parties.

The main points of this annex of the contract are as follows:
- There is an obligation of PPC to buy annually a minimum amount of electric energy from each producer, according to the, so called, Contractual Equivalent Hours of Operation (CEHO). The main coefficients of the CEHO definition formula are:
 - Hourly load demand power system.
 - Maximum hourly load demand power system for the year n-2.
 - Installed power of all wind parks at any time of the year n. This is equal to the sum of the power - as it is defined in Operation license - of all wind parks operating on the system at this moment.
 - The total time during the calendar year for which the wind park is disconnected no due to the producer (e.g. distribution network maintenance, special occasions, etc) with upper limit 360 hours per year, or due to the producer (e.g. wind park maintenance).
- According to the operation conditions of the local power system, when it is possible, PPC will buy energy additional to that is determined by the CEHO.
- In case that the actual equivalent hours of operation for a producer are less than the CEHO, due to reasons caused by PPC, then PPC will balance the difference of the hours during the following year.

2.3 *Current financial incentives for RES*

The main forms of governmental financial support which are currently available for RES and RUE in Greece are the following:
- The tariff structures for energy produced from RES, as defined by Law 2244/94. The current tariffs, at which the PPC buys electricity from RES, are presented, in GDR/kWh for the energy produced and in GDR/kW for the respective capacity credit (1 ECU = 310 GDR).
- Subsidization according to the Development Law 1892/90. This Law, foresees inter alia grants ranging from 40% to 55% depending on the geographical location of the investment and it is available, mainly for commercial-scale RES installations. In addition, loans at reduced interest rates, tax credits and increased depreciation rates are provided. So far, nine (9) wind park investments with total installed capacity 70 MW have already been approved by the Ministry of National Economy with a total budget of 27,3 billion GDR and a total public support of 10,9 billion GDR.
- The Greek government has recently passed the Law 2364/95, which promotes the distribution of natural gas in Greece, but also establishes a 'Board for Energy Planning and Control', to coordinate the planning and implementing of national energy policy. In addition, a new provision in the same Law refers to the tax exemption by 75% from the end user purchase and installation expenses regarding household appliances or systems using RES.
- The Operational Programme for Energy of the Ministry of Development. Under this programme approximately 190 MECUS (EU, private and national funds) have been earmarked by the government, for RES and RUE development programmes (1994-1999). Total public co-financing amounts to 58 billion GDR, of which, 23 billion GDR will be provided for RES projects. Three quarters of the total public co-financing funds constitute

Community Support from the European Fund for Regional Development. The total budget, which includes the contribution of private sector, is 151,9 billion GDR, corresponding to 51,15 billion GDR for RES projects. According to the recent evaluation results of the projects submmitted during the first call for proposals, three (3) wind parks, with 20,2 MW total capacity and total budget 7,8 billion GDR have already been approved for support.

- The Operational Programme for Research and Technology of the Ministry of Development, which support, among others, RD&D activities in the RES and RUE sectors. Under this Programme, RES demonstration projects aiming at the application and promotion of new products are financed up to 50% of the investment. A minimum participation of 50% of the private sector is required (1995-1998).
- Additional funds may, occassionally, be available at regional and local level through the respective Regional Operational Programmes.
- European Commission's Programmes (DG-XVII, DG-XII). One of the main tools of the national policy for the further development of RES in Greece is the efficient use of european programmes, which offer financial support for actions undertaken in the sector, such as, ALTENER (promotion of the infrastructure necessary for the exploitation of RES), SAVE II (promotion of the efficient use of energy, incorporating measures for the Planning of Energy at Regional and Urban level), THERMIE (demonstration and dissemination of non-nuclear energy technologies) and APAS (RES planning and pilot projects).
- An ambitious plan of market incentives for the use of active and passive solar systems, as well as other RES and energy efficiency technologies in buildings, named Energy 2001 has been recently designed, with the cooperation of the Ministry of Development, but is still under consideration by the Ministry of Finance and the Ministry of Environment, Physical Planning and Public Works.
- Third Party Financing (TPF) has been implemented in few cases (solar thermal, small hydros, biomass), but still a specific legal framework has to be defined through a study under the Operational Programme for Energy.

2.4 *PPC's Ten Year Development Plan*

PPC is highly involved in the development of RES with programmes included in PPC's rolling Ten Year Development Plan for the period 1994-2003. The RES programme includes the development of wind energy, solar energy (PV), geothermal energy and small hydro technological applications.

3 WIND ENERGY EXPLOITATION

3.1 *Wind energy potential*

A significant potential for wind energy exploitation exists and is estimated at 6.46 TWh/year from more than 2,4 GW capacity. Based on the wind regime and the high cost of providing electricity in isolated areas, best sites for the installation of wind turbines are located in the Aegean islands. The Table 3 shows the exploitable wind energy potential in island regions and the continental Greece and the Table 4 presents the mean wind speed in some interest island sites.

3.2 *Present status in the field*

Since Law 2244/1994 came into force the Ministry for Development has received 150 applications for approval of RES plants installations with approximately 638 MW of total capacity in all regions of Greece, up to 9.6.97 (Table 5).

Table 3. Exploitable wind energy potential

Region	Energy in TWh/year
Cyclades	3,15
Crete island	0,74
Evia island	0,96
Continental Greece	1,61
TOTAL	6,46

Source: PPC - EC's DG-XVII for Energy

Table 4. Wind potential measurements in several sites

Site	Mean Wind Speed (m/s)	Measurements period
Andros	9,7	1981 - 1990
Tinos	9,5	1987 - 1990
Mykonos	10,8	1983 - 1990
Syros	8,1	1988 - 1990
Crete	8,1	1981 - 1983
Lesvos	8,7	1987 - 1990
Chios	8,1	1986 - 1989
Samos	10,4	1986 - 1990
Evia	9,2	1989 - 1990
Carpathos	9,6	1983 - 1990
Samothrace	6,6	1986 - 1989

Source: Public Power Corporation/Alternative Energy Sources Department

Electricity generation from wind energy converters increased 25 fold between 1989 and 1995 (from 1.331 MWh (0,11 ktoe) in 1989 to 33.789 MWh (2,9 ktoe) in 1995) The situation concerning licences issued so far, are depicted in Table 6.

In the framework of this «market boom» is included the recent granting of installation licences for three big private wind parks in Crete of 24,9 MW total installed capacity with a saving for Public Power Corporation of about 1,3 billion GDR per annum, including taxes, resulting from substitution of fossil fuels. The Ministry of Development expect that, next month six (6) more wind park installation licences will be issued for the islands of Crete, Tinos, Milos and Limnos, with total power capacity of 27,8 MW.

4 ISSUES OF WIND TURBINES LOCATION PREAPPROVALS

The location preapproval is a fundamental prerequisite for issuing installation licances, according to the relevant legislation. The problems of finding out the proper installation sites from technoeconomical and environmental point of view and clear of cultural monuments, in combination with the current land competition, continue to be the main obstacles for the fast promotion of the section, especially in some isolated grids. Nevertheless, the greek Ministry of Development, in close cooperation with the co-competent Minsitry of Environment, Physical Planning and Public Works, has already simplified the relevant procedures. In particular, wind power plants with installed capacity less or equal to 2 MW have already been excepted from the obligation for the location preapproval. It must be noted here, that the official approval of a study about environmental impacts of the plant installation and operation is required in every case.

113

Table 5. Applications under examination for investments in RES, by Region and category of plants, submitted after the publication of the new Law No2244/94.

a/a	REGION OF THE COUNTRY	CATEGORY	NUMBER OF APPLICATIONS	TOTAL CAPACITY in MW
1	EASTERN MACEDONIA & THRACE	Biomass cogeneration plant	1	14,000 MWth + 2,800 MWe
		Wind power plants	1	3,500 MWe
2	ATTICA	Biomass power plants	1	7,125 MWe
		Wind power plants	1	3,600 MWe
		Small hydro power plants	3	4,430 MWe
3	NORTHERN AEGEAN	Wind power power plants	10	17,770 Mwe
4	WESTERN GREECE	Small hydro power plants	3	10,640 Mwe
5	WESTERN MACEDONIA	Small hydro power plants	7	10,760 Mwe
6	EPIRUS	Small hydro power plants	10	18,863 Mwe
		Biomass power plants	1	0,330 MWe
7	THESSALIA	Small hydro power plants	5	6,126 Mwe
		Biomass power plants	1	0,353 Mwe
8	CENTRAL MACEDONIA	Cogeneration with biomass	1	7,200 MWth + 1,300 MWe
		Small hydro power plants	13	10,491 Mwe
9	CRETE	Wind power plants	21	191,350 MWe
		Solar power plants	2	10,000 Mwe
		Biomass cogeneration plant	2	24,000MWth +10,000 MWe
10	SOUTHERN AEGEAN	Wind power plants	30	113,600 MWe
		Hybrids with wind turbines	2	1,000 Mwe
11	PELOPONNESE	Wind power plants	4	28,000 Mwe
		Small hydro power plants	3	3,850 Mwe
12	CENTRAL GREECE	Biomass cogeneration plant	2	9,900 MWth + 0,900 MWe
		Wind power plants	24	171,250 MWe
		Small hydro power plants	4	4,145 Mwe
13	IONIAN ISLANDS	Wind power plants	1	10,000 Mwe
Wind power plants:			92	539,070 MWe
Small hydro power plants:			45	64,875 Mwe
Biomass cogeneration plants:			4	33,90MWth+1 5,000MWe
Solar power plants:			2	10,000 Mwe
Biomass power plants:			5	7,974 Mwe
Hybrids with wind turbines power plants:			2	1,000 Mwe
Total for the country:			150	33,9MWth+63 7,753MWe

Available data up to 09.06.97.

Table 6. Licences issued according to the new legislative framework for res power plants (Law No. 2244/1994)

a/a	RES TYPE	REGION	POWER (MW)	(1)	(2)
1.	Wind	CRETE	5,000	√	
2.	Wind	CRETE	10,000	√	
3.	Landfill gas	CENTRAL MACEDONIA	0,240	√	
4.	Wind	SOUTHERN AEGEAN	0,200	√	√
5.	Wind	NORTHERN AEGEAN	0,150		√
6.	Wind	CRETE	9,900	√	
7.	Small Hydro	EASTERN MACEDONIA AND THRACE	0,938	√	√
8.	Landfill gas	CRETE	0,193	√	
9.	Small Hydro	CENTRAL MACEDONIA	0,220	√	
10.	Small Hydro	CENTRAL MACEDONIA	0,280	√	
11.	Small Hydro	CENTRAL MACEDONIA	0,560	√	
12.	Wind	CENTRAL GREECE	7,800	√	
13.	Wind	NORTHERN AEGEAN	1,000	√	
14.	Wind	NORTHERN AEGEAN	0,225	√	
15.	Small Hydro	CENTRAL GREECE	0,155	√	
16.	Small Hydro	WESTERN GREECE	2,820	√	
17.	Small Hydro	CENTRAL GREECE	0,150	√	

Available data up to 24.06.97
(1) Installation licence issued
(2) Operation licence issued

For issuing a location preappoval the required documents that have to be submmitted are as follows:
- A brief technical report for the project including:
 - the necessary description of the technical characteristics of the power plant (capacity in kW, or MW, voltage)
 - the intended use of the produced electical energy (self production, independent production, reserve production)
 - declaration for the intention or not, of the producer to interconnect the power plant with the networks of the Public Power Corporation (PPC), provided that the power plant do not belong to PPC.
- A topographic map of the geater area of the installation site, with scale that range from 1:50.000 to 1:20.000, with a particular marking of the site.
- A topographic diagram of the installation field, with scale that range from 1:1.000 to 1:200.
- A photo series pointing out the installation field.
- A filled questionnaire concerning environmental impacts, as it is defined in a relevant Ministerial Decision.

It is worth mentioning that in specific cases, when a public forest land concession is required for such uses, there are some problems in constructive cooperation between the involved co-competent Ministries of Finance and Agriculture, because of the complexity, or the lack, of the relevant legislation. The Real Estate Public Corporation, which is, among others, the manager of the public land in the area of Dodecanese islands is also involved substantially in the region.

It is also worth noting that, it is needed an enforcement of the proper staff for the decentralized services of the Ministry of Environment, Physical Planning and Public Works, in order to give a better quality and an acceleration to the necessary procedures for the location preapprovals.

5 ECONOMIC AND SOCIAL IMPACTS OF THE WIND ENERGY DEVELOPMENT

According to data received by our Centre for Renewable Energy Sources (CRES), each installed MW of wind parks corresponds approximately to ten job positions in the constuction period and four in the operation period (two positions for the service and two for the maintenance). Considering both, the high wind exploitable potential and the significant technological infrastructure and know how of the country, in combination with the hopeful aforementioned present status, we believe that it is gradually creating a favourable field for the development of a domestic industry of wind turbines construction in Greece in the near future, which would multiply the new job positions.

It is worth noting, the saving of funds of the substitution of fossil fuls consumed by the thermoelectric power plants of the Public Power Corporation (PPC) is very significant. For example, it will be saved 1,3 billion drachmas included taxes from the installation of the first three private wind parks in Crete with total capacity 25 MW, according to PPC's estimations.

On the other hand, the improvement of the local environmental conditions, the differentiation of the energy sources and the enforcement of the ratio of the energy independence at local and national level are main factors of the further development of wind energy in Greece. Additionally, by environmental aspect of view, it is worth saying, that every kWh produced by wind power generators saves approximately 1 kg CO_2, ratio that corresponds to the emissions of a greek lignite conventional power station.

6 CONCLUSIONS

The whole effort of the Ministry of Development for an accelerating and national development of all RES technologies, including of course wind turbines, is significaly proven by the strong will of the greek government for RES promotion, which is a national priority energy goal, but also from the rapidly increasing market interest and the high level know - how of the research centers, Universities and the national bodies (PPC, CRES, etc) competent for RES exploitation. On the other hand, since 1990, the greek state has adopted a european Directive, concerning the enviromental impacts assessment in a strict Ministerial Decision, signed by many Ministers, that proves the will for an enviromentally oriented development.

Wind Energy and Landscape, Ratto & Solari (eds) © 1998 Balkema, Rotterdam, ISBN 90 5410 913 0

Development of sustainable energy in Denmark with special reference to wind energy

I.Clausager
National Environmental Research Institute, Department of Coastal Zone Ecology, Kalø, Denmark

ABSTRACT: The Danish government has decided to increase the wind energy supply from 600 MW in 1997 to 5,500 MW in year 2030. The main part of the development is expected to derive from off-shore wind farms. Experiences from two small off-shore wind farms of five MW each have given promising results both concerning technical equipment, production, and economy. Large-scaled wind farms of several hundred MW are planned and will during erection be divided into sections of 100 MW which can be handled independant of each other. The development will be followed by base-line and impact assessment studies on the environment and can be suspended or even stopped if the impact is too serious. Furthermore, improved technology implies that turbines without noticeable extra costs can be placed at water depths of 15-20m contrary to today, where the maximum depth is 10m. This opens possibilities for including of new waters where the risk for impacting the environment is smaller.

1 INTRODUCTION

After the energy crisis in 1973/74 Denmark worked out its first Energy policy plan in 1976. The aim was to ensure a safe and continuous energy supply. In 1981 a revised Energy plan appeared. This plan attached more emphasis to socio-economic and environmental regards. In 1990 (Anon.) the action plan "Energi 2000" appeared introducing the goal of a sustainable development of the energy sector. In 1993 (Anon.) a revised "Energi 2000" was published introducing action programmes concerning legislation to improve the future use of sustainable energy. These initiatives were taken in order to fulfil the objective of reduction of the CO_2-emission until the year 2005. In 1996 (Anon.) the fourth energy plan "Energi 21" appeared setting the agenda for the energy policy in the next three to four decades.

The main ambitions of the energy policy are:

- to create a sustainable development
- to follow an active policy
- to improve the engagement and influence of the customer
- to be the prime mover in the international development
- to safeguard the energy supply
- to improve the economic efficiency and increase the employment
- to improve the global environment and to strengthen the efforts against climatic changes.

The objectives until year 2005 are that:

the energy intensity defined as the rate between the gross national product and the gross national energy expenditure shall be improved by 20% in relation to the 1994 level
sustainable energy shall be developed to comprise 12-14% of the total energy expenditure.

The objectives until year 2030 are that:

- the energy intensity shall be improved by 55% of the 1994 level
- sustainable energy shall be developed to comprise 35% of the expected energy expenditure which means an annual increase of 1%.

Furthermore, in the Energy plan it is stated that sustainable energy and natural gas shall replace coal and oil. Sustainable energy comprises different types of energy as:

- energy from biomass
- wind energy
- sun energy
- geothermic energy
- other sources (tidewater, waves).

2 WIND ENERGY

In 1997 nearly 4,000 wind turbines with a total capacity of 600 MW are operating in Denmark. In the year 2005 a total capacity of 1,500 MW corresponding to a development of 150 MW per year is expected. Of the increase 200 MW shall derive from off-shore wind turbines.

After the year 2005 and until 2030 an enlargement to a total of 5,500 MW is supposed. Of this increase 4,000 MW is expected to derive from off-shore turbines.

2.1 Selection of off-shore locations

At the moment only 21 wind turbines (10 MW) are placed off-shore. The remaining turbines are placed on land, mainly in coastal areas. As it is becoming more and more difficult to find suitable places for erecting wind turbines on land more effort has been laid down to find suitable places at sea.

Already in the late 1980s the development of wind energy at land were met with an increasing opposition. The legislation for erecting wind turbines had so far been insufficient, and many turbines were built in areas where they afterwards caused problems, especially from aesthetic point of views. Turbines were in many places erected single or in small groups without any overall planning. In the public this caused an increasing resistance which in fact was not real as most people in general were positive to wind energy. The opposition was more specific indicating that single persons or local societies did not want disturbance from wind turbines near their residence.

As most of the best places on land already have been occupied or cannot be used due to restrictions the considerations for finding new suitable places have turned more and more towards the sea. At sea the wind is also stronger and more stable which means that a higher production of a turbine placed off-shore compared to a turbine placed on land can be obtained.

The Danish waters are in general shallow and thus gives large possibilities for erecting wind turbines. This was realized already in the mid 1980s, but the technology was at that time not yet fully developed.

However, in 1987 the Minister of Energy formed a Committe concerning off-shore wind turbines. Its mandate was to find one or two off-shore sites where wind turbines could be erected. These first wind farms should be more a kind of demonstrations projects where technical questions and ecological and environmental impact could be analysed.

The Committee had representatives from all ministries which were responsible for interests of different kind which could be affected by off-shore wind farms. As it was likely that the existing power companies should be in charge of the development of wind farms at sea they were also represented in the Committee.

The representatives of the Committee were:

- Ministry of Energy: supervision concerning exploitation of oil and natural gas in the Danish underground, approval of power cables at territorial waters,
- Ministry of Traffic: issues permission for establishment of fixed constructions of every kind at territorial waters,
- Ministry of Fishery: responsible for fish stocks and their exploitation. Assists fishermen to perform their occupation in a proper way,
- Ministry of Defence: responsible for military shooting areas, communication and radar systems, and for marking of sail routes,
- Ministry of Commerce: responsible for the security of sailing in Danish waters,
- Ministry of Environment: responsible for the protection and conservation of the wild flora and fauna, for the exploitation of raw materials from sea bottom, and for marine archaeological localities (settlements from the Stone Age, tombs and ship wrecks),
- Ministry of Culture: responsible for the communication network (cables and radio links),
- Power Companies.

In advance, the Committee decided from a nature protection and conservation point of view to omit the North Sea coast and all fiords due to scenic and partly also biological interests. Furthermore, the Øresund region between Denmark and Sweden, all important sail routes, EEC-bird protection areas and Ramsar areas were omitted.

The Power Companies were asked to make a proposal of suitable off-shore sites for erecting wind turbines. In their draft it was taken into consideration that the following conditions should be fulfilled:

- water depths 1.5 - 4 m allowing use of smaller boats and barges,
- distances to west and east directed coast of one and two km, respectively,
- proximity and possibility for connection to a 10 kV net,
- proximity to harbour from where supervision can take place.

With this in mind the Power Companies proposed 31 possible sites of which four were selected for further considerations (Anon. 1988).

As the technical experience and skill at that time still were insufficient the Committee agreed to divide the demonstrations project into two of which the first should elucidate the more technical problems concerning erection of off-shore wind turbines, production, reliability, maintenance etc. The second wind farm should be erected at a locality where also ecological and environmental aspects (impact on especially waterfowl) could be analysed.

2.2 *Off-shore wind farms*

In 1991 a wind farm with 11 BONUS turbines of 450 kW each was erected off Vindeby in the south-eastern part of Denmark. On this site very few birds occurred and fishing was most limited and only with stationary equipment. The experiences from this project were better than expected both concerning production, technical equipment, and economy.

With the good results in mind it was decided to erect the second wind farm fulfilling the latter part of the agreement. After long and difficult discussions a place, Tunø Knob east of Jutland, was selected, and in the summer 1995 ten VESTAS turbines each of 500 kW were erected. Before the final location was determined a visualization study was carried out (Møller & Grønborg 1994).

The Tunø Knob site holds quite good numbers of sea ducks, especially Eider (Somateria mollissima), which is the most numerous species (up to one million) in Danish waters. A study programme was initiated in autumn 1994 nearly one year before erection of the turbines and will be finished at the end of 1997. The aim is to elucidate the possible impact on waterfowl. The impact could be disturbance in combination with deterioration of the habitat. Due to common waterfowl behaviour at sea collissions are considered only as a minor problem.

3 FURTHER DEVELOPMENT

As the government has decided to develop the wind energy supply in the coming years and as most of the increase is expected to derive from off-shore wind turbines the Committee was given a mandate to designate off-shore sites where such a large scaled development of wind turbines could take place.

3.1 Selection of locations for large off-shore wind farms

As a starting point it could be stated, at least theoretically, that wind farms can be erected in the major part of Danish waters, but there are physical conditions as water depth and distance to land to take into consideration. As on land there are also many other interests to consider not least the scenic aspects. The sea is characterized by the open and free views which indicate that wind turbines can be seen over very long distances. Therefore the Committe has attached much emphasis in considering the development of off-shore wind energy to the scenic consequences. A comprehensive visualization analysis including 450 kW and 1MW wind turbines was carried out in 1994 and the results and experiences included in the considerations (Anon. 1994).

Through its work the Committee has given a comprehensive description of so-called:

"Restricted" areas, which are defined as waters where central interests of such a character are connected that these in principle block for development of off-shore wind farms in these waters,

"Weighed" areas, which are defined as waters where development of off-shore wind farms not can be permitted before the importance of energy production has been considered very carefully in relation to other interests in the area.

"Restricted" areas include:

1. EEC-bird protection areas
2. Other types of protected areas (mainly included in the EEC-bird protection areas)
3. Areas pointed out for exploitation of raw materials
4. Areas with concentration of shipwrecks and ancient monuments
5. Military shooting areas
6. Main sailing routes
7. Areas with transmission installations for energy (poles and cables).

"Weighed" areas include:

1. The total Danish territotial waters are of potential interest for fishing. Therefore, all permissions to erect wind farms have to be considered in relation to commercial fishing
2. Areas with special scenic interests
3. Areas with dense waterfowl populations which are not EEC-bird protection areas
4. Areas with occurrence of special raw materials
5. Areas with occurrence of ancient monuments with e.g. settlements from the Stone Age
6. Harbours
7. Areas for leisure sailing
8. Broadcasting chains
9. Approaching strips of airports placed near seashore.

The overall attitude of the Committe has been that off-shore wind farms ought to be placed at sites where the smallest possible numbers of other interests are influenced and idealistic seen so far from the coast that the turbines cannot be seen.

The visualization project indicated that off-shore wind farms situated far from the coast (more than 12.5 km) in general will impact the scenic aspects only to a small degree except in places where high cliffs and dunes are found in coastal areas. Erection of wind farms in these areas ought to be permitted only if the weighing of other interests results in that the energy production must be given highest priority.

The analysis demonstrates that the Danish waters include a number of areas without bindings and only a few weighed interests except possible commercial fishing. The areas of which some are situated far from the coast have such a size and location that they may be subject for further studies for analysing the possibilities for erection of large wind farms.

On the basis of the described reservations and under the condition that the water depth does not exceed 10m four areas covering a total area of 1,000 km² have been pointed out. With a development of 7-8 MW per km² the total potential production in these areas can be nearly 8,000 MW which is app. half of the Danish consumption. The intention is to utilize about half of this potential until year 2030.

3.2 Action plan

In 1996 the Minister appointed a smaller group consisting of representatives from the Agency of Energy, the Forest and Nature Agency and the Power Companies to continue the negotiations and work out an action plan for the development of off-shore wind energy. The action plan is planned to be finished at July 1st 1997.

The Danish coast scenery is very vulnerable in relation to erection of wind farms in the near-shore parts of the sea. A development as presumed in "Energy 21" with many smaller near-shore wind farms may impact the Danish coastal sceneries in such a way that one or more wind farms can be seen from the main part of the coasts. Furthermore, some of these smaller parks erected near-shore may result in a disproportionate negative impact of the coastal scenery without any essential production of energy in relation to the main scope in "Energy 21". Therefore these premises have more or less been abandoned.

The technological progress has already resulted in larger wind turbines (1.5 MW in 1997) than presumed in the visualization project from 1994 and even larger turbines can be expected in the coming years. With these prospects it has been neccessary to revise the criteria concerning distances to the coast for erecting wind farms.

Erection of wind turbines inside a zone of 7-10 km from the coast has (depending of the size of the turbine and the character of the coast) in general to be avoided. In fact, turbines will not start to be invisible from land within a distance of 20-25 km and regards to coastal sceneries

being unimportant. Wind turbines in the intermediate zone (10-20 km) may be a constituent part of elements in the coastal scenery and the possibility for erecting ought to be evaluated in relation to scenic interests and the importance of the potential production of energy.

In most of the year huge numbers of waterfowl occur in Danish waters either breeding, moulting, migrating or wintering and thus the waters are among the most important in Europe. A number of areas are already designated as EEC-bird protection areas and these are in beforehand omitted from erection of wind farms. However, in other waters so high numbers of waterfowl do occur that these are ranged alongside with EEC-bird protection areas and their final status cannot be decided before the results of ongoing studies elucidating the possible impact from off-shore wind turbines on waterfowl are available.

The action plan recommends to organize the development in such a way that an ecological, economic, and technical flexibility are maintained in those areas where the largest development is planned and where there is a motivated doubt about the ecological consequences. This flexibility can be obtained by a stepwise development with sections of e.g. 100 wind turbines (150 MW) and where the single step in economic and technical respect is not strongly connected to the succeeding development. In relation to each section ecological and environmental impact assessment studies including a period of one-two years before the erection and two-three years after will be carried out. On the basis of the results from the analyses it will be decided whether it is justifiable to continue with succeeding sections.

4 CLOSING REMARKS

As the period of the overall development will be rather long (10 years or more) a technical and ecological flexibility will be a benefit as this concurrent allows an adjustment and improvement of the development in relation to the ongoing technical progress and the provided knowledge about the impact especially on waterfowl.

In selecting the four areas only water depths of less than 10m were considered. As the technolgy is improving rapidly water depths of 12-15m are actual in 1997 and in a few year even larger depths will be actual. If depths up to 20m come into consideration new and more interesting areas will be available and conflicts with other interests will decrease as the wind farms can be placed more far from land resulting in decreasing scenic impacts. Also conflicts with biological interests concerning waterfowl will be reduced as it to a higher degree will be possible to avoid areas with large concentrations of birds.

The action plan recommends a governmental planning and steering ensuring that the development of wind energy off-shore takes place alone in a few large and concentrated parks inside special designated areas and in such a way that the Danish coastal scenery in principle is kept clear of wind turbines. Only in special cases smaller and near-shore wind farms may be erected.

In the conclusions and recommendations of the action plan it is underlined that by using the existing technology it is possible to fulfil the goal in "Energy 21" by erecting large scaled wind farms off-shore. The development is expected to start in the designated areas with sections of 150 MW and a total of 1,500 MW. The sections will be erected alternately in the four areas with about one section per year.

REFERENCES:

Anon. 1988. *Forslag til lokalisering af demonstrationsprojekter* (Proposals to localization of demonstration projects). Report in Danish from the Agency of Energy.
Anon. 1990. *Energi 2000, handlingsplan for en bæredygtig udvikling* (Energy 2000, action plan for a sustainable development). Report in Danish from the Ministry of Energy.

Anon. 1993. *Energi 2000 - opfølgningen - en ansvarlig og fremsynet energipolitik* (Energy 2000 - the follow up - a responsible and visual energy policy). Report in Danish from the Ministry of Energy.

Anon. 1994. *Vindmøller i danske farvande - en undersøgelse af de visuelle forhold ved opstilling af vindmøller på havet* (Wind turbines in Danish off-shore waters - a study of the visual conditions be erecting off-shore wind turbines). Report in Danish fron the Agency of Energy.

Anon. 1995. *Vindmøller i danske farvande. Kortlægning af myndighedsinteresser, vurderinger og anbefalinger* (Wind turbines in Danish waters. Mapping of authority interests, considerations, and recommendations). Report in Danish from the Agency of Energy.

Anon. 1996. *Energi 21. Regeringens energihandlingsplan* (Energy 21. The Energy action plan of the government). Report in Danish from the Ministry of Environmnet and Energy.

Møller & Grønborg 1994. *Tunø Knob vindmøllepark - visualisering og æstetisk vurdering* (Tunø Knob wind farm - visualization and aesthetic evaluation). Report in Danish from the power company I/S MIDTKRAFT.

Wind Energy and Landscape, Ratto & Solari (eds) © 1998 Balkema, Rotterdam, ISBN 90 5410 913 0

Social, economical and environmental impact of wind energy conversion systems in mountainous areas

G.M.De Pratti
Università degli Studi di Roma 'La Sapienza', Italy

ABSTRACT: Although in all over the world Wind Energy Conversion Systems (WECSs) are becoming very successful power plant many problems go on interfering with their development. These problems are mainly joined in land planning and use and, together with obstacles represented by planning regulations, building permits, constraints and other ones. Other questions are relevant to environmental impact, in fact the most windy sites are also of interest to landscape and nature. At the present time, in Italy, wind farms are developing in mountainous sites as at Acqua Spruzza (Frosolone, Molise) or at Collarmele (Abruzzo) too. In these areas visual and environmental impact may largely minimized by using some designing criteria. Also the economical and social impact can result positive. For the case of new ENEL wind power plant at Collarmele, an investigation about environmental and social-economical impact has been carried out by use of three different indirect methods, based on the estimate of the "*kWh value*" from wind source.

1. INTRODUCTION

Wind has become a viable source of electric energy for utilities and it is now the cheapest electricity generating option in many remote regions of the world and offers a path to reducing emissions of pollutants and greenhouse gases in the industrialised world (Milborrow 1997). In other locations, such as India but also China, wind is an attractive energy source and, particularly in developing countries, since the lead time for construction is shorter than other power plants.

Modern wind turbines are proving to be relatively very reliable, prices are falling steadily and numerous studies and analysis have confirmed they can integrate with electricity supply networks without great risks for the Energy Systems (Milborrow 1995).

According to Invernizzi & Palenzona 1997 wind farm whose power capacity is about 2-3 MW or more must be connected directly to HT line, while the plants with power capacity from 100-200 kW up to 1-2 MW ought to connect to MT grid. These Authors have established that WTGs (Wind Turbine Generators) joined to reservoir storage

systems, connected to HT and MT grids, could increase Supply System quality.

Furthermore wind power plants may increase the reliability of "not ringed" branches of the grid (Coiante 1994); these particular branches have large spreading in several zones of the Italian Appennini, particularly in inner Abruzzo (Chiatti et al. 1997). In any case, according to BWEA chairman Peter Edwards (BWEA 1997), wind powered electricity is sent directly into local distribution networks.

Also Swift-Hook 1995 reports that although it is intermittent, wind energy can still contribute to firm capacity on the power system, just as fossil fuels and nuclear energy do. From this point of view wind power plants reliability and availability may play an important role.

Utility-scale wind power plants consists of a number of WTGs that depends on chosen "wind farm developing pattern"; particularly US wind farms are characterized by clusters of 100-200 or more different sizes WTGs that are located close to each other. The European cluster is less crowded and is based on medium size WTGs (100-600 kW of power and 17-40 m in rotor diameter). The Italian averaged cluster has about 5-6 WTGs, whose averaged size is about 275 kW; in fact it is based on 250-320 kW WTGs. The averaged unit in the Spanish cluster has reached 438 kW (Abia 1997). The averaged size of the available WTGs on the market has increased in last decades, and from 200 kW (1993) it has reached 326 kW (De Pratti 1996). It would reach 450-600 kW in the next years.

Wind farms have a single electrical connection to the utility grid, and can be managed from a single control room.

Wind turbine availability of actual wind farms is about 95 % or more, better than many conventional power plants.

Actually the wind-generated electricity cost is about 0.05 US$/kWh (with a wind velocity about 6-7 m/s) and at this price the conditions to compete with different types of conventional generations do exist (Milborrow 1997).

Actual efforts are turned to reduce costs by improving aerodynamical performances of blades and rotor, to improve design of mechanical components or to eliminate some of them (the gearbox for an example) by use of variable speed and/or low speed generators and to introduce controls that may increase system efficiency and life time.

In various parts of the world, even in developed countries, for small communities that are too far away to be economically connected to an electric supply system, wind power plants are quite competitive.

In the major part of developed countries the competitiveness of connected grid wind power plants has already been reached since some time.

Actually the exploiting of wind energy may be represented by data shown in tab. 1.
The level of wind power is expected to increase in coming years, partly because of utilities interest in diversifying supplies and partly because of environmental factors.

Only cost-effective, clean power generation will be able to meet the growing world-wide energy demand while conserving resources. Among the different available renewable sources, the hydraulic is the most important and competitive vs. thermal ones and the wind source follows in its footsteps.

According to BWEA 1994 wind energy could provide, for example, at last 20 % of the UK's electricity needs. It is non polluting and environmentally safe: in fact in 1989 the $2,690 \cdot 10^6$ kWh of electricity generated by WTGs throughout the world prevented the release of nearly $3 \cdot 10^6$ tonnes of carbon dioxide and also saved $3.5 \cdot 10^6$ barrels of oil.

In 1996 a record total output of 505 million kWh was achieved from UK's 34 wind farms and it has represented a saving of 435,000 tonnes of carbon dioxide (BWEA 1997). Steer-Diederen ed. 1995 has reported that, in Denmark, "...*1 GWh of wind-generated electricity in 1994 had the following effects: reduction of $1 \cdot 10^6$ t of CO_2, 5,000 t of NO_x, 7,000 t of SO_x and of 5,500 t of flyash...*". So production of electricity by WTGs has saved the environment from a substantial quantity of harmful emissions from coal-fired, and less harmful ones from oil ad gas-fuelled power stations.

Tab. 1: Wind Power World data.

WORLD WIND POWER INSTALLED CAPACITY			
Country	**Total capacity end 1996 (MW)**	**Country**	**Total capacity end 1996 (MW)**
USA	1596	China	79
Canada	21	India	820
South/Central America	33,6	Other Asia	12,9
Total America	*1650,6*	*Total Asia*	*911,9*
Denmark	835	Total other Areas	44
Finland	7,2		
Germany	1552	***Total World***	**6103**
Greece	29		
Italy	70,5	**Installed Capacity in the previous years**	
Netherlands	299	**Country/Year**	**Total capacity (MW)**
Spain	249	USA (1994)	1630
Sweden	103	USA (1995)	1650
UK	273	Germany (1994)	643
Ireland	11	Germany (1995)	1130
France	5,7	Denmark (1994)	540
Portugal	19,1	Denmark (1995)	610
Other Europe	43	India (1995)	580
		Spain (1994)	72
Total Europe	*3496,5*	Italy (1994)	22

Data Sources: IEA - Wind Energy Implementing Agreement and ENEA (1996).-

Tab. 2: Impact of wind power plants on birds in different countries.

BIRDS COLLISIONS WITH WTGs IN UK WIND FARMS					
Wind farms	*Burgar Hill*	*Blyth Harbour*	*Bryn Titli*	*Cold Northcott*	*Cemmaes*
n° of collisions/(WTG)(year)	0,15	1,34	0	0	0,004

Source: ETSU (1996).-

BIRDS COLLISIONS WITH WTGs IN OTHER COUNTRIES WIND FARMS					
	Denmark			*Spain (Tarifa)*	
Wind farms	*Nibe*	*Tjaereborg*	*1993-1995*	*1996*	*total*
n° of collisions/(WTG)(year)	0	7	2	5	7

Danish data source: Pershagen (ed.) (1994).-
Spanish data source: Cererols et al. (1996).-

Although in all over the world WECSs (Wind Energy Conversion Systems) are becoming very successful power plants and they have such interesting characteristics, many problems go on interfering with their development and installation.

These problems are mainly joined in land planning and use and with obstacles as planning regulations, building permits and other ones, or, also servitudes and constraints: military, about landscape, naturalistic, territorial and so on.

The principal aspects of the environmental impact due to wind power plants are: land

occupancy, visual impact, impact on birds (avifauna) and on telecommunications and noise production.

Many windy sites are of scenic importance and in the recent past WTGs' installations have been very invasive (as at Tehachapi Pass in California).

Actually some techniques of design of the landscape (Stanton 1995) have been employed to reduce the visual impact due to WTGs and this has been accepted by the public opinion (BWEA 1994).

According to Stanton wind energy developments may portray a functional image, in relation to a particular building or land use; alternatively they may form a sculptural image in contrast with their surroundings. Visual impact is not directly proportional to WTGs number within a development, however it will vary a great deal between a single turbine and a wind farm. A single turbine will only have a visual relationship between itself and landscape, while a wind farm have more complex visual relationship with landscape, and its design should be related to the characteristics of the land, its use and the vegetation.

About the impact on avifauna there are some interesting contributes. The tab. 2 shows some data about the impact on avifauna in different countries (Pershagen ed. 1994, Cererols et al. 1996 and ETSU 1996).

Eyre 1995 reports that the impact due to noise generation is calculated using a noise dispersion model. This allows the incremental noise to be estimated for each household affected. The loss in amenity is then valued using the results of studies of noise on house prices. It is clear that house prices decrease, due to noise generated by WTGs, is augmented by large population density in the area. In high population density areas, such as Delabole in Galles, the external cost due to noise generated by WTGs could be very significant.

To have external costs very low, according to Eyre 1995, "...*wind energy projects should not be sited: very close to centres of population, in areas of nationally designated scenic importance, close to ornithologically important sites, on important ecosystems sensitive to disruption by construction, or on communication systems routes...*"; in this manner externalities may be lower than energy conventional sources ones.

Wind power is not entirely without environmental costs: the principal are those joined to visual impact and noise generation. Furthermore impacts due to WTGs presence on the territory are reversible and can be eliminated removing the machines.

Land occupancy, on the contrary, is not a problem in fact the area really occupied by the machines is only about 1-3 % of the whole wind farm area.

Based on the land occupancy and on preservation of the primary use or land use designation, a procedure to value social and economical impacts due to wind farms has been proposed (De Pratti & Fedele 1996), together two other ways: one based on the mix of fossil fuels substituted by the wind energy source, and the second based on the estimate of the "*kWh not supplied*".

2. SOCIAL-ECONOMICAL AND ENVIRONMENTAL IMPACT IN MOUNTAINOUS AREAS

The major part of Italian national territory is mountainous and an its substantial part is of scenic importance or naturalistic reserve one.

So the principal constraints are joined in landscape, naturalistic, ornithological and generally in preservation of flora and fauna aspects.

Actually different wind farms have been built in constrained areas, such as Monte Arci, and at least two wind farms are sited near a great area of scenic and naturalistic importance. These two last ones are Acqua Spruzza and Collarmele ENEL wind farms, while the reserve area is the Abruzzi National Park, the most ancient Italian park.

Chiatti et al. 1997 have reported an environmental impact study carried out about the area of Fucino, near Collarmele wind farm, and some power plants based on renewables energy sources consistent with the characteristics of the area.

Bellomo et al. 1996 have showed that wind farms must built in a proper way to allow the coexistence of it and the environment.

They also report that in order to optimise the insertion of a wind farm, it is not necessary to investigate all territorial and environmental aspects, but after a preliminary screening, efforts rather need to be directed to topics selected according to the site characteristics.

So the ENEL environmental study of the area was directed to two main topics: landscape insertion and induced noisiness in inhabited area. Some initial oppositions from the local population was just about these two aspects.

It has to be said that by the installation of greater size power units the impact should be also lower.

The preservation of primary land use designation allows the linked exploitation of the new resource (wind energy) with the traditional one that, particularly in Collarmele case, is pasture, in fact the primary land use designation is "grazing ground".

Wind energy relationship with the land use may be characterized as "major prospected resource" at first and then as "major exploited resource". So social and economical impacts may be estimated in a simple and effective way. This estimation

Tab. 3: Failures data about Trasacco drinkable water pumping station.

FUCINO LOCAL GRID: FAILURES DATA			
STATION	YEAR	FAILURE EVENTS	MTBF (h) (*)
TRASACCO (Water Pumping)	1991		
	1992	1	8760,0
	1993	8	1095,0
	1994	28	312,9
	1995	5	1752,0
Electric Outage Time (°)	1994	250 h	
(*) MTBF: Mean Time Between Failures.			
(°) Estimated value.			

Tab. 4 Failures data about Avezzano industrial area.

FUCINO LOCAL GRID: FAILURES DATA			
STATION	YEAR	FAILURE EVENTS	MTBF (h) (*)
AVEZZANO (Industrial plant n°1)	1996	100	87,6
	1997	5	724,8
AVEZZANO (Industrial Plant n°2)	1996	100	87,6
	1997	2	1812
(*) MTBF: Mean Time Between Failures.			

procedure is consistent with "value added" one (Dulas Consultants 1995) and the results show that social and economical impacts are positive resulting, at last, in greater annual income and profits for local population and in an augmented value of the land as verified for Tocco da Casauria wind farm (an other wind farm in Abruzzo) (De Pratti & Fedele 1996). However this concept is valid not only in areas like Tocco da Casauria's but it can be also extended over mountainous areas.

3. COLLARMELE WIND FARM AND QUALITY ELECTRICITY PROBLEMS OF THE LOCAL GRID

Collarmele wind farm site is at about 1,000 m a.s.l. and 1 km far from the homonymous town, in the NE of the Fucino Plain (650 m a.s.l.).This plain is a large area characterized by the presence of agricultural activities and technologically advanced industrial ones.

The wind farm consists of 36 medium size 250 kW WTGs for a total installed power capacity of 9 MW. The annual energy production will be about $14 \cdot 10^6$ kWh/year employed for 20,000 consumers.

In Collarmele surroundings stock-raising is widely performed and also the wind farm area has this use designation.

The whole area of the plateau, in which the wind farm is sited, extends about 570 Ha (1 Ha = 10,000 m^2), while the real extension of the wind farm is about 200 Ha and the surface really taken by the structures (service lanes included) is not wider than 5 Ha (2.5 % of the whole wind farm area). The fig. 1 shows the wind farm area and the

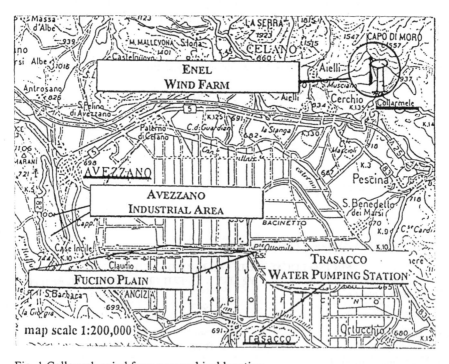

Fig. 1 Collarmele wind farm geographical location.

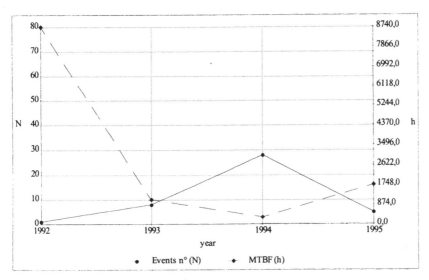

Fig. 2 Failures trend about Trasacco water pumping station.

surroundings with Fucino Plain and its main centres.

In the local grid some problems concerning the quality of electrical energy supply systems do exist. The tabs. 3 and 4 show data about failures in two different locations in Fucino Plain together an estimate of MTBF (Mean Time Between Failures).

The fig. 2 shows failures trend in different years at Trasacco drinkable water pumping station.

For the case of this new ENEL wind power plant an investigation about social-economical impact has been carried out by use of three different indirect methods, based on the estimate of the "*kWh value*" from wind source.

4. SOCIAL AND ECONOMICAL IMPACTS ANALYSIS: DATA, PROCEDURES AND RESULTS

To use the part of the plateau on which the wind farm is sited, ENEL has to pay the Commune of Collarmele for land use concession $100 \cdot 10^6$ liras/year for 29 years. This is the "*beneficio fondiario*" (Medici 1954) and the value of the land will be about $14 \cdot 10^6$ liras/Ha while with the exploitation of the primary resource (pastures) was about only $1.1 \cdot 10^6$ liras/Ha. The procedure employed is the same of Tocco da Casauria's (De Pratti & Fedele 1996) and the values of the land have been computed by use of the averaged data due to Giunta Regionale d'Abruzzo 1994 and 1995.

The presence on the land of the WTGs allows an increase in territory income and profits. The energy revenue is about 99.7 % of the total one and so it is confirmed the prevision (Chiatti et al. 1997) according to which where the primary resource income is lower then the increase due to new resource income will be greater. The tab. 6 shows a comparison with Tocco da Casauria's evaluations.

The above mentioned wind farm energy production will avoid the consumption of interesting quantities of fossil fuels resulting in substituted mix.

Tab. 5: "kWh value" from wind energy source.

Computation of the averaged "kWh value" from wind energy source					
	Energy credit	Capacity credit	Transp. credit	Avoided ext. costs	Value(£/kWh)
Average'94	L. 43,20	L. 3,00	L. 6,00	L. 36,65	L. 88,84
Average'95	L. 43,33	L. 3,00	L. 6,00	L. 36,91	L. 89,24
Average'96	L. 43,33	L. 3,00	L. 6,00	L. 36,55	L. 88,87

Tab. 6: Comparison of energy and total incomes for two wind farm in Abruzzo.

Wind Farm	Energy income	Total income	%
Tocco da Casauria	L. 104.583.600	L. 120.738.600	86,62
Collarmele	L. 14.285.700	L. 14.324.015	99,73

Tab 7: Evaluations of the "kwh not supplied".

Year\kWh not supply value	Estimate by the Author	Serrani et al. (1997) estimate
1994	L. 6.068	******
1995	L. 6.419	L. 6.800
The values are expressed as liras/kWh.		

Applying the same estimate used at Tocco da Casauria (De Pratti & Fedele 1996) it is possible to compute, on the basis of the avoided cost, the value of kWh from wind source which results in tab. 5. The estimate for Tocco da Casauria wind farm were made by use data and values taken from Hohmeyer 1990, van Wijk & Turkenburg 1990 and Sesto & Casale 1994.

When there is an interruption of energy supply we must hold the major costs for ENEL and Consumers in due consideration; these costs are synthetized into the concept of "kWh not supplied".

According to Serrani et al. 1997 this quantity may be estimated about 6,800 liras/kWh (the tab. 7 shows some evaluations for different years based on ENEL data collections (ENEL 1995 and 1996).

Electrical supply interruptions and grid failures cause many problems in local activities, for an example in drinkable water supplying. The cost increase for the local AQUEDUCTS MANAGER BOARD can be estimated, on the basis of some recent data (De Pratti 1995 and 1997), about 2-3 % for the 1994.

5. CONCLUDING REMARKS

The presence of WTGs at Collarmele wind farm causes Commune incomes improvement, a reduction in pollutants release due to a minor consumption of fossil fuels and a general improvement in the quality of local electrical supply system, with minor costs for ENEL and Consumers both.

All this signifies that Collarmele wind farm has a positive social-economical impact with a great benefit for all the parties to the case.

Before doing more complete estimates about quality improvement in local electrical grid management, operative data about wind farm are necessary.

The procedures and the evaluations made may be extended to other wind power plants, particularly Italians, installed in mountainous areas.

REFERENCES

Abia, Felix 1997. Spain: Development Moves North, in *Wind Directions*: vol. XVI, n° 3, April '97: pp.5-6.

Bellomo, B. et al. 1996. Environmental Interactions of Wind Farms. in *EWEA Conference Proceedings on "Integration of Wind Power Plants in the Environment and Electric Systems"*, Rome-Italy 7-9.10.'96: pp. 4.4/1-4.4/9.

BWEA 1994. Wind Energy for the Environment. in *Wind Directions*. vol. XIII, n° 3: pp. 24-27.

BWEA 1997. Wind power tops a billion. in *European Power News*. vol. 22, n° 4, April '97: p.22.

Cererols, N. et al. 1996. Bird Impact Study on the 10 MW Wind Farm of La Peña (Tarifa). in *EWEA Conference Proceedings on "Integration of Wind Power Plants in the Environment and Electric Systems"*, Rome-Italy 7-9.10.'96: pp. 4.5/1-4.5/5.

Chiatti, G. et al. 1997. Environmental Impact of a Combined Wind and Hydro Storage Plant. in *Proceedings ITEEC 97, International Thermal Energy and Environment Congress*, 9-12 June 1997, Marrakesh, Morocco, Symposium on New Energy Technologies, vol. 2: pp. 897-902.

Coiante, Domenico 1994. La strategia di sviluppo delle fonti rinnovabili. in *Energia-Ambiente-Innovazione*. anno 40, n° 11 nov. '94: pp. 19-28.

De Pratti, G. M. 1995. Indagine sulla risorsa idrica nella Conca del Fucino. in *Atti del 2° CONVEGNO NAZIONALE SULLA PROTEZIONE E GESTIONE DELLE ACQUE SOTTERRANEE*, Modena, maggio '95: pp. 1.213-1.219.

De Pratti, G. M. 1996. Database Eolici: Aerogeneratori. in *HTE*. anno XVIII, n° 103, sett.-ott. '96: pp. 214-219.

De Pratti, G. M. - Fedele, L. 1996. Wind-farms land occupation and economic-environmental impact. in *Proc. of the EWEA Conference on "Integration of Wind Power Plants in the Environment and Electric Systems"*, Rome, Italy, 7-9 oct. '96: pp. 2.1/1-2.1/7.

De Pratti, G. M. 1997. Affidabilità di pompe e centrali di pompaggio in sistemi di acquedotti. in *Manutenzione*. anno 4, n° 3, mar. '97: pp. 101-107.

Dulas Consultants 1995. Impact Study of Cemmaes. in *Wind Directions*. vol. XV, n° 1, oct. '95: p.4.

ENEA 1996. In crescita l'Energia eolica. in *"Notizie" in Energia-Ambiente-Innovazione*. anno 43, n° 5-6, mag.-giu- '96: p. 47.

Enel - Direzione Programmazione E Strategie 1995. *Produzione di Energia Elettrica in Italia*, anno XVIII, n° 6, giu. '95: p.6.

Enel - Direzione Programmazione E Strategie 1996. *Produzione di Energia Elettrica in Italia*, anno XIXI, n° 7, luglio '96: p.6.

ETSU 1996. Birds and Turbines Peaceful Co-existence. in *Wind Directions*. vol. XV, n° 4 July '96: p.9.

Eyre, Nick 1995. Putting a Price on the Environment - What does it mean for wind energy?. in *Wind Directions*. vol. XIV, n° 3, April '95: pp. 16-17;

Giunta Regionale D'Abruzzo - I DIP. LL.PP. L'AQUILA 1994. Valori agricoli medi, determinati ai sensi del I comma dell'articolo 16 della L. 22.10.1991, n° 865 per l'anno 1991 (applicabili per l'anno 1994). in *B.U.R.A.* anno XXV, n° 6 Speciale, Parte I-II- III-IV, 22-apr.-'94: p.2-22.

Giunta Regionale D'Abruzzo - I DIP. LL.PP. L'AQUILA 1995. Valori agricoli medi, determinati ai sensi del I comma dell'articolo 16 della L. 22.10.1991, n° 865 per l'anno 1994 (applicabili per l'anno 1995). in *B.U.R.A.* anno XXVI, n° 12 Speciale, Parte I-II- III-IV, 4-apr.-'95: p.13.

Hohmeyer, Olav H. 1990. Latest results of the International Discussion on the Social Costs of Energy - How does compare today?. in *Proc. of the European Community Wind Energy Conference*, 10-14 sept. '90, Madrid, Spain: pp. 718-724.

IEA-CERT 1995. *Enhancing the Market Deployment of Energy Technologies - A Survey of Seven Technologies - Note by the IEA Secretariat IEA/CERT(95)32*. Paris: Organisation for Economic Co-Operation and Development - IEA: pp. 133.

Invernizzi, A., Palenzona, W. 1997. Integration of wind power plants in the elctric systems: opportunities and problems. in *EWEA Conference Proceedings on "Integration of Wind Power Plants in the Environment and Electric Systems"*, Rome-Italy 7-9.10.'96: pp. O.2/1-O.2/11.

Medici, Giuseppe 1954. *Elementi di ESTIMO Rurale, Civile e Catastale*, II ed., Bologna: Edizioni Agricole: pp. 426.

Milborrow, David 1995. What happens when the wind stops blowing?. in *Wind Directions*. vol. XIV, n° 3, April '95: pp. 6-7.

Milborrow, David 1997. Wind is now cheaper than gas?. in *European Power News*, vol. 22, n° 4, April '97: p.21.

Pershagen, Bengt ed. 1994. *IEA Wind Energy Annual Report 1993*. Gotab, Stockholm, (Sweden): NUTEK: pp. 135.

Serrani, Antonio et al. 1997. La riaccensione del sistema elettrico ENEL a seguito di disservizi. in *L'Energia Elettrica*, vol. 74, n° 1, genn.-febbr. '97: pp. 21-28.

Sesto, E. - Casale, C. 1994. Costo e valore dell'energia elettrica da fonte eolica. in *Atti della Giornata di Studio ISES sez. Italiana sul tema "ENERGIA DAL VENTO: ASPETTI TECNOLOGICI ED ECONOMICI"*. 9 giugno '94 Bari: pp. 79-102.

Stanton, Caroline 1995. Wind Farm Visual Impact and its Assessment. in *Wind Directions*. vol. XIV, n° 3, apr. '95: pp. 8-9.

Steer-Diederen, K. ed. 1995. *IEA Wind Energy Annual Report 1994*. Golden, Colorado, (USA): NREL National Renewable Energy Laboratory: pp. 158.

Swift-Hook, Donald 1995. Wind farms are looking good. in *Wind Directions*. vol. XIV, n° 3, April '95: p. 5.

van Wijk, A.J.M.; Turkenburg, W.C. 1990. *Avoided fuel, capacity and emission cost by Wind Energy in the Netherlands*. in *Proc. of the European Community Wind Energy Conference*, 10-14 sept. '90, Madrid, Spain: pp. 748-752.

Wind Energy and Landscape, Ratto & Solari (eds) © 1998 Balkema, Rotterdam, ISBN 90 5410 913 0

Wind energy and public acceptance

C.Geuzendam
IVAM Environmental Research, University of Amsterdam, Netherlands

ABSTRACT: Public acceptance is a prerequisite for the continuity of the implementation of wind energy. Public acceptance is the result of a dynamic process depending on a complex of variables. To increase public acceptance a systematic approach is needed. As a start for such a systematic approach a conceptual research model is proposed in this paper. Part of the model is illustrated by empirical research on public taste concerning the design of wind turbines.

1. INTRODUCTION

In Northern Europe the public acceptance is one of the crucial factors in the slackening rate of implementation of wind energy. Public acceptance of innovations in general, however, is not a static phenomenon, but rather a result of a dynamic process of the trade-off between the costs and benefits for people in time (Rogers, 1983).

These dynamics can also be found in the acceptance of wind energy. For the implementation of wind energy the following process can be observed: first wind energy is strongly preferred above other alternatives as means of generation of electricity; in the planning phase the public acceptance decreases to its minimum just before the realisation of a wind farm; after the realisation of a project the acceptance starts to increase (Wolsink, 1990).

On one hand it is of major importance to minimise the decrease of public acceptance during the development of a specific site, while exactly at this stage of a project the go/no-go decision is made. For the continuation of the implementation, on the other hand, it is of interest to maximise the increase of public acceptance after realisation of a certain wind farm.

But what do we have to do to keep the public acceptance high? In general, public acceptance is considered to be the result of (the perception and expectations of) visual aspects, noise, land use and effects on nature of a wind farm. Some of these variables are measurable, while others are part of a complex of other interacting variables. To get a grip on the driving forces behind public acceptance this paper proposes a conceptual research model.

Part of the model is illustrated by an inventory on public taste concerning the design of wind turbines.

2. CONCEPTUAL MODEL FOR RESEARCH ON PUBLIC ACCEPTANCE

The following model is proposed as a start for a systematical approach to measure the acceptance of wind energy.

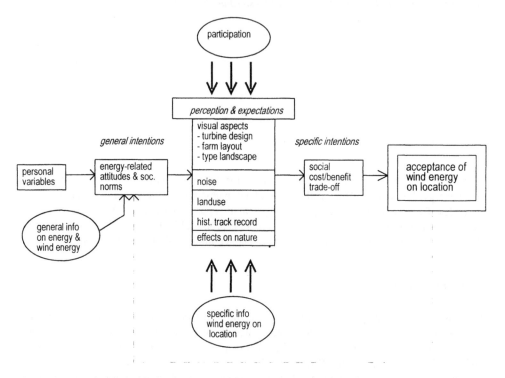

Figure 1: Conceptual model for research on public acceptance of wind energy

2.1 *Explanation of the conceptual model*

The square boxes in the model (figure 1) represent a chain of variables of which the result is a certain magnitude (+ or -) of the *acceptance of wind energy on location* on a certain moment (static). The variables in the circles enable interfering influences from the outside.

The square boxes show that *general intentions* depend on *personal variables*, such as: age, character, education and sex. On their part *general intentions* influence the perception of: *visual aspects, noise, land use, effects on nature* and the *historical track record*.
Visual aspects concentrate on the *appearances of the turbine* (design, colour and size); the *layout of the wind farm* (amount of turbines, shape and size of the farm); and the *type of landscape* the wind farm is placed in. The three visual aspects are supposed to be strongly interactive.
 Noise deals with the perception of the emitted level of noise and the resulting disturbance. *Land use* concerns the fact whether the establishment of a wind farm is conflicting with other desired activities on a piece of land. The memory of the public is called the *historical track record*. This track record concerns past positive or negative experiences with developments being reflected on a new initiative, e.g. wind energy in this case. *Effects on nature* deals for

136

example with expected influence on bird life. All variables in the central box are supposed to influence each other.

Specific intentions are based on the social trade-off of the costs and benefits of the interactive variables from the central box. The outcome of the social trade-off is the acceptance (from positive to negative) for wind energy on a specific location.

Furthermore the model supposes two stages at which variables (in the circles) can exert influence from outside. *General intentions* can be changed by providing *general information* about wind energy in relation to other energy alternatives. Specific intentions can be influenced by different types of involvement (from *information* to financial *participation*).

In our model a feed-back mechanism is supposed from *acceptance of wind energy on location* to *general intentions* (represented by a dashed line).

3 CASE STUDY: TURBINE DESIGN, WHAT DOES THE PUBLIC LIKE?

Recently a preliminary research project on public taste for wind turbine design (Geuzendam&Uitzinger, 1997) is carried out in co-operation with consultancy E-Connection. The project was commissioned by the Netherlands Agency for Energy and Environment and the wind turbine industry. The aim of the project is to find out which turbine designs the public likes and why.

The project was executed among 76 inhabitants spread out over the windy location Schagen and the town of Zutphen, situated in the interior of the Netherlands. Because of the inventory nature of the project and the relatively small research population, the results are only indicative.

The study gives answers to the following questions:
- Which design does the public like?
- Which design does the public dislike?
- Why does the public like/dislike these designs (on the basis of semantic differentials)?
- Which turbine designs does the public find most suitable for four different types of landscape (industrial, open water, meadows, and woodlands)?
- How much does the public know about wind turbines and how much general knowledge does the public have about sustainable energy c.q. wind energy?

Below the results of the study are given.

3.1 *General knowledge and appreciation of wind energy*

The choice of Schagen and Zutphen was made because of the assumption that the familiarity with wind energy influences the appreciation of turbine designs. It became clear from the research that there is a significant connection between the chosen locations and the number of times that a person sees a wind turbine: 54% of the people from Schagen, but only 10% of the people from Zutphen see a wind turbine more often than once a week.

Also was found that:
- 50% of the respondents want more information about wind energy, specifically about the energy yield and the environmental effects.
- The electricity yield of a wind turbine is underestimated considerably.
- 95% of the respondents prefer sustainable energy to the conventional ways of generating electricity (with coal and gas);
- 86% of the respondents are in favour of more wind turbine farms in the Netherlands.

Turbine desig no. 16

Turbine design no20

Turbine design no.36

Figure 2

138

3.2 *Appreciation of wind turbine designs*

The respondents were asked to select the "most beautiful", the "second most beautiful", the "most ugly" and the "second most ugly" design from the 15 turbine designs .

The illustrations of the named turbine designs are added. The illustrations were made by E-Connection.
Wind turbine design 36 is most often pointed out as both the "most beautiful" and (together with turbine 20) the "most ugly" design (figure 2).

On the basis of the number of times "most beautiful", "second most beautiful", "most ugly" and the "second most ugly" marks were given to the turbine designs by a weighing procedure. The result which can be interpreted as, the appreciation of the group, indicates turbine 24 as "most beautiful" and turbine 22 as "second most beautiful" (figure 3). Also according to the appreciation of the group, turbine 36 is the "most ugly", followed by "second most ugly" (see figure 2) turbines 20 and 16. The respondents from Schagen and Zutphen agree on "most beautiful" and "second most beautiful"; about the ugliness of the turbines they have different opinions. This indicates that the appreciation of the group depends on the location or in other words, the familiarity with wind energy.

3.3 *Why do respondents like or dislike a wind turbine?*

The "why" behind the appreciation was investigated with 14 semantic differentials: the semantic differentials express an emotional value such as for instance organised/untidy. The research shows that there is a connection between the semantic differentials light/heavy, balanced/unbalanced and "beautiful" and "ugly", i.e.: a light and/or balanced design is considered beautiful and a heavy and/or unbalanced design is considered ugly.

3.4 *Grouping of turbine designs (and group appreciation)*

By means of 'trial-and-error' we investigated which turbines match with each other and how these clusters of turbines are appreciated by the group.
It became clear that one part of the respondents likes 2-bladed turbines and dislikes 3-bladed turbines, while the other part likes 3-bladed and dislikes 2-bladed turbines.

A detailed subdivision giving systematic insight in the group appreciation of other characteristics than only the number of blades (e.g. design of nacelle or tower) would be valuable. For such a subdivision a larger number of respondents and a systematic approach in the design of the turbines is needed.

3.5 *Appreciation of wind turbine designs in the landscape*

The respondents were asked which wind turbine design they find most suitable for four different types of landscape (industrial, open water, meadows, and woodlands).
The results indicate that the respondents try to connect the designs with the landscape: a beautiful turbine with a beautiful landscape and an ugly turbine with an ugly landscape. In addition to this, other (vertical) elements in the landscape seem to play a role in the preference for a turbine design.

Turbine design no.22 Turbine design no.24

Figure 3

4 REFERENCES

Geuzendam, C. & Uitzinger, J., 1997, *Wind turbine design, what does the public like? (Dutch: Design van windturbines, wat vindt het publiek mooi?)*, IVAM Environmental Research, University of Amsterdam

Rogers, E.M., 1983, *Diffusion of innovations*, New York: Free Press

Wolsink, M., 1990, *Attitudes, expectations and values in relation to wind energy, (Dutch: Attitudes, verwachtingen en waarden met betrekking tot windenergie)*, IVAM Environmental Research, University of Amsterdam

Wind Energy and Landscape, Ratto & Solari (eds) © 1998 Balkema, Rotterdam, ISBN 90 5410 913 0

Improving siting acceptance by involvement analysis

T. Weller
Fair Energy, Unterföhring, Germany

ABSTRACT: Siting acceptance is one of the most critical problems in wind energy. Whereas the open discussion is mainly on "impact on landscape" versus "climate protection", we argue, that quite some personal "hidden arguments" influence the discussion. After discussing some basic assumptions on multistakeholder debates a 4-step approach is proposed which diminishes the impact of negative arguments while strengthening the positive ones. Step one is to act pro-actively and to avoid building up negative attitudes within a community. Step two is to understand and analyse all opposing stakeholders. The next step is to turn opponents into proponents by individual action plans, and finally we have to look for win-win-situations where all major players can profit by the wind energy project.

1 THE IMPACT OF HIDDEN ARGUMENTS

When a new wind energy project is planned, at the beginning of a discussion many arguments are used by opponents and proponents. The arguments in favour of such a project are
- CO_2-free energy
- no depletion of limited supplies
- guaranteed availability of indigenous resources
- support of decentralised energy structures
- creation of local working places
- local community income

Opponents of wind energy, on the other hand, focus on
- visibility of WECs
- their land consumption
- impact on birds
- noise
- disco-effect
- unreliable energy production
- safety problems

After some time, however, most controversies will be resolved and typically only two arguments are left over: the negative impact on landscape on one side, and the positive effects of clean, renewable energy on the other side. Eventually, a compromise has to be found between those two conflicting aspects.

This is a typical example of a multistakeholder policy debate (Connors 1996) where the interpretation and evaluation of performance measures differ markedly from stakeholder to stakeholder. Starting with many variables, consensus is reached on most of them in a rather short

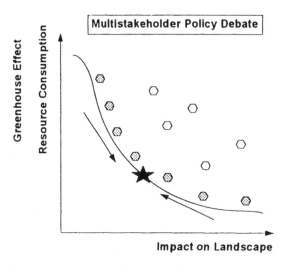

Figure 1. Compromising between two "soft" variables

time, but especially those soft variables, which cannot be reduced to a single performance measure, remain the critical ones (Figure 1).

Whenever people refer to the impact on landscape and the ecological benefits of wind energy, it may well be that those two arguments are really of prime importance for them. There are, however, quite often additional arguments concealed under the pretence of those "socially accepted" aspects. Those hidden arguments are mostly of personal nature and even if people will seldom admit that they are guided by them, their influence cannot be overestimated. Hidden arguments can be found in the minds of opponents and proponents alike. Arguments of opponents include

- lost business (why am I not involved in this profitable project?)
- traditionalism (we never have approved such a machine in our region)
- envy (why is my neighbour earning money with wind energy and not me?)
- personal conflicts (I oppose everything what this neighbour wants to achieve)

Arguments of proponents include

- personal financial profit
- self-actualisation (once in my lifetime building such a powerful monument)
- personal conflicts (I do everything to bother my neighbour)

Whenever we find out the hidden arguments of the opponents of a wind energy project and succeed in resolving their real issues, there is a good chance, that the respective person will change his / her negative attitude towards the project.

2 INFLUENCE DIAGRAMS

Trying to influence every person and every organisation which opposes a given wind energy project is an unmanageable task which exceeds the capabilities of any project team. It is therefore important to focus on those stakeholders where the best effect can be obtained with the least effort. To achieve this goal all major stakeholders have to be defined (Figure 2). As a next step, we define in a matrix for each stakeholder the degree to which he/she influences any other stakeholder. The result is shown in Figure 3 (Gausemeier, Fink 1996). The stakeholder characteristics are visualised by their positions within the diagram:

- "reactive" or "inactive" forces don't really influence other forces. They don't play an important role in a given situation. Visitors or WEC-manufacturers are examples of those stakeholders.

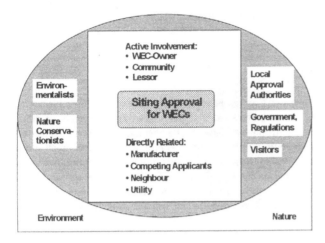

Figure 2. Stakeholders in a wind energy project

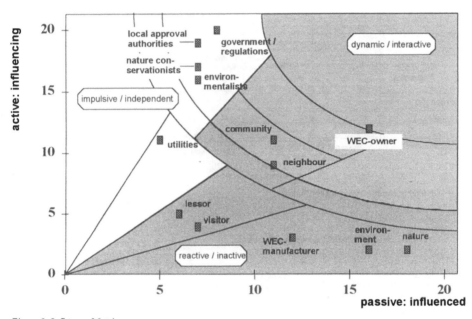

Figure 3. Influence Matrix

- "impulsive" or "independent" factors are only weakly influenced, but exert themselves strong influence. They are those elements which define the overall framework conditions in any project. Governments, nature conservationists or environmentalists are examples.
- "dynamic" or "interactive" forces influence strongly, but are also heavily influenced by others. They are the obvious candidates for any lobbying activity.

The apparent consequence of this analysis is that apart from the WEC-owner the local community and the neighbours of a WEC-site are the prime candidates for any short term activity by which we try to influence stakeholders in a given project. Other players are either not important enough, or they are so hard to influence, that we need a much longer time span to change their behaviour (examples: governments or utilities). In the context of a specific project

there is not enough time for such long term lobbying, which is primarily driven by environmentalist groups or trade associations.

3 CLASSIFYING HIDDEN ARGUMENTS

Not all arguments in favour of or against wind energy have the same weight. Maslow's hierarchy of needs is well known - basic needs have to be covered first, and only then the weight of other factors increases. Additionally, personal arguments have to be distinguished from collective (social) ones (Figure 4), and experience tells us that personal benefits are regarded much more important than collective improvements. Within those two segments, the Maslow pyramid differs. Financial needs are of prime importance for an individual, with safety ranking second and Ego-related factors third. Environmental factors are quite low on the personal scale. Looking at collective needs, the priority sequence is rather inverted. Social aspects rank highest, financial aspects lowest.

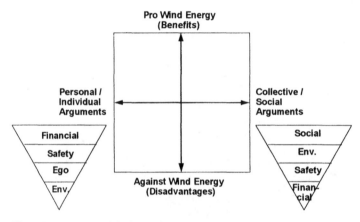

Figure 4. Arguments and the Hierarchy of Needs

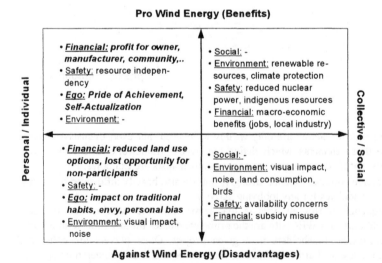

Figure 5. Pro's and Con's (hidden arguments in italics)

In Figure 5 we list the major arguments which are used in any wind energy discussion according to their hierarchy. The interesting fact is, that all hidden arguments (which are represented in italics) are personal ones, and that they rank very high on the value scale, for proponents of wind energy projects as well as for their opponents. This stresses once more the intuitive impression that people are mostly influenced by those factors, which they don't mention in public discussions, and that their public statements do seldom correspond to their real thoughts.

4 A FOUR-STEP-PROCESS TO IMPROVE SITING ACCEPTANCE

Based on these insights we developed a four-step approach which copes with hidden arguments and thereby improves chances of getting a WEC-project accepted.

The first step is maybe the most important one. It concentrates on setting a favourable background for the project and on avoiding the build-up of negative attitudes. The key aspect is to act pro-actively. Before an opposition will be established, we have to inform communities and neighbours on the technology of wind energy, its benefits, on the project itself, its background, the approval process etc. We have to position the project not as "our" project, but as "their" project, the project of the respective community. Every potential stakeholder should have a chance to participate in the project and therefore to exploit its perceived benefits.

Everything has to be done to reduce potential mistrust. Therefore from the beginning best practice guidelines have to be applied, and none of the "smart" approaches should be used, which are maybe accepted within a business society but which are regarded tricky and even unethical in the often rural environment in which WECs are being planned.

Such an approach should help to keep opposition rather low, but will never guarantee its absence. As a second step we therefore have to analyse all opposing stakeholders to quite some depth. What are their expressed and - even more important - hidden arguments against the project? What is the relationship of the opponent to the other key players in the project? What is the story behind the story?

This is a time- and effort-consuming activity and there may be a tendency to prefer shortcut-solutions. For example the open confrontation with an "unreasonable" opponent instead of the tedious task to understand his views in full detail. But engaging in emotional controversies is definitively the wrong approach. The responsibility of a project team is to make its project

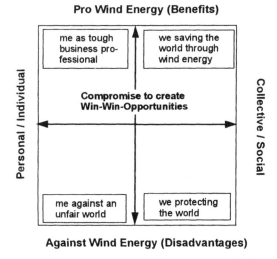

Figure 6. Absolute views against compromising

successful, and that is best achieved by behaving in a rational, business-like way, even if others act differently.

At the end of this step we hopefully have all information to start the third step: creating individual action plans for each major opponent person or group. Basis for those plans should be the argument matrix in Figure 4. Meeting with the respective opponents we should try to offset their personal objections by personal benefits - the higher up the Maslow pyramid the better - and to offset collective objections by collective benefits. Trying to balance personal objections ("This windpark is going to reduce my real estate value") by collective benefits ("But it will reduce environmental pollution by many tons of CO_2") is not likely to be very effective. But also the approach to offset collective objections against personal benefits should be avoided: it is regarded unethical, too close to bribery and may be easily used against the project.

The best projects are those in which everybody wins. This is the fourth step: finding the right level of compromises. It is not always easy to arrive at such win-win-situations. Whenever opposing stakeholders get additional benefits, the profit of the project owner is likely to be reduced. But in the long term win-win-projects have proven to be far superior to enforced power-solutions, especially for long term operations in a dynamic regulatory environment. Besides that, they often work as catalyst for other projects.

Very often, however, we encounter people with fundamentalistic, absolute views (Figure 6). They do not accept win-win-situations and are therefore difficult to deal with. Such behaviour is not restricted to opponents, but can also be found among the proponents of wind energy.

We tend to like absolute proponents, because they are totally committed to wind energy. But in negotiations a good degree of control over them is needed. They are able to destroy with some few statements the entire relationship with some hard opponents, which was built over months.

More difficult are absolute opponents. If we meet 100% resistance, there are only two ways to cope with. At first, we try to keep such opponents isolated and support counterforces which are able to neutralise them. If their opposition is too strong, however, a project team normally doesn't have time and energy enough; it should step back from the project and look for a better opportunity.

5 SUMMARY

Visibility of WECs is in most cases mentioned as the major issue in improving their siting acceptance. There can and will be no neutral measure for the impact of visibility - it is all a matter of personal assessment. This is badness, because it means that there is no technical solution to the problem. But it is also goodness, because it means that it is all a people's game, and that we can be very successful by understanding the motivation, the fears and the hopes of all involved stakeholders. By applying an involvement analysis process and by dealing with all stakeholders in a responsible manner we cannot guarantee the success of a project. But we will certainly reduce the level of troubles and surprises, take better decisions and eventually will improve the success rate of our wind energy projects.

REFERENCES

Connors, S.R. 1996. Informing decision makers and identifying niche opportunities for windpower. *Energy Policy* Vol.24, No. 2: pp 165-176
Gausemeier, J & Fink, A. 1996. *Neue Wege zur Produktentwicklung*. Paderborn: Heinz-Nixdorf Institut

Wind Energy and Landscape, Ratto & Solari (eds) © 1998 Balkema, Rotterdam, ISBN 90 5410 913 0

Multicriteria decision-aid tools for attaining greater public acceptance in renewable energy sources exploitation

E.Georgopoulou & D.P.Lalas
National Observatory of Athens, Greece

ABSTRACT: Public acceptance forms a crucial parameter for a successful development of renewable energy sources (RES). Public opinion is influenced by many factors, often conflicting, such as potential adverse environmental impacts, social and political impacts, economic and technical aspects. Furthermore, public perception is usually expressed by individuals or/and groups with different points of view. In such problems, a multicriteria decision-aid (MCDA) approach can be considered as a valuable tool for resolving conflicts and achieving better decisions. In this paper, the MCDA methodology is applied in a Greek island, Crete. Alternative scenarios for RES development are formulated and their whole range of potential impacts is assessed. The various options are ranked for each actor involved using a particular MCDA method, while a number of sensitivity analyses is carried out. Conflicts are pointed out and possibilities for reaching a consensus are indicated. Finally, conclusions on the advantages offered by MCDA for the achievement of a greater public acceptance in similar problems are drawn.

1. INTRODUCTION

Since the introduction of the sustainable development principle in 1992, the chain of energy supply, transformation and consumption has been identified as a target sector for the implementation of corrective and especially prevention measures. The large-scale development of renewable energy sources (RES), together with rational energy use, indicate an entirely different approach than the one followed during the seventies and eighties, as these measures can lead to the significant reduction of pollutants' emissions and conservation of natural resources.

However, RES present different characteristics from conventional fuels, namely a large dispersion, a low energy intensity and a much smaller size of technology interventions. This fact brings forth the need to shift from the national to the regional/local level during energy planning procedures. Furthermore, although RES are practically free from many adverse impacts (e.g. air pollution), they may imply other environmental interventions, such as visual intrusion, noise, land requirements etc. These impacts can be significant when examined at a local level, where people really face the consequences of any direction adopted in energy policy.

As it is often emphasised by experts involved in the field, public acceptance forms a key-issue for a large scale RES development ("An Action Plan for Renewable Energy Sources in Europe" 1994). However, public opinion is not formulated instantaneously, but on the contrary during a relatively long period, when information and participation procedures can - and must - take place. In order to convince the public that renewable energies may offer an interesting and acceptable energy alternative, two factors are necessary : the proper assessment of the whole range of potential impacts (economical-technical, together with social-environmental) and the

proper consideration of the points of view of the various actors involved. Furthermore, as the answer to the question *"Which renewable technologies and to what extent should be developed?"* is not predefined, a comparison of alternative strategies is required. In contrast to studies carried out in the past, where renewable technologies were compared to each other and/or to conventional ones (Siskos & Hubert 1983), the need to satisfy energy demand under real-world constraints (e.g. existing RES potential, legislative and technical limitations, level of energy demand per specific use etc.) implies the formulation of realistic alternative scenarios involving a combined development of renewable technologies.

For the above mentioned reasons, the multicriteria decision-aid (MCDA) approach can be considered as a valuable tool for resolving conflicts and achieving better decisions, as it allows for a sound comparison of alternatives on the basis of the evaluation criteria selected, while it provides the possibility to clearly identify the different preferences of the various actors involved.

The aim of this paper is to indicate how such a procedure can be applied in a real-world problem - namely the development of RES in a Greek island - and to highlight the most important aspects to be taken into account during such a procedure so that actors come up not with a unique optimal solution, but with a knowledge on the overall potential consequences that their final decision will imply.

2. APPLICATION OF THE MCDA APPROACH IN CRETE ISLAND

2.1 The problem

The island of Crete is the fifth largest island (8,331 km^2) in the Mediterranean Sea and is located at the southernmost part of Greece. Its permanent population is approximately 540,000 inhabitants, while it is significantly increased during summer due to tourists' arrivals. Regarding electricity supply, the island's grid is autonomous and actually comprises fossil-fired steam turbines (111.2 MW), internal combustion engines (49.2 MW), gas turbines (108.6 MW), a combined-cycle unit (133.4 MW), small-hydroelectric plants (0.6 MW) and wind farms (7.1 MW). Energy supply is accomplished by import of fossil-fuels (diesel oil, heavy fuel oil, LPG and gasoline) from the mainland. Actual RES exploitation in end-use is limited to solar collectors for water-heating purposes in the residential sector and hotels (approximately 130,000 m^2) and traditional biomass use (which however is continuously declining) in rural areas mainly for space-heating purposes.

Electricity demand in Crete increased rapidly during the last years, presenting an annual rate of increase almost double compared to that of the mainland (9% and 5% respectively). The domestic and tertiary sectors account for 70% of the total electricity consumption (Public Power Corporation 1975-1994), thus being the most intensive electricity consumers. The fact that some of the existing power units are old and consequently have a low energy performance and often imply maintenance works, in combination with the rapid increase of electricity demand, has lead to several failures of the electricity system during the last years. In order to deal with these peaks, the public utility (PPC) had to overuse gas turbine generators - which have a high specific fuel consumption rate - and thus the electricity production cost has increased substantially (National Technical University of Athens 1996a). Thus, it is generally accepted that there is an urgent need for new power generation installations. However, there is not a unanimous perception on the direction of this extension. Since many years, PPC's development plans have been directed toward the construction of a new conventional power station. After investigating several sites, a suitable location at a rather isolated area and relatively far from rural communities has been selected. However, neighbouring communities and NGOs strongly oppose this solution claiming that the environment will be seriously degraded, while there are other actions - namely the large-scale development of renewable energies and energy conservation - which can provide a solution to the problem faced. Despite this opposition - rigidly expressed during public hearings and conferences - PPC proceeds to the first phase of the construction, comprising the installation of two internal combustion engines of a total capacity of 80 MW. Regarding the second construction phase, namely the installation of two steam turbines of a total capacity of 80-120 MW, final decisions have not been taken, as an alternative to heavy fuel oil combustion examined is the use of LNG.

2.2 Estimation of future trends and prospects

2.2.1 The "Reference Scenario"

The "Reference Scenario" for the year 2005 (i.e. the target year of the present study) forms the basis for the formulation of alternative options to be examined, as well as for the evaluation of these options according to selected criteria. The basic assumptions in building this scenario are the following: a) Energy requirements in end-use activities will follow the past trends observed. In order to estimate this future evolution, simple prediction models concerning a number of characteristic parameters per end-use activity (e.g. number of households or buildings, cultivated area per crop type, bed capacity in hotels etc.) are applied. Regarding the contribution of the various energy forms to the satisfaction of energy requirements, no radical changes are considered, apart from a normal evolution (e.g. a gradual substitution of traditional biomass use by diesel oil in space heating etc.). Further information on the results of these models can be found in relevant studies (National Technical University of Athens 1996a; National Technical University of Athens 1996b). b) As for electricity generation, it is assumed that the construction of the new fossil-fired power station will be completed by the year 2005 (both the first and the second phase, the latter implying the use of heavy fuel oil). As for renewable energies, apart from licences already granted by the Ministry for Development, no other changes are foreseen.

2.2.2 Maximum RES penetration

For the estimation of the maximum RES penetration for the year 2005 (Table 1), relevant research studies on the potential of RES already carried out were used (National Technical University of Athens 1996a; National Technical University of Athens 1996b; Union of Municipalities of Crete 1993). It should be noted that in order to estimate the maximum penetration of certain renewable technologies, such as wind farms, the existing technical constraints (i.e. maximum capacity limits) were also taken into account.

Table 1.
Maximum penetration of renewable energies for the year 2005

Renewable energy form	Maximum penetration	Remarks
WIND ENERGY	160 MW	Grid-connected wind farms. The figure corresponds to the maximum capacity limit.
SMALL-HYDROS	3.7 MW	
SOLAR ENERGY		
Solar collectors in residential	261,964 m^2	*End-uses* : water heating and combined space/ water heating (60% and 4% of total households respectively).
Solar collectors in rest buildings	165,316 m^2	*End-uses* : water heating in hotels (80% of total bed capacity), space heating and combined space/cooling in public buildings (10% and 5% of total energy requirements respectively), water heating and combined space/water in hospitals (45% and 10% of total energy requirements respectively).
Solar collectors in industry	39,876 m^2	Low and high efficiency collectors (30% and 10% of low and medium-temperature requirements respectively)
Roof-top PVs	1 MW	Penetration in 10% of new (i.e. after 1995) semi-urban households.
PVs central	2 MW	Grid-connected power station located in the south of the island.
BIOMASS		
Central co-generation units	20 MW	Co-generation units located in the two agricultural areas of the island, using agricultutal by-products (olive kernels etc.)
Co-generation in industry	5 MW	Application in food industry, agricultural products industry etc.
Advanced systems	20,641 units	Penetration in 15% of semi-urban and 20% of rural households for water and space heating purposes.

2.3 Formulation of alternative scenarios

The alternative scenarios formulated for Crete are presented in Tables 2 and 3.

Table 2.
Penetration of renewable technologies (in addition to the "Reference scenario" REF) - Case A

Renewable energy form	REF	ALTERNATIVE SCENARIOS - CASE A							
		A1	A2	A3	A4	A5	A6	A7	A8
WIND ENERGY (MW)	31.5	-	79	-	57	40	79	40	40
SMALL-HYDROS (MW)	0.6	-	-	-	-	-	-	-	-
SOLAR ENERGY									
Solar collectors									
Residential (m^2)	145165	-	107763	103689	103689	49702	47665	107763	49702
Rest buildings (m^2)	100906	-	33948	-	-	17283	17283	33948	17283
Industry (m^2)	-	-	39876	-	-	20051	20051	39876	20051
PVs									
Roof-top (MW)	-	-	-	-	-	-	-	-	-
Central (MW)	-	-	-	-	-	-	-	-	-
BIOMASS									
Central cogeneration units (MW)	-	-	10	-	-	5	5	5	10
Cogeneration in industry (MW)	-	5	5	5	5	2	2	2	5
Advanced systems (number)	-	-	18954	3708	3708	9477	9477	9477	18954

Table 3.
Penetration of renewable technologies (in addition to the "Reference scenario" REF) - Case B

Renewable energy form	REF	ALTERNATIVE SCENARIOS - CASE B							
		B1	B2	B3	B4	B5	B6	B7	B8
WIND ENERGY (MW)	31.5	-	129	29	79	64	129	64	64
SMALL-HYDROS (MW)	0.6	3.1	3.1	3.1	3.1	3.1	3.1	3.1	3.1
SOLAR ENERGY									
Solar collectors									
Residential (m^2)	145165	-	116799	103400	103400	54375	54375	54375	116799
Rest buildings (m^2)	100906	-	64410	-	2446	32446	32446	32446	64410
Industry (m^2)	-	-	39876	-	-	20051	20051	20051	39876
PVs									
Roof-top (MW)	-	-	1	-	-	0.5	0.5	0.5	1
Central (MW)	-	-	2	-	-	1	1	1	2
BIOMASS									
Central cogeneration units (MW)	-	17	20	17	17	19	19	20	19
Cogeneration in industry (MW)	-	5	5	5	5	5	5	5	5
Advanced systems (number)	-	-	14481	-	20641	10371	10371	20641	10371

The formulation of alternative scenarios for RES exploitation was carried out in two successive stages :

• **Stage 1.** A multi-objective linear programming (MOLP) model has been formulated, comprising two objective functions, namely the total investment cost and the supply of fossil fuels, as well as a number of appropriate constraints. Two cases were considered : *Case A* (completion of both phases of the new fossil-fired power station) and *Case B* (only construction of the first phase, comprising two internal combustion engines of 80 MW in total). The model was applied in each of the two cases, providing a set of "non-dominated" solutions (i.e. solutions such that when one moves from one to other, improvement in one objective function is accompanied by worsening of the other). By a "filtering procedure" (Diakoulaki et al. 1996), four alternative scenarios in each case (i.e. A and B) are identified.

• **Stage 2.** Next, in each of the cases A and B, additional combinations are formulated, either focusing on a specific renewable energy form (which is exploited at its maximum limit) - resulting in three more scenarios in each case - or involving a balanced RES development (i.e. all RES present a moderate penetration). Thus, the total number of final scenarios equals to 16 (A1-A8 from stage 1 and B1-B8 from stage 2).

2.4 Multicriteria analysis

2.4.1 Definition of evaluation criteria

The set of evaluation criteria was selected as to encompass all possible consequences of RES penetration, both positive and negative. As shown in Table 4, they represent the surplus impact in comparison to the Reference Scenario (except if a different definition is given, as in criteria N° 3, 4, 6 and 8).

Table 4.
Set of evaluation criteria

A/A	CRITERIA	DIRECTION	ATTRIBUTES & MEASUREMENT UNITS [1]
C1	Investment cost	min	billion GRD, in addition to REF
C2	Electricity generation cost	min	billion GRD/y, in addition to REF
C3	Safety in covering peak load	max	% above peak power
C4	Operationality	max	MACBETH scale (0 - 100)
C5	Contribution to employment	max	number of new jobs/y (10^3), in addition to REF
C6	Air quality	max	% decrease of "pollution index" compared to the year 1992
C7	Risk of climate change	min	% increase of CO_2 emitted compared to the year 1992
C8	Visual amenity	max	MACBETH scale (0 - 100)
C9	Conservation of non-renewable energy sources	max	TJ of conserved fossil fuels (10^3), in addition to REF
C10	Land use	min	Ha of occupied land, in addition to REF
C11	Noise	min	dB(A) added × population affected (10^6) compared to REF

[1] "REF" denotes the "Reference Scenario" for the year 2005

Final alternative scenarios were evaluated according to the above presented criteria set. It should be noted that :

• Regarding *investment cost* (i.e. criterion N° 1), the construction cost for the second phase of the new fossil-fired power station was subtracted from the total in the case of scenarios B1-B8. As for the investment cost of wind farms, it differentiates between scenarios not only because of the total installed capacity, but also because of different installation sites.

151

- Regarding *safety in covering peak load* (i.e. criterion N° 3), it is assumed that the penetration of RES in end-uses - resulting in a substitution of electricity - will not affect the load factor of the electricity system (which is 55% in the "Reference Scenario"). Consequently, the peak power demand P_N (in MW) for a scenario N is calculated according to the equation $P_N=E_N/(0.55/8.76)$, where E_N is the electricity demand of this scenario (in GWh).

- In the case of *operationality* (i.e. citerion N° 4), renewable technologies were classified in three types : a) Type A, comprising fully commercial technologies (i.e. solar collectors for water heating and traditional biomass use for space heating) b) Type B, comprising moderately mature technologies (i.e. wind farms, advanced biomass systems and small hydroelectric works) and c) Type C, comprising technologies with a rather demonstration character (i.e. all the rest renewable technologies). Alternative scenarios were classified into 10 categories (X1: best, X10: worst) according to the contribution of RES to the total energy supply and the distribution of energy from RES in the three categories mentioned before (Table 5).

Table 5.
Classification of alternative scenarios

| Category | Scenarios | RES in supply (%) | Type of renewable technologies | | |
			A (%)	B (%)	C (%)
X1	A1	7.0	51.3	46.5	2.2
X2	A3	8.7	41.3	25.5	33.2
X3	B1	10.2	18.2	18.3	63.5
X4	A4	10.6	28.4	48.8	22.8
X5	A5 / A7	10.3 / 10.9	24.6 / 29.3	37.0 / 34.3	38.4 / 36.4
X6	A6	11.6	20.5	47.6	31.9
X7	A8 / B3	12.8 / 11.8	18.0 / 21.6	27.0 / 26.7	55 / 51.7
X8	A2 / B8	14.7 / 15.1	19.1 / 18.9	34.7 / 29.6	46.2 / 51.1
X9	B5 / B4 / B7	14.4 / 15.4 / 15.3	15.3 / 14.6 / 13.9	31.2 / 32.6 / 28.5	53.5 / 52.8 / 57.6
X10	B6 / B2	16.8 / 18	12.8 / 15.4	42.6 / 39.2	44.6 / 45.4

Next, the MACBETH approach (Bana e Costa & Vansnick 1994) was applied. In specific, categories were compared in pairs and by answering the question "*How much more attractive is category x compared to category z ?*", an ordinal score was attributed to each pair (e.g. weak attractiveness, extreme attractiveness etc.). Then, ordinal statements are converted into cardinal ones by the use of a specific linear optimization model. The initial statements and the final scores are presented in Figure 1.

- For the calculation of scores according to the *employment* criterion (i.e. N° 5), data provided from literature, as well as by the Greek Association of Solar Manufacturers were used.

	X1	X2	X3	X4	X5	X6	X7	X8	X9	X10	MACBETH scale
X1		2	3	4	4	4	5	6	6	6	100
X2			2	3	3	4	4	5	6	6	86.7
X3				2	2	3	3	4	5	6	73.3
X4					1	2	3	4	4	5	60.0
X5						1	2	3	4	5	53.3
X6							2	3	3	4	46.7
X7								2	2	3	33.3
X8									1	2	20.0
X9										1	13.3
X10											0

Note: *1*: negligible, *2*: weak, *3*: moderate, *4*: strong, *5*: very strong, *6*: extreme

Figure 1.
MACBETH scale for the criterion of operationality

- In order to calculate the *"pollution index"* of alternative scenarios (i.e. criterion N° 6), the "Critical Surface-Time" method was used (Jolliet 1994). Emissions concern SO_2, CO, NO_x and particulates. For each of these pollutants, the method provides for an aggregation pollution factor, taking into account the relevant toxicity of each pollutant, as well as its overall lifetime in the atmosphere. Individual pollution factors are combined with energy consumption and emission data figures in order to produce the overall "pollution index" of a scenario.

- For the calculation of scores according to criterion N° 7 (i.e. *Risk of climate change*), CO_2 emission factors for the various fuel types derived from EUROSTAT and PPC (Ministry for the Environment, Physical Planning and Public Works, 1995).

- In the case of the *visual amenity* criterion (i.e. N° 8), it was assumed that only wind energy may imply a possible threat for visual amenity. Thus, alternative scenarios were sorted according to the added MW of wind energy compared to the "Reference scenario" and the concentration of wind farms to the prefecture of Lassithi (where there is a high tourist activity, while there is a possible threat for over-concentration of wind farms because of the favourable wind potential). Thus, seven distinguishable categories were identified (Table 6).

Table 6.
Classification of alternative scenarios

Category	Scenarios	MW added	Concentration (%)
X1	A1 / A3 / B1	-	-
X2	B3	28	36
X3	A5 / A7 / A8	39	64
X4	A4	57	44
X5	B5 / B7 / B8	64	39
X6	A2 / A6 / B4	79	32
X7	B2 / B6	128	27

As in the case of criterion N° 4, the MACBETH approach was applied. The initial statements and the final scores are presented in Figure 2.

	X1	X2	X3	X4	X5	X6	X7	MACBETH scale
X1		1	3	3	4	5	6	100
X2			2	3	4	5	6	94
X3				1	2	4	5	71
X4					1	3	5	65
X5						2	4	53
X6							4	35
X7								0

Note: 1: negligible, 2: weak, 3: moderate, 4: strong, 5: very strong, 6: extreme

Figure 2.
MACBETH scale for the criterion of visual amenity

- In the case of criterion N° 10 (i.e. *Land use*), only 3% of the total area occupied by wind farms was considered to be prohibitive for the development of alternative land uses.

- Regarding *noise* (i.e. criterion N° 11), the population of villages and towns within a specific radius close to each electricity generation facility was determined by using detailed maps and data from the National Statistics. Next, by using appropriate equations (Lipscomp & Teylor, 1978), as well as data from literature on noise emissions for the various technologies, the noise level at each village/town within the specific radius was calculated. Only the cases where the

background noise level increases by more than 10 dB(A) were taken into account. Then, the total noise impact is calculated by multiplying the incremental noise level with the population affected.

The scores of the final alternative scenarios according to the criteria selected are presented in Table 7.

Table 7.
Scores of final alternative scenarios (Evaluation matrix)

	CASE A								CASE B							
	A1	A2	A3	A4	A5	A6	A7	A8	B1	B2	B3	B4	B5	B6	B7	B8
C1	1.4	63.8	9.1	36.2	32.5	49.3	38.6	40.5	-16	70.6	4.1	33.4	28.4	57.3	32.7	39.6
C2	-1.2	-3.6	-4.4	-4.5	-1.9	-2.4	-3.4	-1.9	24	9.9	17.1	12	15.5	12	15	13.2
C3	27.7	34.4	31.6	31.6	30.2	30.2	32.2	32.3	9.2	14.6	12.3	13.2	12	12	12.6	14.3
C4	100	20	86.7	60	53.3	46.7	53.3	33.3	73.3	0	33.3	13.3	13.3	0	13.3	20
C5	0	1.71	1.03	1.06	0.82	0.81	1.68	0.82	-155	1.78	0.89	0.94	0.78	0.81	0.78	1.75
C6	0	10.9	1.2	7.2	5.1	9.5	6.2	5.4	-5.8	9.7	-2	2.6	1.3	8.2	1	2.6
C7	37.8	21.2	35	27.8	30.4	25.8	28.7	27.7	37.3	14.6	30.8	22.5	25.3	17.2	24.4	23
C8	100	35.3	100	64.7	70.6	35.3	70.6	70.6	100	0	94.1	35.3	52.9	0	52.9	52.9
C9	0.5	5.3	1.3	3.4	2.7	3.9	3.1	3.4	0.4	7.1	2.3	4.7	3.9	6.3	4.2	4.6
C10	0	326	0	207	162	306	162	181	-284	270	-182	2	-4	226	0	36
C11	0	60.6	0	11.0	46.5	55.6	46.5	51.5	46.9	67.6	48.8	60.7	56.5	67.6	56.5	56.5

2.4.2 Determination of criteria weights

In order to get a clear picture of the different points of view related to the problem faced, the following actors have been considered as being the most important :

1. Ministry for Development/Department of Energy (MD)
2. Ministry for the Environment, Physical Planning and Public Works (ENV)
3. Ministry for Agriculture (MAG)
4. Public Power Corporation/Division for Renewable Energies (PPC)
5. Centre for Renewable Energy Sources (CRES)
6. Technical Chamber of Greece (TCG)
7. Association of Solar Manufacturers (ASM)
8. NGO "New Ecology" (NGO)

Each of these actors was asked to rank the evaluation criteria by order of importance, following the "cards' method" developed by Simos (Simos 1990). The implementation of this technique presupposes the ranking by each actor of the various criteria in a decreasing order of

Table 8.
Weight values of evaluation criteria

Criteria	MD	ENV	MAG	PPC	CRES	TCG	ASM	NGO
C1	15.35	6.44	6.06	11.74	15.91	3.8	1.48	9.09
C2	15.35	6.44	7.58	14.78	15.91	5.06	1.48	7.58
C3	7.89	1.49	4.55	17.39	9.09	10.13	1.48	4.55
C4	7.02	1.49	12.88	8.7	7.58	11.39	11.85	6.06
C5	13.16	14.85	12.88	6.96	3.79	16.46	14.81	10.61
C6	11.84	3.96	16.67	15.65	11.36	13.92	17.04	16.67
C7	11.84	17.33	10.61	2.61	11.36	1.27	17.04	13.64
C8	2.63	9.41	3.03	4.78	3.79	8.86	5.93	12.12
C9	0.88	17.33	9.09	11.74	13.64	15.19	17.04	15.15
C10	9.65	9.41	1.52	0.87	1.52	6.33	5.93	1.52
C11	4.39	11.88	15.15	4.78	6.06	7.59	5.93	3.03
TOTAL	100	100	100	100	100	100	100	100

preference. Indifference between criteria is expressed by placing them in the same rank, while spacing between criteria implies a higher weight to the upper ranked criterion. Then, weight values are calculated. The results are shown in Table 8.

2.4.3 Application of ELECTRE III

In order to translate the decision maker's judgments concerning the relative importance of the evaluation criteria into a global preference on the alternative scenarios, the use of a particular method of multicriteria analysis is required. One of the most widely applied outranking MCDA methods available is ELECTRE III (Roy 1990). A basic concept of ELECTRE III is the concept of *pseudo-criterion*. In the case of a *real-criterion*, actions *a* and *b* are indifferent according to this criterion only if their performance is equal, otherwise *action a* is preferred to *action b* or vice-versa. In the case of pseudo-criterion, indifference is extended to a zone where the difference between *a* and *b* is small, while between the zone of indifference and the zone of strict preference there is a zone of weak preference, which indicates a hesitation between indifference and strict preference. For the definition of the indifference relation I, the weak preference relation Q and the strict preference relation P in the case of a pseudo-criterion j, two thresholds, the *indifference threshold* q_j and the *strict preference threshold* p_j must be defined. For each couple of actions *a* and *b*, the outranking hypothesis "*a* outranks (i.e. is not worse than) *b*" is tested through the conditions of concordance (i.e. there is a majority of criteria in favour of *a*) and discordance (i.e. there is no criterion too much in favour of *b*). For the examination of the latter condition, a *veto threshold* v_j is used. The method finally provides two rankings where indifference is permitted : the ascending distillation (i.e. picking the worst, then excluding the worst picking the second worst etc.) and the descending distillation (i.e. picking the best, then excluding the best picking the second best etc.). These two rankings are then compared, in order to build the final ranking. In the latter, incomparability between *action a* and *action b* may occur. Two actions *a* and *b* are incomparable when *a* has a very good performance on certain criteria for which the performance of *b* is poor and vice-versa. Incomparable actions are difficult to be ranked and thus no recommendations on the selection between them can be made.

Apart from "Base Case", four sensitivity analyses were carried out : 1) *Sensitivity Analysis 1*, where the criterion of visual amenity (i.e. N^o 8) is excluded from the criteria set, in order to check the degree of its influence to the final ranking of scenarios 2) *Sensitivity Analysis 2*, where stricter thresholds for economic and technical criteria (i.e. N^o 1, 2, 3, 4 and 5) are retained 3) *Sensitivity Analysis 3*, where stricter thresholds for environmental criteria (i.e. N^o 6, 7, 8, 9, 10 and 11) are retained 4) *Sensitivity Analysis 4*, where a drop of investment cost of wind turbines is assumed, due to the progress of the relevant technology.

The dispersion in the ranking of each separate alternative strategy according to all actors' value systems and for all the analyses performed is graphically depicted in Figures 3(a) - 3(p). Each figure shows the results obtained for a particular scenario by the application of ELECTRE III for the various actors, as well as for the sensitivity analyses. Consequently, in each of the graphs there are five different sets of points (i.e. for the "Base Case" and the four sensitivity analyses). Each set comprises eight different points (i.e. for the eight actors). Each of them is characterised by a pair of co-ordinate values : x (representing the position of the strategy in the descending distillation for the specific actor and sensitivity analysis) and y (representing the position of the strategy in the ascending distillation for the specific actor and sensitivity analysis) (Simos 1990). Good strategies are those which come up highly ranked if the distillation is descending and remain highly ranked with ascending distillation. Consequently, good strategies will be located at the top and right area of the graph. In the present application, the area between (6,6) and (1,1) was considered as the *area of "good actions"*. It is clear that the definition of the boundaries of the area of "good actions" includes a degree of arbitrariness : One could select a smaller area (i.e. between (5,5) and (1,1)) or a greater one (i.e. between (7,7) and (1,1)).

Figure 3.
Ranking of alternative scenarios by ELECTRE III

156

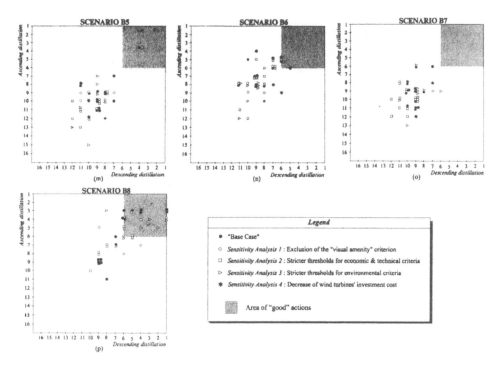

Figure 3 (continued)

From the results obtained, alternative scenarios can be grouped in three categories :

• *Alternatives that never fall within the area of "good actions"*, comprising scenarios B1, B4, B5 and B7. In all these scenarios, only the first construction phase of the new fossil-fired power station is completed by the year 2005. Scenario B1 is very controversial, as it has the best score for 3 criteria and the worst score for 5 criteria. Scenarios B4, B5 and B7 have a moderate score for the majority of criteria, while a poor one for the rest.

• *Alternatives that always fall within the area of "good actions"*, comprising scenarios A2, A4 and A7. In all these scenarios, both construction phases of the new fossil-fired power station will be completed by the year 2005. Scenarios A4 and A7 have a very good performance in 3 criteria and a moderate one in 7 criteria. Scenario A2 has a very good performance in 4 criteria (which are considered as important by many actors), a moderate one in 3 criteria and a low one for the rest 2 criteria (which are considered as less important by the majority of actors).

• *Alternatives that are in between* the two previous categories, comprising all the rest. Out of these, four sub-categories can be distinguished :
 - Scenarios that are rarely placed within the area of "good actions", namely B3 and B6.
 - Scenarios that are more often placed within the area of "good actions", namely A3.
 - Scenarios that present a great controversy between actors and sensitivity analyses, namely A5, A6, A8 and B8.
 - Scenarios that are moderate solutions for the majority of actors and sensitivity analyses, namely A1 and B2.

From the analysis presented above, the following conclusions can be made :

a) *If the new fossil-fired power station is fully completed* by the year 2005, the most interesting

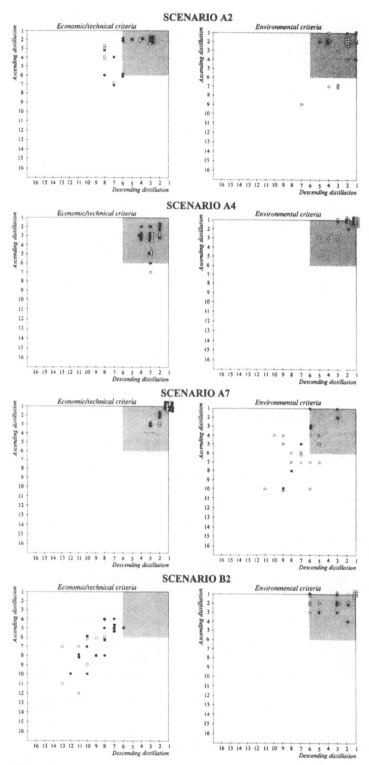

Figure 4.
Ranking of alternative scenarios according to economic/technical and environmental criteria

solutions for the actors questioned are scenarios A2, A4 and A7. *Scenario A2* implies a high penetration of wind in electricity generation, as well as a high penetration of RES in end-uses (excluding capital intensive solar energy applications, such as space heating and cooling). *Scenario A4* (implying a penetration of wind up to actual maximum capacity limits and a high penetration of economic solar energy applications in end-uses) represents the most probable scenario for Crete, taking into account the actual attitude of investors and of the competent central ministries. In *Scenario A7*, emphasis is paid more on a combination of non-capital intensive end-use interventions than in electricity generation.

b) *If only the first phase of the new fossil-fired power station is completed* by 2005, the most interesting solution for all actors is *Scenario B2*, implying an intensive exploitation of all renewable technologies. It should be noted that the relative position of this scenario is significantly improved (it falls within the area of "good actions" for all the actors involved apart from one) if the criterion of visual amenity is excluded from the criteria set.

Furthermore, in order to examine how the introduction of the environmental dimension affects the ranking of the above mentioned scenarios (i.e. A2, A4, A7 and B2), ELECTRE III was again applied in two separate cases : *Case I*, where only economic and technical criteria were considered (i.e. criteria C1-C5) and *Case II*, where only environmental criteria (i.e. C6-C11) were considered. The results are shown in Figure 4.

Scenario A2 is moderately ranked according to economic/technical criteria (ET), while it is rather highly ranked according to environmental criteria (ENV), especially if the visual amenity criterion is not taken into account. The above features explain its final overall high rank if all criteria are considered. Scenario A4 is also highly ranked according to both ET and ENV criteria, although it becomes less attractive according to the latter if the visual amenity criterion is not considered. Scenario A7 is highly ranked according to ET, but poorly ranked according to ENV. Finally, scenario B2 (representing the most optimistic scenario for RES exploitation) is poorly ranked according to ET, but highly ranked according to ENV.

3. CONCLUSIONS

The following conclusions can be drawn after the application of the proposed methodology :

• MCDA tools can offer significant assistance in gaining greater public acceptance in problems related to RES exploitation, as by their use it is possible to incorporate often conflicting points of view in the analysis performed and to get a clear picture of the conflicts arisen between the various actors involved. Furthermore, by performing a number of sensitivity analyses, it is possible to examine how imprecision, subjectivity etc. influence the final results.

• The introduction of the environmental dimension can significantly affect the final ranking of scenarios, as it is the case of the optimistic scenario for RES (i.e. B2). Scenarios such as the latter which have a rather low economic performance can turn into attractive options if environmental criteria are included in the criteria set. It is clear that a future introduction of the "external (or social) cost" of energy forms into the market prices will significantly change the way decisions in the field of renewable energies are taken.

• In order to gain the best profit from the application of MCDA tools in similar problems, the whole procedure must be carried out early enough, following a "pro-active" instead of "reactive" process. Furthermore, special attention should be paid in formulating alternative options and selecting the evaluation criteria, as these form the basis of the whole analysis.

REFERENCES

"An Action Plan for Renewable Energy Sources in Europe" 1994. *Proceedings of the conference, Madrid, 16-18 March 1994.*

Bana e Costa, C.A. & J.C. Vansnick 1994. MACBETH - an interactive path towards the construction of cardinal value functions. *International Transactions in Operations Research* 1, 4 : 489-500.

Diakoulaki, D., E. Georgopoulou & L. Papayiannakis 1996. Designing a Decision Support System for regional energy planning. *Foundations of Computing and Decision Sciences* Vol. 21 (2) : 67-79.

Jolliet, O. 1994. Critical Surface-Time : an Evaluation Method for LCA. In H.A. Udo de Haes, A.A. Jensen, W. Klopfeer and L.G. Lindfors (eds), *Integrating Impact Assessment into LCA, Proceedings of the LCA symposium held at the Fourth SETAC-Europe Congress, Brussels, 11-14 April 1994* : 133-142, Brussels.

Lipscomp, D.M. & A.C. Teylor 1978. *Noise control (Handbook of principles and practices).* USA : Litton Educational Publishing.

Ministry for the Environment, Physical Planning and Public Works 1995. *Climate Change - The Greek Action Plan for the Abatement of CO_2 and Other Greenhouse Gas Emissions.* Athens.

National Technical University of Athens 1996a. *DRILL : Developing Decision Making Support Tools for the Utilisation of Renewable Energies in Integrated Systems at the Local Level.* Report of research project N^o JOU2/CT92/0190 carried out within the framework of program JOULE II of EU. Athens : NTUA.

National Technical University of Athens 1996b. *Implementing Large Scale Integration of Renewables : a pilot study for operational plans and policies.* Report of research project N^o RENA-CT94-0005 carried out within the framework of program APAS of DG II of EU. Athens : NTUA.

Public Power Corporation (PPC) 1975-1994. *Annual Reports.* Athens : PPC. (in Greek)

Roy, B. 1990. The outranking approach and the foundations of ELECTRE methods. In C. Bana et Costa (ed), *Readings in Multiple Criteria Decision Aid,* 155-183. Berlin : Springer-Verlag.

Siskos, J. & Ph. Hubert 1983. Multi-criteria analysis of the impacts of energy alternatives : A survey and a new comparative approach. *European Journal of Operational Research* 13 : 278-299.

Simos, J. 1990. *Evaluer l' impact sur l' environnement.* Lausanne : Presses Polytechniques et Universitaires Romandes / Ecole Polytéchnique Fédérale de Lausanne (EPFL).

Union of Municipalities of Crete 1993. *Feasibility study for the exploitation of wind energy in the island of Crete.* Final Report of Contract No 706/90-37 of the Regional Energy Planning Programme / DGXVII of EU.

Wind Energy and Landscape, Ratto & Solari (eds) © 1998 Balkema, Rotterdam, ISBN 90 5410 913 0

Author index

T - #0271 - 101024 - C0 - 254/178/10 [12] - CB - 9789054109136 - Gloss Lamination